ART

A CRASH COURSE

ART
A CRASH
COURSE
JULIAN FREEMAN

SIMON & SCHUSTER
A VIACOM COMPANY

First published in Great Britain by
Simon & Schuster Ltd, 1998
A Viacom company

Copyright © THE IVY PRESS LIMITED 1998

3 5 7 9 10 8 6 4 2

SIMON & SCHUSTER UK LTD
Africa House
64-78 Kingsway
London WC2B 6AH

Simon & Schuster Australia
Sydney

A CIP catalogue record for this book is
available from the British Library

ISBN 0-684-84018-9

This book was conceived, designed and produced by
THE IVY PRESS LIMITED
2/3 St Andrews Place
Lewes, East Sussex. BN7 1UP

Art director: PETER BRIDGEWATER
Designer: JANE LANAWAY
Commissioning Editor: VIV CROOT
Managing Editor: ANNE TOWNLEY
Page layout: CHRIS LANAWAY
Picture research: VANESSA FLETCHER
Illustrations: CURTIS TAPPENDEN *and* ANDREW ROBERTS

Reproduction and Printing in Hong Kong by
Hong Kong Graphic and Printing Ltd

DEDICATION

*This book is dedicated to my
teachers, colleagues, students and friends,
for years of good humour and patience;
to Estelle, Alanna, Graham, Ruth and
Sarah Freeman, for their love and support;
and to the memory of Sim Freeman
(1915–1987), who liked a good laugh.*

Contents

Introduction

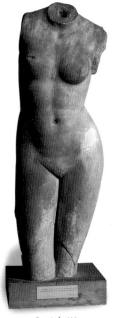

People respond to art with their minds, heart and guts; you shouldn't need a degree in art history to do that, and for true great art, it works. You couldn't fail to be moved by a grave van Eyck madonna or whatever. But... a little bit of background can help you understand a lot more. All those pictures, all those names, all those isms? What do I look for? What do they mean? Who were all those Italian guys with names ending in 'o'? Don't panic. This book is just for you. Art: A Crash Course *isn't Art's Greatest Hits, and not quite 'everything you need to know about art but were afraid to ask'; but it comes close.*

Cave painting

How this Course Works

This course proceeds more or less chronologically, although each double page spread is dedicated to one artist, a school, a group, or an ism. And on each spread there are regular features. It will not take you long to work them out. Examples are shown on this page.

Praxiteles' Venus

Like most books about Art, it follows a rough chronology, but it is selective. Everyone has a view on art. Those views can change like the weather, and not everyone can say why they think what they think with clarity. This book is intended to kick-start, or support, a real interest, to give you courage, not only to find out more, but also to begin to form opinions of your own. No book on Art can teach you your own mind. That's for you to develop.

It's easy to be irreverent about Art, and this book often is. Contrary to popular belief, Art isn't a mystique. Art was and is made by real people, most of them with all their

Seurat's bathers

faculties intact. Some – but not all –
of them have starved in garrets. In the
twentieth century some of those people
have called directly for attention, banging
a drum in writing or through their work.
Some of the greatest artists – such as
Rembrandt – can still speak to us
across three hundred years, to
give us an understanding of the
artist's experience in a lifetime's
output that extended from
personal triumph, through tragedy, to
obscurity. Others simply worked away quietly
and allowed their art to be discovered in due time.

Boccioni's Unique Forms of
Continuity in Space

Don't think you have to be a gallery groupie or a
museum bore to bring Art in to your life. Art and museums
don't always mix. Art is to be found in homes, or in
more public places such as churches or
banks or civic buildings. It might
have been bought or commissioned for
a special purpose. Works like this often
reflect the fantastic changes undergone
by Art through the centuries.

"☆"

Starred boxes

Starred Boxes contain gosh
facts; you didn't need to know
it, but it beefs up your art cred.
Just the thing for pompous
dinner parties.

*You'll find the most important
in this book, along with some of the most
pathetic, preposterous notions and concepts
ever devised by real people. Through all these
extremes, Art lives.*

Julian Freeman

Timeline

Not so much a time line
because it's impossible to
run a continuous
chronology: artists are
constantly tripping over
each others' mahlsticks
and isms collide,
interbreed and self-
replicate in slightly
different forms elsewhere
in the universe; so more of
a contextual commentary,
really, a selected list of
major events happening
at the time the artists in
question were working, to
give their expressions a
social context and to
demonstrate how all
aspects of life, inevitably,
are fogbound in the same
zeitgeist. It's also a bit
brainboggling to discover
that the lightbulb and van
Gogh are contemporaries.

Say What?

You may now know what you like, but can you tell anyone? Some artist's
names are more challenging than others and many a blagueur has fallen at
the last fence when they name their hero; here's how to say it (roughly); if
you already know, have patience. You were once a learner-driver...

Beuys	Boyce
Boccioni	Botch eeonee
Bonnard	Bonnar
Botticelli	Botti chelli
Boucher	Booshay
Boudin	Boo-dan
Braque	Brarck
Pieter Bruegel	Peter Broogel
Broederlam	Brooderlum
Caravaggio	Caravad jee-o
Cellini	Chell-eeni
Cimabue	Cheemaboo
Cranach	Cranach (as in loch)
Cuyp	Kipe
David	Da- veed
Derain	De ran
Duccio	Dooch yo
Duchamp	Doo shum
Durer	Dyew-rer
van Dyke	vn Dyke
Fragonard	Fragonah

della Francesca	della Francheska
van Eyck	vn Ike/vn Ache
Gauguin	Go gan
Ghuirlandaio	Gear-larndayo
Giotto	Jee otto
Gleizes	Glaze
van Gogh	van Goch (as in loch); (if you are Dutch you say vn Hoch, no problem)
van der Goes	vn de Hooss
Gris	Gree
Grosz	Gross
Grünewald	Groonevult
de Hooch	de Hoke
Kitaj	Kit-aye
Klee	Klay
Leger	Le-jay
Maes	Maass
Mantegna	Mantain ya

Massaccio	Mass ach yo
Mettzinger	Metzanjay
van Meegeren	vn Mayg–heren
Munch	Moonk
Nolde	Nolder
Raphael	Raffayel
Riemenschneider	Reemenshnider
Rodin	Road-an
Schiele	Sheela
Titian	Tishun
Uccello	Yew chello
Velázquez	Velathkweth
Veronese	Veronaizey
da Vinci	da Veenchi
Vuillard	Voo-ee-yar
Watteau	Vuh-to
van der Weyden	vn der Vaiden
Wolgemut	Volg-emoot
Bauhaus	Bowhouse
Der Blaue Reiter	Der Blouwe Riter
Die Brücke	Dee Brewkeh

8000–3500 BC After eons of hunting-gathering, humanity settles down into proto-villages based on farming. The first communities appear in Egypt and Mesopotamia; reed and wattle huts, flint sickles and axes.	**3400 BC** Kilns established in Sumeria (modern Iraq). Mass production of coil pots for all aspects of domestic life.	**c.3000 BC** Wheel invented in Mesopotamia; the wheeled cart swiftly followed, making the hitherto ubiquitous sled obsolete (except in bad weather).

8000 BC ~ 400 AD

Early Days
A Combination of Brains and Beauty

About 28,000 years ago, and a few million years after the Almighty rested on the seventh day, people suddenly got the urge to express themselves on cave walls. Why? We don't know. They just started drawing. Old, yes. Old Masters, no. These drawings were tucked away out of sight, away from the cave-mouths, deep down in the depths of the earth, behind big rocks, or near underground pools. They weren't trendy, or

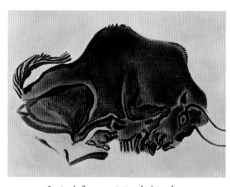

Raging bull; cave painting of a bison from Altamira, Spain. Eat your heart out, Damien Hirst.

meant for easy access like New York's SoHo or London's Cork Street. Just think. No dealers. No reviews. No sarcastic critics. Just people and their art. It must have been so refreshing.

Aiming to please: Athenian red-figure plate, late 6th century BC.

Most early artefacts and drawings have been found in central Europe, and of these the best known are probably at Lascaux in France's Dordogne region (discovered in 1940 and presently closed because of overuse). Others, dated a little later (c.18,000 BC), are at Altamira in Spain. Subject matter? No Waterlilies or Irises,

thanks very much. Animals were definitely in. Mammoths (in or out of traps at the cave at Les Trois Frères, or carved into the wall at Rouffigny, both in France). Ibex. Stags. Reindeer. Horses. Wolves. Bison. Cattle. The animals people knew and depended on for food. Or predators such as lion and bears, drawn with a skill probably developed from wearily watching and trailing the beasts for miles, and which no late twentieth-century art student could possibly match. Early Man wasn't too interested in portraiture, unless you count

3000-700 BC
Copper and tin alloyed to form bronze, strong yet malleable. Weapons, ornaments and artefacts found all over Europe.

c.2500 BC Great Pyramid of Cheops built at Gizeh. It is 146.6 m/481 ft high, covered in glittering limestone and capped with gold .

c.2000 Northern Europe responds with an enigmatic edifice of its own. Stonehenge in Wiltshire, England, a circle of standing stones that is either an astrocalendar, or a Druidic temple, or both or neither.

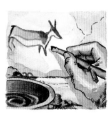

Painting *au naturel* with pigments from earth, plants, and animal blood and fat.

the dancing figures of shamans: tribal healer figures who dressed in animal skins in order to commune with the animal spirits.

Size? Cave artists had a sense of grandeur. They drew their animals big and bold, in colours they made from mineral oxides or from natural clays or juices. Mostly yellows, browns, reds and (horror of horrors)...

black, a colour shunned by the later know-alls of the Renaissance and after. But then the early artists had magic in mind. Their colours were mixed with charcoal or animal fat and were either daubed onto the cave wall with a kind of wax crayon, or blown onto it, using a tube.

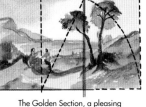

The Golden Section, a pleasing visual proportion, imposed on a Turner landscape composition; he's spot on.

Whatever their subject – and humans do eventually enter the frame – such drawings were usually strong. They were urgent visual requests to the Maker for Plenty; for Food; for Fertility.

As Humankind settled into farming-based communities, around 4000 BC, society and civilization developed, architecture became necessary, and so art grew too. Egypt went hieroglyphic. Greece was Glorious and Rome Imperial, and

.here, in what we like to call 'Classical Antiquity', we find the sources of Western art as we now understand it. What's more, those sources are still with us today, more or less the same as they were in the time of Pericles (c.490–429 BC), Athens's greatest statesman and art-lover. Sure, the Romans fiddled about with these ideas a bit, and the Renaissance (c.1200–1550 AD) took all the fun out of them, but if that pedigree sounds daunting it isn't nearly as complicated as it may seem.

So. Greece. Home of the Greek myths, eh? Yes, but first and foremost the Greeks kindly donated the Golden Section, or Golden Mean. The Greeks did not have a word for it, but they knew it well. A mystical, proportional, visual harmony, based on a ratio, and the later basis for many Renaissance paintings (and many after that too).

Next, the Orders of Architecture. These are about the proportions of buildings, but are best understood when looking at the columns we see on buildings, even today. *Doric*, squat, quite plain, straight up and down, dating from the 7th century BC, and a little

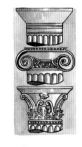

From the top: Doric, Ionic and Corinthian capitals.

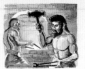

1100 BC The fall of the Hittite empire scatters the Hittite ironsmiths who take their state-of-the-art wrought iron technology with them.

1000–700 BC Warmongering Assyrians invent the cavalry, battering rams, siege towers and go-faster biremes, troop-carrying warships.

800 BC Glass technology established; glass beads all over the civilized world. Glass blowing would not be developed until 100 BC, when bottles, tumblers, bowls etc. became available.

earlier than similar Tuscan. *Ionic*, similar, but with a scroll top, or capital, which came from Asia Minor in the 6th century BC. And, best known, *Corinthian*, a home-grown Athenian product of the 5th century BC, taken over by the Romans, Cecil B. de Mille, Las Vegas, Hollywood generally, and every City Hall in Europe and the USA. You know Corinthian: fluted, topped off with some nice foliage (usually acanthus leaves). The Parthenon at Athens (begun 447 BC) has some good examples.

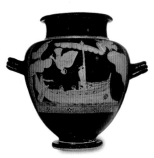

The narrative vase (c.490 BC). Greek hero Odysseus lashed to the mast to resist the call of the Sirens.

The concept of ideal beauty, brainchild of the Greek philosopher Plato (c.428–347 BC) was translated into Greek sculpture, and then adopted by the Romans and transported ever onward. Stern male figures looked as though they'd lived in the gym for a month. But females … aaah. Venus was definitely a Greek, with or without arms. What the great Greek sculptors Phidias and Polyclitus (mid-5th century BC) did for Gods and mere men, Praxiteles (mid-4th century BC) did for women, initiating the tradition of free-

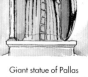

Giant statue of Pallas Athene in all her original gold and ivory glory.

standing female figures with his Aphrodite of Cnidus or Cnidian Venus (c.350 BC). And those famous myths did sterling work as the subjects for sculpture and the equally famous Greek vase painting, a tradition taken on by the Romans in their turn.

The Romans loved the art of the following Hellenistic period (4th century BC to 1st century AD). By 120 BC they were using that fabulous white marble for funerary monuments, and they kept it on for palely immortalized generations of emperors and heroes. If you were god enough, you got the marble treatment, but you should also remember that the Romans invented

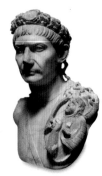

Roman Emperor Trajan (42–117 AD) dignified in marble.

concrete (oh yes they did: a cement mush with brick or shingle strengthening called *Opus reticulatum* or *Opus signinum)*.

Pompeii always catches the imagination. This town on the Bay of Naples was covered with, and preserved by, volcanic ash during the eruption of Vesuvius in 69 AD. Its splendours have

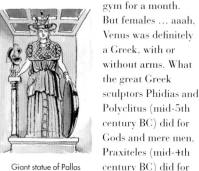

c.620 BC Potter's kick wheel invented. It could be turned independently by an energetic potter. Before this, he needed two assistants to spin the wheel while he potted.

612–538 BC Nebuchadnezzar rebuilds Babylon with exotic Hanging Gardens, the glittering Ishtar Gate and the noisy Tower of Babel; Babylonia top city state.

461 BC Pericles (c.490–429 BC) becomes leader of the Athenian Democratic Party. He creates a confederation of cities led by Athens.

In Flagrante

The volcano that smothered Pompeii preserved some of its naughtier frescoes showing what the Pompeiians got up to after work. This fresco, one of many, shows a lively scene in a brothel.

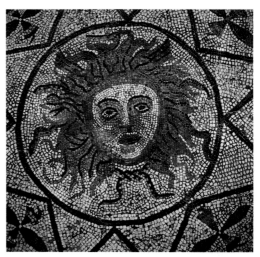

Mosaic was the Romans' strong suit and examples appear all over the Empire. This Medusa is from North Africa.

been progressively robbed since the nineteenth century, but it's still a gold-mine for students of the four main Roman styles of fresco (wall) painting (120 BC–63 AD), and there, and throughout the world, archaeology has turned up wonderful examples of Roman mosaic floor decoration. Painting? There's not much of it left from the Empire except for a few portraits on board from Egypt. And though the sculpture is big, it's rarely a patch on the Greek stuff.

Apollo, father of the muses, and Dionysus, god of altered states.

After a long look at Pompeii and at what followed, you'll understand just what those later Renaissance fat-cat patrons did to Art. They took all the fun out of it. Before Church or State became involved, Greek and Roman art was vibrant, bawdy, erotic, refined, cerebral and classy in equal part. Apollo and Dionysus. Those days, it seems, are gone forever.

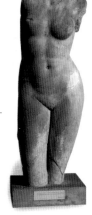

The first 3D female nude; this is a Roman copy of Praxiteles' gorgeous original.

ART ~ A CRASH COURSE **15**

476 End of Western half of Roman Empire when Rome falls to Oadacer the Goth. In 493, Theoderic the Ostrogoth kills O. and sets up his own imperial capital in Ravenna, Italy.

800 Charlemagne, keen art buff, is crowned in the Romanesque chapel at Aachen, the first Holy Roman Emperor. Brings peace to France (with bits of Belgium and Germany).

732 Moslems invade Europe, reaching as far north as Poitiers, France. Moorish design ideas influence Spain and southern France.

AD 700~1000

Lady Madonnas
Byzantine and Romanesque

While you're chilling out to Gregorian Chant in heavy traffic, remember that its inventor was the same guy who said, 'Painting can do for the illiterate what writing does for those who can read'. So POPE GREGORY THE GREAT (c.540–604) was also the inadvertent inventor of the comic strip – because that's exactly the way the early Latin Church saw the role of pictures in its basilicas: as educational visual aids for pre-literate humans.

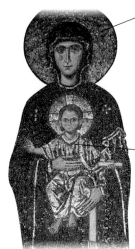

All executed in mosaic; note excellence of appearance, and humanity of Madonna's tenderness

Jesus appears as a small adult figure, not a baby or infant

Mary with Child Jesus, c.1118. This gloriously Byzantine black and gold pair form part of a mosaic from Hagia Sophia, Istanbul. In the original they are flanked by saints Irene and John II Comnenus.

THE FRAME **NAMES IN**

Abbot Suger *(c.1081–1151)*
Powerful patron and counsellor to kings; he was Abbot of St Denis, Paris and introduced to his own architects and to the French at large the lofty vaulted abbey type we associate with most French cathedrals.

This didn't go down too well with everyone, but no-one could quibble with the results: calm gilt Madonnas, serene Christs, in mosaic at the large, oblong basilicas at Ravenna, on Italy's eastern seaboard: capital of the Western half of the Roman Empire, and centre of the Latin Church.

In Constantinople, aka Byzantium (now it's Istanbul), centre of the Eastern half of the Roman Empire and of the Greek Church, feelings were similarly polarized. But by 745 AD you might have seen Christ, the Virgin, and anyone else in the picture, portrayed in a way that would be unchanged for several centuries. In the

912 Vikings trash Europe. Rollo the Viking becomes Robert, Duke of Normandy, founding the dynasty that will lead to William the Conqueror, 1066 and all that.

1067-1070 The Bayeux Tapestry shows a Norman-biased view of events leading to the battle of Hastings and celebrates the victory of W. the Conqueror.

1225 Ghenghis Khan and his Mongol Horde invades Persia and Russia. Barbarians at the gate.

North it was broadly absorbed into International Gothic, a style that preserved many fundamentals of Ancient Greek art, added detailed decoration, but which also prevented progress. Thankfully, such constraints didn't prevent some Byzantine artists from developing their Madonnas into a state from which later artists, like *GIOTTO* (1267–1337) and *DUCCIO* (c.1255–1318) would take them, just as sensitively, if not into the dark, then into hitherto unexplored pictorial realms.

ROMANESQUE = SOLID AND CERTAIN

Back on the European ranch, the Romanesque was grinding into top gear. This was an architectural process, clear and ordered, whose best-known building hallmark is the rounded, sometimes decorated arch. Regional variations spread like wildfire during the following decades. From those long, echoing Italian Basilicas,

the great west fronts of French and German early Gothic cathedrals were born, and with them the monastic orders that became an integral part of the central Middle Ages. The visual arts kept pace. Anonymous monks or craftsmen painted walls or decorated manuscripts with sudden splurges of colour and in some countries, such as England for example – with the exception of major (but stop-start) monastic projects such as Durham Cathedral – architecture was less of a big deal. At Cluny, France, centre of the Benedictine world, there was a sculpture boom under *GILBERT* (or Gislebertus, fl.1125–35), one of the greatest Romanesque sculptors.

While all of this was going on, the Spanish version of the Romanesque was meeting fabulous Islamic mosque patterns (e.g. at Cordova), and the Christian faith would soon combine with Moslem culture to provide Spain's own terrific Mudejar buildings. Arts, science and letters were hotter here than in the rest of Europe. Time for a Renaissance.

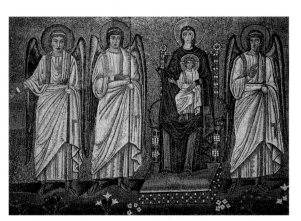

Madonna and Child Enthroned with Angels, a 6th-century mosaic from Ravenna, capital of the Western half of the Roman Empire. Note the connections: grave-faced Mary, Jesus as a miniature adult. The spring flowers indicate this is Italy not Byzantium.

1210 Franciscan Order established, founded by St Francis of Assisi, a rich man's son who gives up material trappings to talk to the animals and help the poor.

1301 Halley's comet, last seen on the Bayeux Tapestry and still without a name at this point, grazes the Earth's atmosphere once again. Giotto features it in his Adoration of the Magi, at the Arena Chapel, Padua.

1310 Spectacles mass-produced in Venice.

1250~1350

What Ho, Giotto!
Early Renaissance

Thus ejaculated young Stanley SPENCER, oddball (but important) British artist. And what did the thirteenth-century Florentine master have to offer the twentieth-century resident of Cookham? Great, sensitive drawing, deep emotion, and more imagination in his work than any Byzantine artist had attempted for many years, that's what.

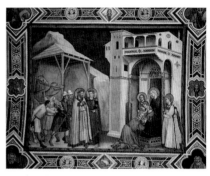

The Adoration of the Magi, a fresco from the church of San Francesco, Lower Assisi. This has been cautiously ascribed to the School of Giotto since it is difficult to ascribe any of Giotto's work with certainty. Note the realistically posed figures, compare the Madonna and Child to the stiff formal mosaics of the Byzantium school and you'll understand why Giotto was considered revolutionary.

Spencer depended on reproductions in a little book for his understanding of Giotto's work: at the time of his exclamation he had not yet seen the beautiful (and magnificent) fresco cycle of *The Life and Passion of Christ* on the walls at the Arena Chapel, Padua (begun in 1304 and complete by 1313), a major treasure of Early Renaissance painting.

Beware. Although it is widely agreed that *Giotto di BONDONE* (1266/7–1337) was a founder of modern painting, and his realistic depictions of the human figure mould-breaking, his career is one of those swamps which suck down the reckless *blagueur*. This is because, apart from the Arena Chapel, few undisputed examples of his work survive, and now there are even fewer. The most important questions

surrounded a series of frescos at the Upper Church of St Francis, Assisi (before 1306), but an earthquake wrecked these beyond repair in September 1997. One less problem to solve. Did someone say that Nature was the servant of Art? Giotto was famous enough to be mentioned by *DANTE* (Dante Alighieri, 1265–1321, author of *The Divine Comedy*), but don't be drawn: talk only of the radiant kindness of G.'s characters; they really do look benevolent.

DUCCIO: A CONTRARY GUY

Florentine superstar *GIOTTO* is normally mentioned in the same breath as the Sienese artist *Duccio di BUONINSEGNA* (1255/60–1315/18), but don't be fooled: though extremely influential, they are as different as their birthplaces.

1309 Dante begins work on the Divine Comedy, written in the Tuscan language. Giotto namechecked.

1334 Giotto's great reputation gains him supervisory post in building of Florence Cathedral. The cathedral tower (the campanile) is sometimes known as Giotto's Tower.

ARTSPEAK

Cimabue thought that he held the field in painting, but now Giotto is acclaimed and Cimabue's fame obscured.

Dante, The Divine Comedy, Purg. XI

As Giotto revolutionized Florentine painting, so Duccio did in Siena. Giotto broke away from stylization and introduced recognizable forms and figures to painting. But Duccio's work invites studied contemplation, as seen in the *Maesta* (Madonna and Child enthroned in majesty, surrounded by saints and angels) on the High Altar of Siena Cathedral. Giotto's images are profound, simplified and ideally suited to a Life of St Francis; Duccio's are richly coloured, elegant and gilded, out of keeping with Duccio's character: a contrary guy, in and out of all sorts of trouble during his life, constantly being fined for all manner of offences.

THE FRAME — NAMES IN

Giovanni Cimabue (c.1240–?1302) usually seen as Giotto's teacher and the 'father of Italian painting'; blended Byzantine backgrounds with natural figures; only one positively attributed work, a mosaic of St John at Pisa Cathedral; the rest is arguable.

Giovanni Pisano (c.1245/50–after 1318) one of the creators of modern sculpture, along with his father Nicola (c.1220/5–?84); they are famous for their four great pulpits (at Pisa (2), Siena and Pistoia); Giovanni went on to be such a great artist that he was exempted from taxes. A great influence on Duccio; not to be confused with **Andrea Pisano** (c.1290–1348/9), the sculptor and bronzeworker, and his son the sculptor Nino (c.1315–?68).

Taddeo Gaddi (d.1366) dedicated fresco follower of Giotto; he worked for the master for 24 years. Greatest hit: Life of The Virgin, Sta Croce, Florence.

Bernardo Daddi (c.1290–1349/51) leader of the next generation of Giotto wannabes, with a distinct Sienese bias.

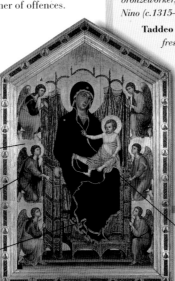

Duccio's Ruccellai Madonna, 1285; note the gilt, bold colours and sophisticated pose; you cannot believe that this Madonna and child were ever anywhere near a stable.

Note heavy gilt treatment, a hangover from the Byzantine style

Attendant angels are all different – individuals, not a composite bunch

Garments rendered with realistic folds and drapery

The central figures of the Madonna and Child are designed to be contemplated; their quiet repose encourages meditation

1406 Florence, top city state, buys Pisa, gaining a sea view. More wealth, more art.

1435 Leon Baptista Alberti (c.1404–72) writes his blockbuster Treatise on Painting – a guide book on perspective.

1434–95 Medici (Cosimo, Lorenzo, Catherine) become the godfathers of Florence and bankroll the Renaissance; golden age of patronage.

1300~1450
Everything Al Fresco
Masaccio, Piero della Francesca, and the rest

Masaccio, the klutz touched by genius.

Masaccio and Piero are the frescoist main men of the early Renaissance. Only four frescoes can be positively attributed to MASACCIO (1401–28) (real name Tommaso di Ser Giovanni di Mone, literally translated as 'Hulking Tom' because he didn't keep his room neat; Masaccio is the original role model for artistic slobs everywhere); but, in his short lifetime, the kid turned the art of fresco painting upside down, in and outside Florence.

In a combination of maths, scientific perspective, and clear-headedness, Masaccio took a breezy look at the spikey, North European Gothic style, gave it the finger, and went for classical simplicity instead. Outcome: a unique visual version of the Gospels, foreshortened as never before, and with several firecrackers thrown into the lighting department.

Light and shade (*chiaroscuro*) were completely rehashed, with realistic colours and natural forms used in new, untested ways. In other words, things began to echo their appearance for the first time: his frescoes for the Brancacci Chapel in the Florentine church of Santa Maria del Carmine say everything necessary. Until *MICHELANGELO* (1475–1564), who slavishly

The Tribute Money, c.1425–28, Brancacci Chapel, Santa Maria del Carmine, Florence. Divine propaganda for the heavy-taxing Florentine princes. Christ sends St Peter (far left) to catch a fish with a silver coin in its mouth to pay the disciples' dues to the tax man (far right).

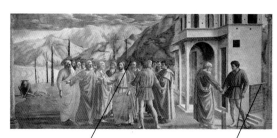

Strong, individual, reassuringly human faces, full of vigour and expression

Bold use of colour as a structural device

1452 Leonardo – the Renaissance Man's Renaissance Man – born at Vinci, Tuscany. He was the illegitimate son of a Florentine notary, but rose above such sordid beginnings.

1453 Turks take Byzantium (Constantinople, Istanbul) breaking the old empire in two. No more Christian art east of the Med.

1492 Oh come on... Columbus sailed the ocean blue, eventually 'discovering' America.

The Nativity, c.1470–75, Piero's last, unfinished masterpiece. A close harmony group celebrates the birth of Christ in a Tuscan landscape.

admired him, no-one could touch Masaccio for sheer genius, class, or invention. The Incredible Hulk was the real founder of the Early Renaissance.

PIERO: ART AND MATHS

Where Masaccio was sound and solid, *Piero della FRANCESCA* (?1420–92) was just as much of a head but saw the light more grandly, especially in his fresco masterpiece

The Legend of the True Cross at Arezzo (1452–65?). For many people, P. is the passport to Renaissance painting (and for some he's also the passport to Cubism, but this may prove treacherous territory for badly briefed *blagueurs*). Piero followed Masaccio's use of realistic human figures in his frescoes and elsewhere, but there's no mistaking his own originality. Daylit scenes in bright pastel shades distinguish Piero from his peers, and his mostly religious themes can seem almost unearthly compared with other Italian painters of the period. But if P. began by painting according to the diktats of taste, he was capable of flouting them. The incomplete *Nativity* (c.1415–20, N.G., London) combines a slap-happy understanding of Netherlandish oil-painting techniques with an in-your-face readiness to use that knowledge, regardless of the outcome. In the 1470s, he handed in his brushes and took to writing about the theory and mathematics of painting and perspective.

1500–1527 The High Renaissance. Three decades of creative ecstasy. Leonardo and Michelangelo are the supernovae in a crowded firmament.

1513 Niccolo Machiavelli (1469–1527) writes The Prince, the manual for scheming politicoes everywhere.

1520 Martin Luther (1483–1527) excommunicated. Protestantism established.

1450~1570

The Million Lire High Renaissance Men
Leonardo and Michelangelo

The enigmatic Mona Lisa, Leonardo's trademark. Why is she smiling?

LEONARDO da Vinci (1452–1519) and MICHELANGELO Buonarotti (1475–1564), the Godfathers of the High Renaissance. Naturally, they couldn't stand each other: chalk e formaggio. Leonardo had a brain the size of a planet and it never stopped fizzing: painting, sculpture, architecture, poetry, anatomy, engineering… helicopters, tanks, mechanical motion, water-power are just a few ideas brained out and written-up by Leonardo light-years before anyone else disturbed their own scurf.

Sadly, Leonardo's head was in such hyperdrive that he never actually quite finished very many projects but left reams of notes, sketches, and outlines at which we can only gasp and marvel.

Unfortunately, everyone's had a piece of one of the few projects he did actually finish, *Mona Lisa* (aka *La Gioconda*) (c.1500–4, Paris, Louvre). That smirking baggage is L.'s best-remembered picture. But it's a late work, and you should know that, despite its excellent, oil-painted atmosphere, he painted better; it's almost compulsory now to say that the art gangster *Marcel DUCHAMP* (1887–1968) was right to ridicule Mona with a moustache (on a photograph, naturally) in

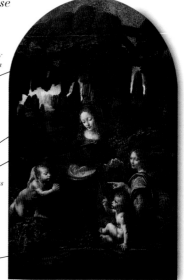

The famous misty 'sfumato' effect, a Leonardo trademark

Natural detail is given as much importance in the frame as human images

The Virgin's infinite tenderness of pose and expression

At last children in art begin to look like children in life

Leonardo da Vinci: The Virgin of the Rocks, Louvre. Paris. This is one of two versions of this subject. Both are stunning, but why did Leonardo repeat himself? What problem was he trying to solve?

1536-9 Henry VIII (r.1509-47) rejects Rome (the Pope will not allow him to divorce), dissolves the monasteries and elects himself head of the Church of England.

1543 Nicolas Copernicus (1473-1543) astounds the world on his deathbed by asserting (and proving) that the Sun, not the Earth, is the centre of the Solar System.

1550 Giorgio Vasari (1511-74) publishes Lives of the Artists, biographies of the major names in the Renaissance. Michelangelo, who gets a hagiography, is the only living artist to be mentioned. Lives sells so well a second edition comes out in 1568.

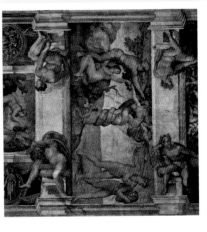

Michelangelo Buonarotti: The Expulsion of Adam and Eve, Sistine Chapel Ceiling, Vatican, Rome. Adam and Eve caught in the act and dismissed from paradise.

1920. Drink a toast instead to *The Virgin of the Rocks* (c.1483) (note: 'of' and not 'on'; she's not a slug of bourbon). There are two versions, in London and Paris. These, and *The Lady with the Ermine* (Krakow) came after 1483 (but before 1509), when Leonardo arrived in Milan and sold his stupendous talents to the city's Dukes – the Sforza family.

MICHELANGELO: ACTION MAN

And Michelangelo? Compared with L., M. was a doer rather than a thinker: his splendid work for pope after pope proves the point that when St Peter's successors

saw his handiwork they just had to have him. In life and art, he was an utterly fearless Florentine megatalent, hitched to a succession of heavy patrons, including the Medici family, and the warmongering Pope Julius II, for whom he created the *Sistine Chapel Ceiling* paintings (1508–12, Vatican, Rome), his most complex and important work. If asked to name any part of the work, try *The Creation, The Prophets, The Sibyls* or *The Expulsion from Eden*. Remember that the Sistine *Last Judgement* was commissioned later, in 1534, and executed 1536–41; it wasn't part of the original ceiling scheme. While he was painting the ceiling (mostly single-handed), Michelangelo kept notes of his progress. In verse. To see yet another side of M., compare the sculptures of *The Pieta* (1499; St Peter's, Rome) and *David* (1501–4, Accademia, Florence); the composition is the thing.

THE FRAME **NAMES IN**

Domenico Ghirlandaio *(1449–94) M.'s fresco master; don't look for oil painting – he never touched a drop.*

Andrea del Verrocchio *(c.1435–88) Painter, goldsmith, sculptor; alleged pupil of Donatello (his work is Donatello lite) and traditionally Leonardo's master, reputedly threw in the paint-rag when he saw L.'s angelic brushwork contribution to his painting, Baptism.*

Benvenuto Cellini *(c.1500–71) Sculptor, goldsmith and lover-boy, devout admirer of Mike, and hater of Vasari. Famous for his autobiography, considered to be a shade economic with the verismo.*

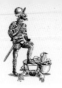
AD 1515~1590

Mind your Manners
Titian and Raphael

Like Ole Man River, TITIAN (Tiziano Vecelli) (1487/90–1576) just kept on rolling along, but poor RAPHAEL (Raffaelo Sanzio, 1483–1520) died aged 37. When it comes to star quality, both were in the High Renaissance Billboard Top 5, and both were mould-breaking: they weren't from Florence, but from north Italy.

Titian's artistic background was Venetian (completely different from Leonardo or Michelangelo; Venice was a rival city state to Florence and Siena). His long life and enormous ability allowed him and his art to improve with age, and because he was pretty damn good to begin with, by his death he was unspeakably marvellous. If tested on Titian's range, suggest his enormous *Assumption* (1518, Frari Church, Venice), *The Venus of Urbino* (c.1538, Uffizi, Florence), and *Bacchus and Ariadne*, plus *Diana and Actaeon* (1523/4 and 1560s, both London, N.G.), which should do the trick, but be careful: Titian's late style involved a famously free handling of paint, far from the studied Venetian style of his youth. He even painted with his fingers. Advanced crash students might anticipate the glimmer of Impressionism.

Venus of Urbino, Titian, c.1538, Uffizi Gallery, Florence. The prototype for handsome reclining nudes, a noble tradition followed by Velasquez, Goya and Manet to name but three.

Venus achieves a quiet intimacy with the spectator

The hunt for clothes continues

Titian's strongest suit: to make paint come alive against a dead background

A modest pose; nothing indecent was allowed

RAPHAEL: STAR BURN OUT

Of course, if you prefer a tale of meteoric fame, Titian's steady achievements may seem stodgy when compared with Raphael's. Infant phenomenon and provincial superstar, he was reckoned by some in his own backyard to be better than sliced bread, so he left for Florence and fame before he was twenty. Once there… crisis of confidence. His work looked unimpressive next to that of Leonardo and Michelangelo. Learning from their examples (especially M.'s), Raphael went his own way. Which meant Rome, around 1508, where Pope Julius II had the decorators in. R. got a foot

1564 William Shakespeare born the son of a glover in Stratford-upon-Avon, England.

1570 The potato comes to Europe from South America. All are baffled until top French foodie Parmentier devises ways to make it delicieux. For a while it is the nouvelle cuisine of its day.

1577–80 Francis Drake (c.1540–96) circumnavigates the globe for England.

in the door, and his frescoes in the Pope's new Vatican apartments (collectively *The Stanze*, 1511–14) are among his greatest achievements, portraying nearly every human emotion. *The Stanze* are less restless and more thoughtfully beautiful than Michelangelo's *Sistine Chapel Ceiling* (1508–12). R. might have been influenced by Michelangelo's drawing and colour-scheme in the Sistine, during these magnificent, overlapping commissions from the same boss-man.

Barely had the paint dried on *The Stanze* when Raphael was invited to take over the design of St Peter's in Rome, the one we know today, on the death of the architect *BRAMANTE* in 1514. Everyone wanted a piece of the action. Executive stress followed. And worse, Raphael's work was so beautiful that no-one could cap it. The result: Mannerism, a reaction to the High Renaissance (and frankly its butt end) which even Michelangelo followed. The signs? Excess of everything. Overkill in all departments. Muscles, facial features, colour, dramatic lighting… yuk.

The Set Piece
This is a Mannerist cliché: the elevation to prominence of a sculpture, a fountain, or an architectural object, raised on a dais of some kind, in a garden scheme, a courtyard, or piazza; it is still with us today in many city plans.

Portrait of Agnolo Doni, Raphael, 1505–6, Pitti Palace, Florence. Raphael lived life 'more like a prince than a painter'; this may be one of his noble acquaintances.

1582 Gregorian calendar established to standardize dates of religious festivals. Ten days deleted overnight. Citizens went to bed on October 4 and woke up on October 15.

1588 Spanish Armada trounced in the Channel off Plymouth by Sir F. Drake. He plays his famous game of bowls while waiting for the tide to turn in his favour.

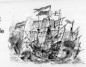

1605 Gunpowder Plot to blow up Parliament hatched by Guido Fawkes and a group of like-minded plotters. He fails, but the British still annually celebrate his spirited attempt.

1600~1680

Baroque
What more can one say?

Tired of Mannerism? Feel that the subject has escaped from Art? Ever wanted to dump those confused ideas, or that bad, overblown painting, and try something new? Well, now Baroque is here to help!

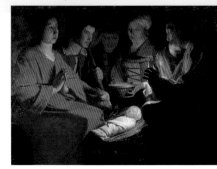

The Adoration of the Shepherds, Georges de La Tour, Louvre, Paris. A fine picture by a devoted follower of Caravaggio.

THE FRAME NAMES IN

Caravaggio had many devoted followers, and just as many detractors, but we won't talk about that. These are some of the fans:

From Holland – the Utrecht School...

Gerard van Honthorst *(1590–1656)*

Dirck van Baburen *(c.1595–1624)*

Hendrick Terbrugghen *(1588–1629)*

From Italy...

Francesco Barbieri, *aka Guercino (Squinty)(1591–1666). Loathed Reni.*

Guido Reni *(1575–1642). Loathed Guercino.*

From France...

Georges de La Tour *(1593–1652) influenced via the Utrecht School.*

The Le Nain Bros *(Antoine, c.1588–1648, Louis, c.1593–1648 and Mathieu, c.1607–1677). Founder members of the Paris Academy in 1634; even the trained eye cannot say for sure who did what in their oeuvre.*

NAMES IN THE FRAME

In its day Raphael's art was considered unsurpassable. The power and glory of *The Stanze* (not to mention Michelangelo's *Sistine Ceiling*) dominated Italian painting. Lesser artists felt the aesthetic squeeze, in and outside Italy. Something had to give. What we got was Mannerism, a kind of petrification of style and stultification of content. Mannerism reacted against the giddiest heights of the High Renaissance, but led art down a blind alley rather than into pastures new. In practice it meant some forty years of sensationalist painting, in which human bodies were depicted as though they'd been pumping iron non-stop for months, lips stopped smiling, teeth were gritted, faces convulsed and every object was subjected to extremes of light. Forget Leonardo's beautiful *sfumato* behind the lovely Lisa: what your Mannerist wants is nil observation, lorry-loads of imagination, and as much hard illumination as you can give us. It couldn't last, and mercifully it didn't.

1608 Telescope invented by Dutch lensman Hans Lippershey (c.1570–1619). Dramatic revelations in the night sky. Galileo (1564–1642) uses the instrument to discover some of the moons of Jupiter.

1620 Oliver Cromwell, the Roundhead leader, denounced by fellow-Puritans because he played 'the disreputable game of cricket'.

1620 Pilgrim fathers sail in the Mayflower from old Plymouth (England) to New Plymouth (Massachussetts). Modern America begins.

CARAVAGGIO: LIGHT AND DARK

Such gross artistic flatulence was banished by the Baroque, which, like most interesting styles, was a blend of arts, in this case all the plastic ones (painting, sculpture and architecture). Beginning in Italy around 1600, and with religion and the classical past at its very heart, the Baroque style demanded high levels of grey matter. Baroque painters and architects put a premium on clarity. They looked for direct, understandable themes, and treated them with simplicity and power. The shock wave hit every country in Europe, and the ripple effect continued well into the eighteenth century.

So, who do you call if you want a characteristic Baroque artist whose work epitomizes the no-nonsense combination of

" ☆ "

Light Fantastic

A particular feature of Caravaggio's work is his controlled lighting, a sensitive response to the harshness of Mannerist treatment, and a source for other, later, European painters, including Rembrandt and La Tour.

accuracy and technique? Say *Michelangelo Merisi da CARAVAGGIO* (1571–1610), loud and clear. His private life was riotous: as full of expressive light and shade as his paintings; he had to run from Rome in 1606 after killing a man in a knife fight, so you may have to defend him, but he was a 100-carat artist of the High Baroque first rank. From 1600 Caravaggio painted only religious subjects, but his no-holds-barred approach defied every technical pictorial convention (he worked directly onto canvas) and appalled most clerics. Why? He painted ordinary people as biblical characters. Angels with dirty faces. No sanitized saints for him, yet the cardinals still queued for his work.

Caravaggio used regular models for his heavenly host; look out for them in other paintings

Likewise, the venerable model for Abraham appears elsewhere in different robes

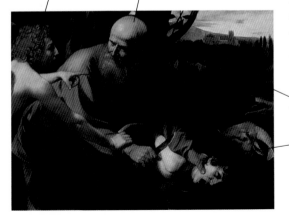

The biblical story is presented as an everyday scene in what was modern Italy to the artist

Isaac does not fancy his fate; in the nick of time the ram is sacrificed instead

The Sacrifice of Abraham, Caravaggio, Uffizi, Florence. Note Isaac's very realistic expression of fear and horror.

1415 Battle of Agincourt. England v. France. Henry V's finest hour. English bowmen sweep the field. Cry God for Harry! England and St George!

1454 Johannes Gutenberg (c.1400–68) uses movable metal type to print a Bible in Mainz. He had taken the idea from the Koreans.

1470–80 Lorenzo di Medici (the Magnificent) rules Florence. Opulence all round, swiftly followed by decadence.

1400~1550

Paint and Pleasure

Northern Renaissance
France and Germany

If you imagine the Italian Renaissance as a long, loud party going on in a big padded cell, and Northern European art as a sedate, but important gathering in the next apartment, then you'll have a fuzzy picture of the European art scene during the late fourteenth and early fifteenth centuries. The Italian door is flung open for several minutes at a stretch, but because of the noise we miss the neighbours' comings and goings.

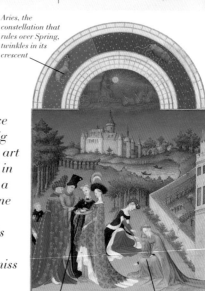

Aries, the constellation that rules over Spring, twinkles in its crescent

A young man's fancy... a loving couple exchange rings, watched by their parents

Flowers in bloom – there can be no mistake that this is Spring

The Limbourg Brothers: April, from Les Très Riches Heures du Duc de Berri, Musée Condé, Chantilly, 15th century. Books of Hours were very popular at this time, but the Limbourgs' version still shines like a jewel through the centuries.

Some people blame the Alps for this: the medieval equivalent of the Iron Curtain, an obstacle to the transmission of new ideas. But this is stupid. So let us away to the lands of the 100 Years War, the Black Death, the Pursuit of the Millennium (the first one), of Martin Luther and his unstoppable Reformation.

BERRI AND BURGUNDY

Did you ever hear that Gallic close-harmony group *The LIMBOURG Brothers* (Paul, Jean and Herman, c.1400s, all dead by 1416)? Briefly banish from your mind those vicious Anglo–French conflicts of the same period. The Limbourgs' beautiful manuscript illustrations, small, jewel-like

images, point the way to their last and finest work: the *Très Riches Heures du Duc de Berri* (c.1411), a magnificent Book of Hours – almanac, zodiac and prayer cycle combined. Its densely coloured narrative is an atmospheric, sometimes naughty, record of each passing season in France, decorated with peasants and nobility alike, unsurpassed by any animator. Some people may know these pictures as anonymous

1475 Rifles invented in Nuremberg, Germany.

1476 William Caxton (c.1422–9) prints the first book in England, Dictes or Sayengis of the Philosophres. He had learned his craft in Cologne.

1495 Outbreak of new disease in Naples. Italians call it the French disease; French call it the Neapolitan disease. It is syphilis, spread by the armies of soldiers fighting on battlefields all over Europe.

Isenheim: the Musical

German composer Paul Hindemith (1895–1963) based his fine opera *Mathis der Maler* (Mathis the Painter, 1933–35) on the Isenheim Altarpiece. A modernist, Hindemith was naturally out of favour with the Nazis, but hoped that the symphony's German theme would invite renewed confidence. Wrong. By 1940 he was in the USA, a political refugee, and (surprise) enjoying great success.

reproductions on Christmas cards, so you should be ahead on points. But check the Limbourgs' patrons, the ducal brothers Burgundy and Berri. These were serious connoisseurs, especially Burgundy, who backed *Claus SLUTER* (active c.1380–1405/6), sculptor of *The Well of Moses*, at Dijon: a well-head surrounded by the figures of six prophets. Only Moses survives, but he's in a realistic style so different from the prevailing International Gothic that Sluter gets credit for kick-starting a new wave of 3D representation in Europe.

GRÜNEWALD DER MALER

Further north, in the German lands, and a century away, *Matthias GRÜNEWALD* (1470/80–1528) would paint his masterpiece, the *Isenheim Altarpiece* (Colmar 1515/16): an altarpiece for a Leper hospital; the Crucifixion cycle re-enacted in an agony of paint, an emotional flagellation. But what is this? Grünewald seems to have been alive to Renaissance techniques and to have used them, but to have dismissed the *esprit* of the Renaissance in favour of German ideals... and the Reformation.

Moses, Claus Sluter, from The Well of Moses, Champmol, Dijon, France, 1395–1404. A triumph of detail in stone; note Moses' bifurcated beard.

THE FRAME NAMES IN

In the French corner, the painters **Melchior Broederlam** *(fl. 1381–c.1409), early International Goth, and* **Jacquemart de Hesdin**. *And from the Germanic team, the great sculptors* **Veit Stoss** *(1440/50–1533) (Late Goth, known as Wit Stwosz in Poland),* **Michael Pacher** *(c.1435–98) (Goth im Tyrol), plus the painters* **Konrad Witz** *(1400/10–44/6)(the big Swiss cheese before Holbein),* **Martin Schongauer** *(fl. 1465–91) (painter and engraver),* **Stephen Lochner** *(fl.1442–51) who made International Gothic pretty.*

1492 Spain captures the Moorish stronghold of Granada; Moors retreat from Europe.

1517 Martin Luther (1483–1546) nails his credentials to the door of the Wittemberg Castle church. His 95 Theses form the agenda for the Reformation.

1519 Charles I of Spain becomes Holy Roman Emperor, cunningly changing his name to Charles V. He rules until 1556. Spain becomes top nation.

1400~1450

Getting the Needle
Albrecht Dürer

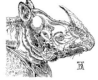

Rhinoceros à la Dürer

You might never have guessed it, but serious Albrecht DÜRER (1471–1528) was Grünewald's direct contemporary. And that business about the Alps: Dürer makes nonsense of it. He went to the party next door, collected artistic ideas and influence, especially in Venice (probably in 1495, certainly in 1505 when he met Giovanni BELLINI), returned to Germany and – effectively – acted as a channel for those ideas.

OK: so the northerner Dürer could be 'deep' where Florentine Leonardo was simply brilliant, but there were some very interesting cross-overs: in Dürer's own way he came close. Scintillating? No. Vitally important? Aber natürlich.

What needle? The burin: staple tool of the etcher. A brilliant draughtsman, Dürer was at his best in the areas of copper engraving and wood-cutting and because his etchings and wood-cuts, plus his drawings and his other graphic work, far outnumber his paintings, it's easy to understand the extent of his influence on others. Just think: a small piece of paper is no weight. Carried safely, rolled or flat, it can go from Germany to the Netherlands, France or elsewhere without real problems. A quick round-up of Dürer's *tour de force* engravings, from *The Apocalypse* (1498), through one-offs like *The Knight, Death and the Devil* (1513), to *Melencolia* (1514) makes the size of his fan-club instantly intelligible. Such power, such detail (in reverse!) and so small. No wonder that in 1512 the Emperor Maximilian became a member of the club, followed in 1520 by his successor, Charles V, and such later artists as the Swiss *Hans HOLBEIN* (1497–1543).

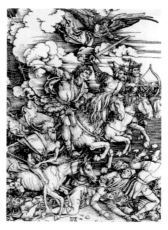

The Four Horsemen of the Apocalypse, 1497–8, British Museum, London, shows Dürer's treatment of a common theme.

1519-20 Ferdinand Magellan (1480–1521), the Portuguese navigator, discovers and names the Pacific ocean.

1541 Jean Calvin (1509–64) establishes his Reformist power base in Geneva, Switzerland. He believes in predestination; those who are to be saved are already chosen.

1542 The Portuguese are the first Europeans in Japan. A Catholic mission is established.

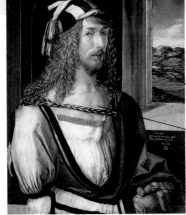

Self-portrait, Albrecht Dürer, 1498, Prado, Madrid. This is Albrecht at 27, dressed to kill in Italian finery.

Even the exterior detail is 'virtual Italy': Nuremburg it isn't

Obviously influenced by his Italian journey, Dürer represents himself as a very Italianate young prince

Well cut, expensive Italian clothes; this is showing off on a grand scale

DON'T TRY THIS AT HOME

Etching

Coat a polished metal plate smoothly with something acid-resistant, wax, for instance. Scratch through this with a needle, or burin, exposing the metal beneath. Place the plate in an acid bath. The acid 'bites' into the lines of the design. The longer you leave it, the deeper it bites. To emphasize a line, bite again. To prevent deep biting 'stop' the process by covering existing lines with varnish. Repeat until satisfied. Ink well, and pull through a heavy press.

But the Man from Nuremberg had only just begun. His visits to Italy sharpened his curiosity and intellect, and on his return Dürer decided to devote lots more time to brains and much, much less to having fun. The main source of this influence was probably Leonardo, but while such behaviour might have been cool in Venice, it wasn't calculated to keep your German friends happy. 'Fancy a few nice foaming steins after work, Albie?' 'Er, sorry, nein danke… I gotta finish mein *Treatise on Fortification* (1527)' …and at least two others between 1525 and 1528. Dürer's rapt self-portraits before and after his Italian visits search for something inside. You can hear the brain bubbling: a brain publicly celebrated in the Rhineland, and later influenced by Humanism and the main-men of the Reformation.

THE FRAME · NAMES IN

Michael Wolgemut *(1434–1519)* *Dürer's teacher and mentor; channel for Dutch influence in Nuremburg.*

Hans Baldung Grien *(1484/5–1545)* *Woodcut and stained glass designer, and painter; influenced by Dürer (he may have worked in D.'s shop).*

Albrecht Altdorfer *(c.1480–1538) First modern landscape artist.*

Lucas Cranach *(1472–1553) Painter, etcher, woodcut designer; influenced by Dürer; beware, his work is difficult to attribute because his sons Hans and Lucas II were equally adept.*

The Vischer family *(Hermann, Peter I, Peter II) Amazing Nuremburg sculptors; both Peters contemporaries of Dürer.*

Tilman Riemenschneider *(c.1460–1531) Late Goth, sculptor in wood, and sometime Burgermeister of Wurzburg.*

1416 Dutch fishermen invent the drift net. More herrings all round.

1430 An improved windmill devised by the Dutch; it has shorter sail arms and a central hollow post which links the sail-driven shaft to machinery in a separate building below.

1431 Joan of Arc, the French visionary and national heroine, is burnt at the stake.

1420~1460

Dutch Treat
Van Eyck and the rest

Would you want a graffiti tag on your wedding photo? Slap bang in the middle of your wedding photo? Johannes de Eyck fuit hic (Jan van Eyck was here) is the inscription in just that place, on the delightful painting known as The Arnolfini Marriage (1434, N.G., London). A valuable signature then and now.

It used to be thought that *Jan VAN EYCK* (working from c.1422–1441) and his mysterious (but definitely non-fictional) brother Hubert were the inventors of oil paint. This is tosh: it was in crude use some six centuries earlier. However, the breathtaking way in which the van Eycks developed the technique to its full potential still places them among the very best anywhere (Jan even painted with his fingertips).

Around 1432 Jan and Hubert executed their masterpiece, the *Ghent Altarpiece* (St Bavon Cathedral, Ghent). Serene and clear, with its central mystical picture of *The Adoration of the Lamb* and surrounding panels, the painting is a complex work of great beauty, as you'd expect from the Duke of Burgundy's Court Painter (c.1425–30).

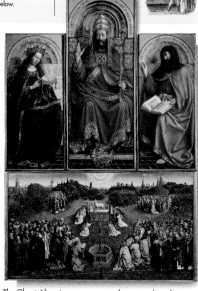

The Ghent Altarpiece, Hugo and/or Jan van Eyck, St Bavon Cathedral, Ghent, 1432. They don't come any better much earlier, and this is only the central panel: The Adoration of the Lamb.

1465 Birth of Erasmus of Rotterdam, northern Europe's own Renaissance man. He began his career as a monk in Gouda, Holland, but eventually taught in universities all over Europe.

1561 Tulips arrive in Europe from the Near East. They swiftly become the Dutch national flower.

1568 Gerard Mercator (Gerrit Kremer) (1512–94) unveils his projection; this is familiar as the map of the world shown as segments of a sphere.

BOSCH AND BRUEGEL

Look out for Jan's major rival, *Rogier VAN DER WEYDEN* (1399–1464), a rising star destined to last. Where the van Eycks went in for characteristic Dutch pragmatic realism, Rogier (from exotic Flanders) pushed up the emotional temperature. By the mid-1400s religion hadn't exactly disappeared from Netherlandish painting, but at its extremes it had really polarized. Unless you were King Philip II of Spain, you couldn't have dreamed up an artist like *Hieronymous BOSCH* (c.1450–1516). Philip absolutely adored his stuff, especially the weird ones, like the *Garden of Earthly Delights* (Prado, Madrid), and was an avid collector, but none of Bosch's works is dated, so his development is hard to assess. Powerful, equally unpleasant, and probably earlier, are paintings like *Christ Crowned with Thorns* (N.G., London).

Unlike *Pieter BRUEGEL the Elder* (1525/30–69), one of the early major Northern landscape painters, who seems to have been unaffected by an Italian experience. Bruegel is just as famous for his fine landscapes including *Hunters in the Snow* (1565, Vienna) and for his paintings of peasants, many of which have strong moral themes.

Donor Portraits

In Netherlandish painting of this period a Donor Portrait is very common. This is a likeness of the person – or perhaps the husband and wife – who presented an altarpiece to a church, and whose name is often linked with the painting. In the case of van Eyck, a famous example is the The Rolin Madonna (Louvre), in which the donor, Chancellor Rolin, is painted, with the Virgin, in a side panel of the altarpiece.

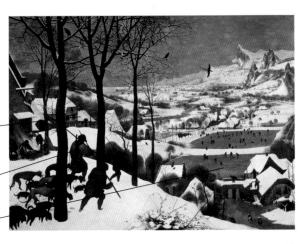

The Hunters in the Snow, Pieter Bruegel, 1565, Kunsthistorisches Museum, Vienna. The background mountains are an unlikely sight in the lowlands; they are a fond memory of Bruegel's Italian visit.

Fabulous atmospheric winter colours; shiver while you look

Dark, rather sinister figures of the hunters and their skinny dogs returning empty-handed; a hard winter may be ahead

Everyone enjoying themselves robustly in typical Bruegel fashion, unaware of the hunters' return

1572 Tycho Brahe (1546–1601), the Danish astronomer, observes the first supernova, which happened in the constellation of Cassiopeia. He looks at it for 485 consecutive days.

1600 Dutch East India Company seizes Brazil. Sugar and silver all round.

1626 The Dutch Olympic-class wheeler-dealers, buy Manhatten for $24.

1550~1645

Crowned Heads, Big Bums
Think Large, Paint Larger

Think of Sir Peter Paul RUBENS (1577–1640), and one simply sees pink flesh. Lots of it. Bums. Thighs. Plump forearms. Chubby angels ducking and diving. Mercifully, not all P.P.'s painting conforms to this fatty fantasy. Just as well, because he's hailed as the great painter of the Baroque in Northern Europe. In Italy in 1600, P.P. was wowed by Titian and Michelangelo, but he just flipped over Caravaggio. His powerful Descent from the Cross (1611–14, Antwerp) shows why he was tops in the religious department of his day, and why such heavyweight bosses as the Dukes of Mantua, the Spanish Governors of the Netherlands (c.1603), or the King of Spain flocked to employ him.

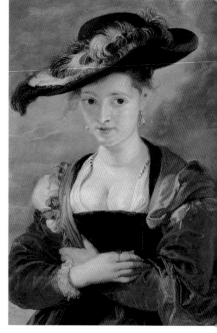

A stint for King Charles I of England resulted in the fabulous ceiling in the Banqueting Hall, Whitehall (London, 1634: the only painted ceiling by P.P. that remains). And his fine, atmospheric landscapes were major influences on this genre across Northern Europe. But popularity meant that P.P. couldn't finish work: he needed studio assistants. Ready cash? Money talked, and he would paint according to your purse. No money? You got Van Dyck ... at first, at least. Afterwards, other, not-so-masterly, hands, although the boss, P.P., controlled the whole thing.

Le Chapeau de Paille, Sir Peter Paul Rubens, N.G., London. A charming image, with rather less flesh than is usually associated with Rubens.

1637 René Descartes (1596–1650), French philosopher 'thinks therefore he is'. Publishes A Discourse on Method, applying scientific method to the understanding of the human mind. Body and soul part company in Western philosophy.

1652 Anglo–Dutch wars, the result of Cromwell's 1651 Navigation Act. Admiraal van Tromp trounces British ships at home, in the Channel. He nails a broom to his mast to signify his sweeping victory.

1660 Boers (Dutch farmers) settle in South Africa.

The Art of Politics

Rubens was probably the only painter in history to have been an active politician for many years. For at least a decade from 1623 he was Ambassador to the Spanish Governors of the Netherlands. In 1629, as one of the Embassy which made peace between Britain and Spain that year, he met King Charles I, who gave him his knighthood.

Excellent portraiture showing deep feeling

Statuesque pose to show off gorgeous clothes and emphasize artist's exquisite treatment of fabric

VAN THE MAN

Sir *Anthony van Dyck* (1599–1641) gave his name to the style of pointed beard cultivated by his patron (from 1632), King Charles I of England, to a brand of cigar, and to a short-lived 1960s pop group. Another Antwerpian, Van entered P.P.'s studio c.1617, became his first chief studio assistant, and forged his own career and identifiable style in Genoa. You'd think a difficult man like brooding Van couldn't easily compare with P.P.'s top-rankin' stature. But his portraits of the great and the good say much about their subjects. None better than *Charles I in Three Positions* (c.1638), a sad, beautiful reflection on this unfortunate English monarch, and one of many executed (sorry) with Royalist nobility as subjects before the English Civil War (1642–52). By this time Van had probably seen the writing on Charlie's wall (always remember Rembrandt's *Belshazzar's Feast* when using this phrase), and was trying to transfer from the English XI to a continental side, but to no avail.

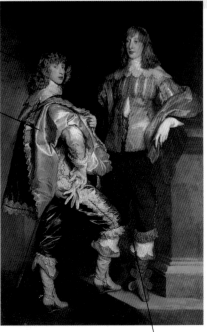

Lords John and Bernard Stuart, Sir Anthony van Dyck, c.1639, N.G., London. Exquisite brothers in exquisite clothes.

Two young fellows at their best in a crumbling society

Every picture tells a story, don't it?

Allegorical paintings were not new, and continued for centuries after Rubens (the Victorians loved them), but they reached their first peak with him. An allegory is a symbolic parable, in art or literature (the Bible is peppered with them), representing a given situation, past, present or future. Rubens was undisputed master of this form, in the shape of huge pictures, in rich glowing colours, based on the Antique, and fabulously alive.

Delights of the flesh

1572 Dutch War of Independence (from Habsburg rule) begins. Carrier pigeons used at the siege of Haarlem.

1585 Amsterdam and Rotterdam become top Euro ports and trade centres; Antwerp sinks into decline.

1608 The Dutch invent the cheque.

1606~1670

Soul Man

Rembrandt van Rijn

Roll up for the Peepshow! Surveying the past from a twentieth-century telescope, we quickly pick up the lone, dark-but-strangely-rich figure of REMBRANDT Harmenszoon van Rijn (1606–69). His name's as well known as Rubens or Van Dyck, but, unlike them, his number keeps changing.

In the gloriously Italianate surroundings of Kenwood House, London, there's a late, very great self-portrait, among the last of many Rembrandt executed throughout his career. Pausing in his painting, our hero regards us – and his own ugly mug – quizzically and dispassionately, as if contemplating his entire experience of painting, life and existence to date. Like nearly all his work,

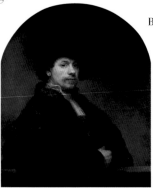

Self-Portrait, Rembrandt, 1640, N.G., London. One of many self-portraits, this shows the 34-year-old Rembrandt in his prime; note the rich man's fur coat.

but particularly the self-portraits, it's a deeply affecting picture. Small wonder that modern critics speak in hushed tones of Rembrandt's 'psychology'.

Born in Leyden, Netherlands, Rembrandt trains in Amsterdam, where he absorbs Caravaggio's influence, and gains a considerable reputation as a portraitist with a lively, dramatic style. True: these are visibly optimistic, basically in-your-face

Baroque paintings. In 1634 he marries Saskia, his great love (and the affectionate subject of some of his portraits, e.g. *Saskia as Flora*, N.G., London), and receives a very large dowry, which the happy couple immediately settle down to spend. In 1642 the world collapses. Rembrandt goes bankrupt. Saskia dies and leaves him with a son, Titus. Suddenly belts are tightened, the society portraitist is forgotten, and R.'s optimistic style becomes more reflective. Deeper. Intense. His most famous (but not automatically best) painting, *The Company of Captain Frans Banning Cocq* (aka *The Night Watch*; Rijksmuseum, Amsterdam) was executed that same year.

In adversity Rembrandt becomes the big man we now think we know. Living in

1609 Dutch East India Company ships tea to Europe from China; a new addiction is created.

1637 The collapse of the tulip trade; consternation, bankruptcies, alarm, despondency and some suicides among Holland's super-rich bulb dealers.

1644 Abel Tasman (1603–59), the Dutch navigator, sights Australia but does not bother to land and explore it.

the Jewish quarter of Amsterdam, he begins his greatest series of images: his Biblical pictures, in oils, in wonderful sepia drawings, or in etchings. It's as if his own life becomes a metaphor for his work. New or Old Testament; it doesn't matter. Drama counts, but the subjects are important. Individuals between a rock and a hard place feature often. *The Sacrifice of Isaac. The Woman Taken in Adultery. David. Saul. Belshazzar's Feast. The Crucifixion. Joseph and Potiphar's Wife.* Rembrandt knows his Bible, and boy, does he use it. He dies in poverty and alone but glory-bound, for sure.

The Dutch have a word for it

They not only painted it, they also named it; 'landscape' is the Anglicized version of the Dutch word *landschap*.

> " ☆ "
>
> ### Here's looking at me, kid
>
> Rembrandt's self-portraits record every stage of his existence, every stage of his life and career. They are remarkable in themselves, in allowing us to trace the artist's development, but also because so many later artists – from Sir Joshua Reynolds to Marc Chagall – tried it themselves in an attempt to find similar insights

THE FRAME — NAMES IN

Jacob van Ruisdael *(1628/9–82) The greatest of a dynasty of Haarlem landscapists, and the most prolific (1,000 pictures); a typical Ruisdael is restful and contemplative with vast skies dominating cautiously undulating dunes.*

Jan van Goyen *(1596–1656) Precursor of Ruisdael, equally prolific (1,200 pics at last count); lost all his money speculating in tulips.*

Meindert Hobbema *(1638–1709) Friend and pupil of Ruisdael; fewer dramatic skies, more mills and watermeadows.*

Albert Cuyp *(1620–91) A versatile painter of still-life, sea pieces, landscapes; admired by Constable for his handling of light.*

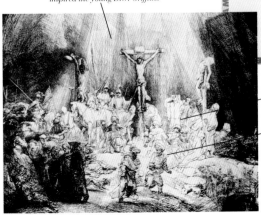

Stark lighting for the dramatic scene that must surely have inspired the young D.W. Griffiths

Although the canvas is crowded with figures, each is shown as an individual character

Incidental details bring home the realism of the scene; this actually happened

The Three Crosses, Rembrandt, B.M., London. A sketch of the harrowing scene on Calvary. Crucifixion was the lot of thieves and common criminals, normally a banal sight, but here transfigured by the charisma of Christ.

1642 Dutch take Gold Coast from the Portuguese. The seventeenth century is proving a golden one for the Netherlands.

1657 Christiaan Huygens (1629–95) invents the pendulum clock. This is the first timepiece to tell the time to a minute. Time is, after all, money.

1666 Sir Isaac Newton (1642–1727) discovers the spectrum (via a prism). The rainbow is trapped.

1630~1680
Small is beautiful
Vermeer

You wouldn't call Jan VERMEER (1632–75) Mr Nobody... but until recently his name was unfamiliar, except among real devotees of Dutch painting. This isn't too surprising. We know of only 35 pictures by Vermeer that are 100 per cent kosher, and many of them are unsigned or undated, or both. But let's forget statistics and ask ourselves why, in the mid-1990s, Vermeer has become the top man of Dutch seventeenth-century painting.

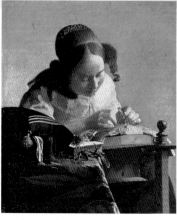

The Lacemaker, Jan Vermeer, Louvre, Paris. Tenderness, intimacy, good lighting – it's all here, as if you had just come across the industrious young girl at her work.

Very little is known about V.'s life. Local Delft boy makes good: becomes a family man with wife and 11 little Vermeers to feed; develops as a steady, no-pyrotechnics painter, rises to become

Master of his guild... and then everything goes pear-shaped. He dies young(ish), and his slow work-rate and small output mean that there isn't sufficient to pay his debts. His family are destitute. End of story? Not quite.

Open an art book and look at his reproduced work. Pretty run-of-the-mill? Much like many other Dutch painters? Yup. Take *Pieter de HOOCH (1629–78)*, for example, good on interiors and street scenes, even nowadays a familiar name, a solid-as-a-rock artist, fine to note at dinner parties. But along comes Vermeer and everyone goes gooey-eyed. The difference between the two is technical, like the timing of a good joke. It's not the paintings, it's the way he paints them. Be assured: every critic in town is in agreement on this point.

1677 Anton van Leeuwenhoek (1632–1723), Dutch biologist, invents the single lens microscope and observes protozoa through it; in 1683 he will observe bacteria.

1678 Chrysanthemums come to Holland from Japan.

1688 William of Orange, the Dutch-born grandson of Charles I, assumes the throne of Great Britain and Ireland ('King Billy'). He shares his reign with his wife Mary II; they are known as William and Mary.

Fabulously painted sky; it will be years before anyone this good comes along again

The sky dominates the picture as in much Dutch painting; the Netherlands are as flat as a pancake and the eye of heaven is always looking down on the industrious Dutch

City rooftops rendered with meticulous accuracy

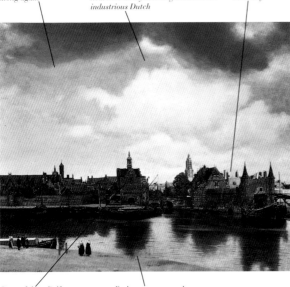

Some of these Delft buildings are recognizable today

Perhaps a camera obscura was used to enlarge the foreground; the added detail and light are slightly different from the rest of the image

Flattery will get you everywhere

The notorious forger and Vermeer wannabe Hans van Meegeren (1889–1947) took advantage of Vermeer's small output to execute and promote Christ at Emmaus, which he successfully sold as a real Vermeer to the Rotterdam Museum in 1937. It was merely one of many brilliant Vermeer forgeries. H. was caught out trying to sell one of his masterpieces to Hermann Goering. Bad idea.

A View of Delft, Jan Vermeer, 1661, Mauritshuis, The Hague. His most famous painting, for its light, life and truth to nature.

Vermeer's great achievement was that he understood movement and light. His subjects – objects or people – look exactly as they do to us, familiar, as we see them, not just selected for inclusion in a painting. They're like snapshots in exquisite paint: facial expressions are like those we know best. We almost recognize the sitters. But it gets better. Vermeer is also master of the Dutch freeze-frame: such a king of slow motion that, in his painting *Maid with a Milk Jug* (aka *The Cook*, c.1660,

Amsterdam), the pouring milk will curdle before we've finished looking at it. What body language, as in *The Love Letter* (c.1670, Amsterdam), or *The Lacemaker* (c.1665, Louvre, Paris); or the arrested time in one of Vermeer's most famous paintings, *View of Delft* (c.1660, The Hague). V. was ahead of the Impressionists (and a mite more stylishly) by two hundred years. How did he slip through the net? Because our taste was vile. Don't worry. Just sit back and enjoy what little is left.

1605 Cervantes publishes part one of Don Quixote. Part two follows ten years later.

1622 Velázquez paints a self-promotional portrait of big-league poet Luis de Góngora, hoping to catch the new king's eye. He succeeds and at 24 becomes Spain's top brushmeister.

1621 Philip IV empties the Spanish treasury, but initiates the golden age of Spanish art and culture.

1620~1700
¡Olé! Velázquez
By Royal Appointment

It's not what you know, but who you know. And Diego Rodriguez da Silva y VELÁZQUEZ (1599–1660) would have been a really boring old fart if he hadn't been introduced to Rubens when Peter Paul visited Madrid in 1628.

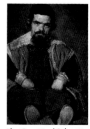

The Court Fool Sebastián de Morra (detail, c.1644, Prado, Madrid).

Put it this way: if P.P. hadn't pushed Velázquez to visit Italy, V. would never have painted *The Surrender of Breda* (aka *Las Lanzas*, *The Lances*, 1634/5, Prado, Madrid) the way he did. Great. Or *Las Meninas* (1656, Prado). Terrific. Or *The Rokeby Venus* (aka *The Toilet of Venus*, 1648, N.G., London). Woo-hoo. And that's just three from an unusual career. But we are being previous. I'll begin again.

Velázquez was born in Seville. He entered the studio of *Francisco PACHECO* (1564–1654), pictorial censor to the Inquisition (not a lot of room for experimentation there), married the boss's daughter, and was good enough as an artist and bold enough as a man to secure a place as a court painter to Philip IV of Spain. Phil loved his work and wanted only V. to paint him thereafter. Who was complaining? Well, V. maybe. Phil wasn't exactly a bundle of laughs, and at that time the scope for imaginative painting in Spain was limited.

Detail subordinated to overall effect

Upright Spanish lances symbolize victory

The Surrender at Breda. Philip IV's general thrashes the Dutch but is magnanimous in victory.

Feeling of reportage and immediacy

Sympathetic, dignified portrayal of subject

1625 Ambrogio Spinola takes the Dutch town of Breda after an 11-month seige; this was part of the Dutch War of Independance, begun in 1572.

1648 End of Thirty Years' War (how did they know it would last that long?), an exhausting struggle that devastated Europe. The Habsburg Empire vs The Rest. No-one 'won'.

1661 Louis XIV 'The Sun King' on the French throne. End of Spain's glory years. France now top nation.

Velázquez stuck it like a man. However, there was no tradition of religious painting in Spain as there was in Italy, so V.'s Italian trip (1629–31) did wonders for him. His use of colour (previously *daaaaark*) improved, and his ideas too. His style… well, his boring old style was more or less unchanged, but you can't have everything. But those sludgy monochrome backgrounds; those single figures, isolated against them… they were the basis for real improvement after Italy. Because then V. began to hit pictorial high-flyers, in the shape of marvellously observed character portraits of individuals such as Phil's court dwarfs or fools, or multiple scenes such as *The Surrender of Breda*, more a study in the psychology of defeat than an academic, narrative history painting.

This is where his brilliance lay: the unflattering portrayal of humans as they are. He got away with it too. The Italian painter *Luca GIORDANO* (1632–1705) called *Las Meninas* 'the theology of painting' because of the great example it set to others. And V.'s portrait of *Pope Innocent X* (1650, Galleria Doria Pamphili, Rome) would have its fame renewed in the 1950s as the basis for another notorious artist's negative attentions: for how could *Francis BACON's Screaming Popes* have howled so loudly had Velázquez not got there first?

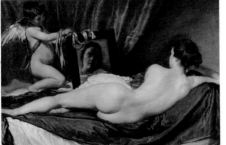

" ★ "

The Rokeby Venus

She is the only surviving Velázquez nude, so is a curiosity. V. apparently painted others, but in the Spain of his day such images were regarded as obscene, and so the picture holds a unique status in his output – deservedly so, as it is unlike virtually anything else surviving from his hand. The painting was slashed by an outraged suffragette in 1914 in the National Gallery in London.

1616 Inigo Jones (c.1573–1652) English architect and Palladio buff builds The Queen's House (for Queen Anne) at Greenwich in London. It is a perfectly proportioned residence; now an art gallery.

1628 William Harvey (1578–1657) establishes beyond doubt that blood is pumped from the heart and circulates around the body and that valves in the veins prevent it from falling down into the ankles.

1632 The first coffee shop opens in London. Men of letters and leisure have somewhere respectable to meet and bicker.

1 6 0 0 ~ 1 7 0 0

Absolutely Fabulous
Poussin and Claude

Sceneshifting in the theatre and on canvas.

Which of course they were. But don't allow a Poussin–Claude condition to go critical. Fact is, we habitually talk about these two artists in the same breath as if they were Butch Cassidy and the Sundance Kid. However… you guessed… they weren't. French? Yes. Contemporaries? Yes. Devoted to Italian High Renaissance ideals and stimuli? Yes. But roped together like the early twentieth century Picasso–Braque double act? No. Au contraire.

A Dance to the Music of Time, Nicolas Poussin, c.1639–40, Wallace Collection, London. Poussin's mortals dance in a classical landscape, connected but uncommunicating; note Phoebus Apollo dashing across the sky in Time's wingèd chariot, and the solemn cherub with the relentless hourglass. Tempus fugit, unfortunately.

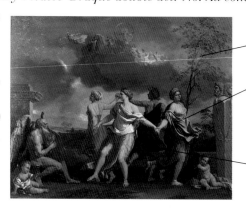

Colours to match nature accurately

Precisely arranged figures appear frozen in a tableau even though they are moving to the music of time

All detail harmoniously integrated into the whole

Oh, but they were so right for their gorgeous Baroque age! *Nicolas Poussin* (1594–1665) is the man we need to understand first. For him, everything had to be harmonious, just so. In Rome from 1624, he studied the Antique in depth, was influenced by *Titian* and *Veronese*, and by 1630 was so hot that he got the job of decorating the Grand Salle of the Louvre. But illness forced P. to

pull out of the Baroque bonanza, and it was back to Rome and devotion to a study of *Raphael* and the Antique… again. And – apart from a bad trip to Paris in 1640 (Cardinal Richelieu was no-one's idea of a breeze) – there he stayed. It was the making of his style. Poussin's frozen scenes of Roman morality are his trademark. *Et in Arcadia Ego* (c.1638, Louvre, Paris); *The Holy Family on the Steps*

1637 Pierre Corneille (1606–84), top French writer, uses classical rules of drama and produces Le Cid, a heroic drama composed entirely of Alexandrines (rhyming couplets of 12 syllables per line).

1642 Ballet (an Italian invention) developed at the French court of balletomane monarch Louis XIV; in 1651, he danced himself.

1675 Rebuilding begins of St Paul's Cathedral, London, destroyed during the Great Fire of 1666. Architect Sir Christopher Wren has met Bernini in Paris, who has shown him the plans for the Louvre (on the back of an envelope, to paraphrase Wren). Wren returns to London just busting to build a great dome…

(1648, Washington, USA: his masterpiece). He composed them like a pictorial chef devising a recipe: add 2 tsp moral content and 3 drops pleasure: add 4 oz colour… no, too much; flavour with intellect and bake for 200 years.

CLAUDE AND THE THEATRE OF NATURE

Bizarre or what? *Claude GELÉE* (1600–82), aka Lorrain or Lorraine (N.E. France) because that's where he was from, trained reluctantly as a pastrycook. Throwing away his apron and rolling pin, Claude settled in Rome in 1627 and collected a few nasty Mannerist habits. However, once he'd settled down, his sensitive paintings

Scene Painting

Claude's receding pictures, with their stage-by-stage perspective stops (coullisses) reflect another interesting development of the same era: the staggered, receding scenery of the Italian Baroque playhouse, which allowed side-access for actors to enter or leave the stage. We take such features for granted now, but they were novel then.

of Nature, drenched with that beautiful Italian light, proved enormously popular.

A worried Claude was forced to make detailed notes of all his major oils in a sketchbook (the *Liber Veritatis*) to prevent forgeries. The paintings differed in subject, but not in arrangement, where perspective played a great part. *Landscape at Sunset* (1639) and *The Expulsion of Hagar* (1668) (both N.G., London) are just two of many Claudian masterpieces. But where Poussin used humans for a stodgy reason, Claude just chucked them in to balance that beautiful scenery.

Landscape: Aeneas at Delos. Claude Lorraine, 1673, N.G., London. The small-scale humans appear rather baffled by their presence in this grand setting.

1679 Denis Papin (1647–1712) invents the pressure cooker. More leisure time for the kitchen classes.

1709 The pianoforte invented, probably by the Italian Bartolommeo Cristofori (1655–1731); wires were struck by hammers rather than being plucked, as in a harpsichord. The pianoforte offers new flirting opportunities for young ladies.

1735 Rubber discovered in South America by Charles Marie de Condamine (1701–74). He had gone there to measure the curvature of the Earth.

1715~1750

Curvey but Cute: Rococo
Saucy boys: Watteau, Boucher and Fragonard

Here's an interesting one, partly because Rococo was such a hit-and-miss movement (roughly 1715–65; at its height c.1730), but more because it was basically a very major style of interior decoration. Because many surviving Rococo pictures were executed as commissions for specific interiors, and not simply for exhibition at the Academy, we rarely see them in the right context, simply because those glorious interiors themselves no longer exist.

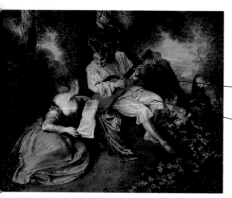

Musical instruments carried saucy overtones in 18th century pictures.

Subjects in indolent pose; strange, for an arch-fidget like Watteau.

La Gamme d'Amour, J.A. Watteau, N.G., London. A world at ease characterizes Rococo painting. There's plenty of style but everything slows down and we enjoy a pleasurable scene in a bosky paradise.

Rococo derives from the French term *rocaille*: rock-work. Lots of C- and S-shapes in your furniture, with scrolls, and counter-curves. Beginning in France as a reaction to the Baroque excesses of Louis XIV (1638–1715), the South-Germans couldn't get enough of it (visit Salzburg for an excess), but you won't find much pure Rococo in England, Spain or Italy: it just didn't happen there like Baroque did.

HERE TODAY, GONE TOMORROW

About Rococo painting. A park full of pleasant sensory adjectives. Idyllic, pastoral, often sensual (even erotic!). Prettiness. Gaiety. Scenes drawn from (and for) every kind of nature: the great outdoors or the naughty boudoir, in which innuendo became an art-form in itself. *Jean-Antoine WATTEAU* (1684–1721) was a short-lived leader in the field and, like his contemporary *François BOUCHER* (1703–70), was heavily influenced by Rubens. Most of Watteau's paintings were a mixed bag of tricks, composites: several superlative drawings used to form a single imaginary composition; but at the end of his consumption-shortened life his work

1742 Colour printing technology developed in Japan. the establishment of the Ukiyo-e (floating world) style will have a huge impact on artists to come, particularly the Impressionists.

1759 Voltaire (François-Marie Arouet, 1694–1778) publishes his Candide, a satire on materialism, politics, greed and guile.

1762 Jean-Jacques Rousseau (1712–78) publishes his Social Contract, lobbying for the rights of Man. 'Man is born free but is everywhere in chains'.

Disapproving Denis

Boucher's titillating bums didn't please the French philospher and encyclopaedist Denis Diderot (1713–84), whose moralistic writings were in strong opposition to anything sensual, and thus to the core of Rococo taste.

shows a sharper view of nature. Most people note his *Fêtes Galantes:* idylls of figures in court dress, or enacting a masquerade. *A Halt in the Chase* (c.1719, Wallace Collection, London) reveals the man at his best.

OO LÀ LÀ, FRAGONARD

Every inch the Rococo artist, engraver, designer of interiors, tapestries, sets and costumes for the Paris Opera, Court Painter to Louis XV, Boucher also painted the best ladies' pink, powdered *derrières* on the planet. But *Jean-Honoré FRAGONARD* (1732–1806) was much more interesting (and romantic) as a painter than Boucher. Swoon knowingly at F.'s beautiful synthesis of Nature and Lust in *The Swing* (1766, Wallace Collection, London) where an awed young voyeur peers up his girlfriend's skirt. And gain merits for noting that Fragonard's small paintings are better known than his even better work, which was much, much bigger. But Fame's flame goes out. When his grand patrons, the courtesans Mesdames Pompadour and Barry, tired of his art they dumped him, and he died in poverty.

The Swing, J.H. Fragonard, Wallace Collection, London. A joyful celebration of adulterous flirtation; the husband pulls the strings for his young wife, whose ardent lover hides in the bushes to enjoy a glimpse of stocking.

THE FRAME — NAMES IN

Rococo was essentially interior decorating. Much of the excellent Rococo panelling used to line and decorate the interiors of Parisian rooms has travelled the world. Many such interiors were demolished after 1853 to make way for the new boulevards of Paris, designed by Baron Haussman. Before destruction, the Rococo panelling was removed and sold off, sometimes to notable effect: the Rothschild mansion at Waddesdon, Buckinghamshire, near London, is designed as a chateau, and incorporates beautiful examples of Rococo panelwork and furniture taken from Paris, with much else to delight the eye.

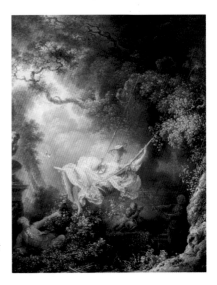

1694 The Bank of England was founded to fund the wars being waged by William III (King Billy, 1650–1702); guns and money begin their long-term folie à deux.

1749 Henry Fielding (1707–54) publishes Tom Jones, inventing the English picaresque novel, chronicling the rollicking adventures of his handsome young hero.

1752 Benjamin Franklin (1706–90) flies his kite and establishes that lightning is electricity; he also invented bifocals and the Franklin stove and was the first US Ambassador to France.

1690~1790

A Great Little Double Treble Act
Hogarth, Reynolds and Gainsborough

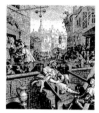

Gin Lane, William Hogarth. Society collapses drowned in a sea of cheap gin imported from Holland.

In eighteenth-century Britain, nearly every city in the land produced an artist of some note. Home-grown artistic talent was on the increase, but without an Academy artists were disorganized, enfeebled, Sir, before a wave of second-rate foreign muck brought back from the Grand Tour by silly young fellas with no idea of Taste. William HOGARTH (1697–1764) kicked some self-esteem back into British painting, effectively beginning a national School. H.'s conviction that pictures should entertain resulted in his Modern Moral Subjects: no-nonsense satirical prints in series of two or more, melodramatic as any soap opera. From A Harlot's Progress (1732) to The Four Stages of Cruelty (1750–1), they were copied from H.'s excellent oils and skilfully marketed to become the first popular prints in Britain. He never looked back.

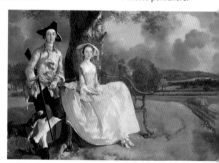

Mr and Mrs Robert Andrews, Thomas Gainsborough, N.G., London. Alfresco portraiture.

Though London was the epicentre of Art, it was jungle-land if you were a painter: only the fittest survived. Landscapes were definitely out, and portraits in, and the best in the business were *Sir Joshua REYNOLDS* (1723–92) and *Thomas GAINSBOROUGH* (1727–88), country-boys both, from Devon and Suffolk.

SOCIETY PORTRAITURE

No-one who was anyone had their likeness taken by any artists other than Reynolds or Gainsborough. But whereas Reynolds was cosmopolitan, Gainsborough learnt in his own backyard. R. visited Italy in 1749 and devoured Raphael, Michelangelo and Venice in that order. G. preferred Rubens:

1769 James Watt (1736–1819) patents the steam engine as an industrial power source. First glimpse of the dark satanic mills encroaching on the English landscape.

1774 The rules of cricket are drawn up. These will sustain and underpin the British Empire throughout the next two centuries.

1778 Joseph Bramah (1748–1814) invents the flushing water closet. Civilization takes a great leap forward.

the Netherlands was nearer, and anyway he could develop his own style (see *Mr and Mrs Robert Andrews*, 1748–9, N.G., London). When Reynolds returned with a reconstituted Renaissance vision, he quickly became *numero uno* in portraiture, and First President of the Royal Academy (1768... not before time). His *Fifteen Discourses* (1769–90) given while he was President have but one message: kick paint in their faces! Develop your own personal style after just a few years of intensive study of Classical Art!

Grand Tourists
The Grand Tour could last up to six years and was undertaken by the sons (usually) of the wealthy, as a polishing process. They needed it. Italy and sometimes Greece were visited, in an attempt to introduce the *jeunesse doré* to some form of culture, although the local girls usually proved more attractive.

Landscape background quite rare in Reynolds work

Reynolds followed his own rule, as seen in his many portraits of ladies wearing what look like nightgowns, but Gainsborough violently disagreed, and went his own way, cussing at Reynolds at every turn. Did he outpaint the President with his sizzling *Bath Portraits* (1759–74), in which every brushstroke is his own? Or did the President's hired studio assistants get the upper hand? Gainsborough's technique has kept his pictures clean and fresh, whereas Reynolds... oh dear ... don't ask. Too dreadful for words.

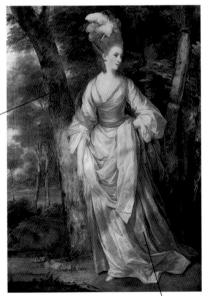

Mrs Elizabeth Carnac, Sir Joshua Reynolds, c.1775, Wallace Collection, London.

Stiff drapery: very statuesque and classical

THE FRAME

The great London-based Americans, portraitist **John Singleton Copley** *RA (1737–1815) and history painter and neo-Classicist* **Benjamin West** *(1738–1820); Swiss-born* **Angelica Kauffman** *(1741–1807), the first woman Royal Academician much beloved by Reynolds;* **Philip de Loutherburg** *(1740–1812), devoted friend of Gainsborough, and* **Joseph Wright** *'of Derby' (1734–97), enlightened portrayer of Science and Industry.*

1769 Napoleon Bonaparte born in Ajaccio, Corsica. A general at the age of 27, he went on to alter the face of Europe.

1776 Declaration of Independence carried by the American Congress and the colony frees itself from the mothership. The United States is born.

1779 The first 'velocipedes' (proto-bicycles) bump along the cobbled rues de Paris. Artists do not record them; not heroic enough?

1790~1870

Paris Passions: David to Delacroix
Neo-Romans and Neo-Romantics

If the names Neo-Classicism and Romanticism don't sound exactly harmonious… you're right. The two major art movements of the late eighteenth and early nineteenth centuries are best seen against the revolutionary background of the age, strongest in France. And Jacques-Louis DAVID (1748–1825) and Eugène DELACROIX (1798–1863) represent the opposing parties.

Napoleon Bonaparte, First Consul, Crossing the Alps, J.-L. David, Musée de Versailles. The Little Emperor in full heroic mode on what must be quite a small horse.

Neo-Classicism was a 'crossover' style, a reaction to Rococo excess, drawing on archaeological discoveries from c. 1750 at Pompeii and Herculaneum which enabled artists to understand what Roman art was really like. Big figures like David used this Roman source material for 'grands machines' (large historical canvases often laced with political symbolism) such as *The Oath of the Horatii* (1785, Louvre, Paris), whose strong republican message was explicit. A political animal, David voted for the execution of the King (at which point his wife left him; they later made it up), but was as quick to become an ardent Bonapartist, as *Napoleon Crossing the Alps* (1801, Louvre, Paris) shows. It owed much

to the art of the High Renaissance… but not nearly as much as David's pupil *Jean-Auguste-Dominique INGRES* (1780–1867).

DRAWING LOTS: INGRES
To Ingres, the finest drawing included 'everything except the tint'. Anything less was the work of a charlatan. And if you were Ingres you drew and painted fleshy ladies in imaginary Eastern Harems, a state of pre-Freudian ecstasy.

1783 Les Frères Montgolfier (Joseph-Michel and Etienne-Jacques) ascend in a hot-air balloon at Annonay, France on 21 November. It is the first successful human flight.

1792 France declared a republic after a revolution instigated by the bourgeois and supported by peasant muscle. Louis XVI guillotined in 1793.

1816 Joseph Nicéphore Niépce experiments to produce photography. Art is changed forever, especially the highly representational kind such as that of Ingres.

Ingres rose to high office and loathed Delacroix (and Romanticism) unreservedly. 'His art is the complete expression of an incomplete intelligence', he said. The fact that Delacroix is now regarded as France's greatest Romantic painter, and infinitely more memorable than Ingres (who?) speaks volumes. Delacroix's greatest influence was Théodore GÉRICAULT (1791–1824), as political and just as fickle as David, a great flouter of artistic rules, whose minute output was enormously inspirational. His leviathan *The Raft of the Medusa* (1819, Louvre, Paris) was painted direct onto canvas with no preliminary drawing.

Delacroix was creative, unashamedly inventive, and passionate about foreign travel, bright colours, Franz Liszt and contemporary literature. He combined some of these in the big production numbers all to be seen at the Louvre, Paris: *The Massacre at Chios* (1824), *Sardanapalus* (1827) and *Liberty Leading the People* (1830), much paraphrased in the sets of *Les Misérables* (c.1980s). He managed some murals too. But most pundits reckon Delacroix's small pictures were his best: wild animals, hunting scenes and portraits. Intense, heated Romantic stuff, away from the chilly, Neo-Classical grandeur of Ingres.

THE FRAME — NAMES IN THE FRAME

Baron Antoine Jean Gros *(1771–1835), with* **Horace Vernet** *(1789–1863) and his brother-in-law* **Paul Delaroche** *(1797–1856) not too far behind. They conspired in paint to make Napoleon the monumental embodiment of the Romantic hero, a mythic legend in his own lifetime, in several colossal paintings of his military accomplishments.*

All at Sea

Géricault painted *The Raft of the Medusa* after a shipwreck in 1819 in which sailors had been cut adrift and left to drown, resulting in a political scandal. G. had interviewed survivors including the ship's carpenter who made him a scale model of the doomed raft. The picture became so famous that Géricault took it abroad, notably to England, where it went on tour.

Tortured figures reflect the barbarity of the slaughter

Empty, pitiless sky; no help from the heavens in war

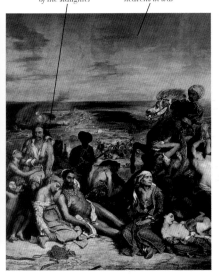

The Massacre at Chios, Eugène Delacroix, 1824, Louvre, Paris. Delacroix captures the senseless barbarism of a real event in the Greek War of Independence, when the Turks butchered their captives.

1781 Uranus discovered by William Herschel (1738–1822). Astrologically, it is the planet of invention and perversity.

1791 Tom Paine (1737–1809) writes The Rights of Man, a revolutionary tract; he advocates the abolition of slavery, female emancipation and republicanism. Naturally, he has to flee England for America.

1804 Napoleon declares himself emperor. His immortal longings know no bounds.

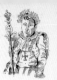

1750~1850

Nightmare Vision: Goya

Undertones of War

The Sleep of Reason Produces Monsters, Goya, 1779, Private Collection.

Nightmares. War. Bullfighting. This could be a heavy conversation. If ever an artist had a love–hate relationship with his own species, it was Francisco de GOYA Y LUCIENTES (1746–1828), a painter-etcher like Dürer, and, like him, a man whose etchings still speak clearly across the years. That's where the similarity ends. Most of Goya's contemporaries were churning out Neo-Classical offerings, and couldn't cut through their own idealism to see that there was a most unpleasant downside to life at the time. Goya saw it, and put it into context. His only equals were in the field of music: Mozart, Beethoven, and Schubert.

Born near Saragossa, and trained in Madrid and Rome, by 1776 Goya was a successful tapestry designer for the Royal Manufactory in Madrid. Then his career took off, and by 1799 he was at the top of the greasy pole: principal painter to King Charles IV. Not so fast. In 1792 a serious illness had left Goya deaf and (some say) traumatized. He certainly became very introspective as a result, and the colours and tones in his work (and in his ideas too) grew darker. His first series of etchings, *Los Caprichos* (*The Nightmares*, or *Phantasmagoria*, 1796–9, Prado, Madrid), attacked manners, customs, and the reactionary Spanish church. Goya intended

The Sleep of Reason Produces Monsters (c.1799, British Museum, London) to be its frontispiece, and, with hindsight, it's an all-embracing advertisement for his etchings of the next decade. In it, huge nocturnal creatures threaten a man slumped over a desk. Is he asleep? Or is he hiding from something we don't yet know? Will we?

You may already know of *The Disasters of War* (c.1810–15). Goya is rightly famous for these etchings, made during the French occupation of Spain (1808–14). They appear to represent an uninhibited account of guerrilla warfare, with every possible degradation graphically depicted, but Goya demands that we answer an

1808-14 Peninsular Wars devastate Spain. Joseph Bonaparte, brother of the more famous Napoleon, declares himself King of Spain in 1808. This is not a popular move.

1812 Napoleon and his troops retreat ignominiously from Moscow. It is the beginning of the end for the imperial one.

1820 Liberal rebels kidnap Ferdinand VII and force him to restore the 1812 Constitution.

implicit question: *by what criteria can a so-called 'civilized' audience accept such activity within its own society? The Disasters*, and two equally famous and ferocious oils, *2nd May 1808* and *3rd May 1808* (c.1814, Prado, Madrid) have been massively influential as art and as anti-war statements since their first appearance.

For all of this, and for his direct… ah… unflattering… treatments of mere mortals, Goya would be revered by a later generation of painters, among them *Edouard MANET* (1832–83) who patently owed him a thing or two.

THE FRAME NAMES IN

Honoré Daumier *(1808–79), French artist who will follow Goya as the Realist era's most acerbic observer of society in graphic format. He will breed a host of followers, worldwide, from the Mexican* **José Guadaloupe Posada** *(1852–1930) to Germany's* **Otto Dix** *(1891–1969), all crying for attention.*

NAMES IN THE FRAME

The Clothed Maja, Goya, c.1805, Prado, Madrid. Goya's Majas, dressed or not, convey clearly erotic messages which we can only guess at. This Maja's face suggests she knows the painter rather well.

Filthy Rumours
Much has been written about Goya's private life, particularly a rumoured affair with the Duchess of Alba, who is said to have posed for his extremely erotic (but in this respect not unique) painting The Naked Maja (c.1800, Prado, Madrid). But as nothing has ever been conclusively proved, all you gossipmongers can go back to sleep.

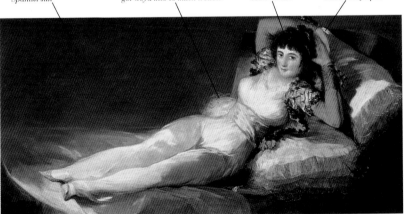

Dark background, perhaps inside a boudoir shuttered against the enervating Spanish sun

The clothes look very much an afterthought; this is a 'decent' version of the nude maja which got Goya into so much trouble

A knowing expression; this maja's seen some action

A languorous pose that will influence many painters to come; compare Manet's Olympia

1750~1850

When there are grey skies...
Friedrich and Constable

At last! European landscape comes into its own. The visionary, Caspar David FRIEDRICH (1774–1840), uses hazy German locations, nostalgic, snowy ruins, balmy seas and calm sunsets to call our innermost emotions

Clouds, a source of constant inspiration to Constable.

collect. He doesn't move too far from Dresden in his lifetime. As for John CONSTABLE (1776–1837), who swears by his own backyard when composition's in question, he's one of the two English superstars of his age. (The other is TURNER, of whom more directly.) As people or artists, Friedrich and Constable are two gloomy specimens at times, and may not be much to your liking, but they're important, so keep at it.

The Stages of Life, Caspar David Friedrich, 1835, Museum der Bildenden Kunst, Leipzig.

Five figures of various ages are reflected by five ships at various stages in their voyage through life.

The dark, dense German forests bring out the best in Caz. For him, their meaning is multi-layered. Made into art, they can be symbolic, nationalist responses to the Napoleonic invasions of the German lands (a theme which goes back to Roman times), or made to contain spiritual and /or semi-religious undertones. Friedrich's images are brooding and magnificent (for example *Abbey Graveyard under Snow*, 1810, Schloss

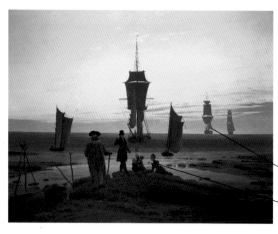

Tall ships sail off into the unknown; the voyage of life is equally uncertain

Figures face out to sea, contemplating the boundless future

1811 Jane Austen
(1775–1817) publishes
Sense and Sensibility,
contrasting the limitations
of rationality and the
excesses of romanticism.

1815 A little light in
the encroaching industrial
darkness: Sir Humphrey
Davy (1778–1829)
invents the miner's
safety lamp.

1830 Oil paints sold
in tubes for the first time.
Painting en plein air
become much easier.

THE FRAME NAMES IN

The Norwich School *(1803–33),*
a really cohesive English regional school
of painting, dependant on Dutch
seventeenth-century work for its
examples. Names to conjure with: the
two **Johns, Cotman** *(1782–1842)*
and **Crome** *(1768–1821), very great*
watercolourists by the highest standards.

ARTSPEAK

Constable was always
one for reducing matters
to essentials. Of landscape
painting, he wrote:

'There is room enough for a
natural painture. The great vice
of the present day is bravura,
an attempt at something
beyond the truth... Fashion
always had & will have its day,
but Truth (in all things) only
will last and can have just
claims on posterity'.

Henry Huntingdon Gallery, Pasadena) are
shown at the 1824 Paris Salon and win
Gold Medals: their use of Nature as a
direct source is a legendary influence on
Delacroix and the future Barbizon painters.
(Actually, Constable has observed Nature
in depth, and made countless studies – like
those of clouds, 1818–20, in Hampstead,
London – before touching any large
canvas.) If he has a fault, it's that he can't
leave a painting alone; some of his studies
often seem more natural to our eyes, and
his sketchbooks are delights.

Charlottenburg,
Berlin), but you
need an overcoat to
view them: their
settings are cool at
best, Arctic at worst.
You might like to
think of him as the
first great modern Northern painter to
consider equivalents for Life and Death, an
early independent, a forerunner of the later
Norwegian *Edvard MUNCH* (1863–1944).

GOING FOR GOLD

Constable's a different kettle of fish. He
loves the Dutch landscapists and
Gainsborough, but hates Turner
pathologically, mainly because Turner's a
sensory animal, and Constable is not; he's
an observer of the real world. John plays a
vital part in the development of
Impressionism, when his *Haywain* (1820,
N.G., London) and *View on the Stour* (1822,

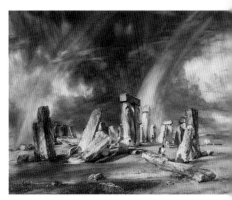

Stonehenge, John Constable,
Victoria and Albert Museum,
London. A vibrant watercolour
in which the sky arches over
the carelessly scattered
ruins of Stonehenge, at
that time not the tourist
trap it is today.

When Constable's wife dies in 1819,
his handling of paint becomes freer,
darker; but greens change to browns. He
lingers longer over a canvas, and it suffers
accordingly. See him earlier, at his best
before he starts overgilding his lilies.

1788 The Times newspaper founded in London. It had already been published since 1785 under the name Daily Univeral Register.

1792 Mary Wollstonecraft (1759–1797), proto-feminist, writes The Vindication of the Rights of Women. Married to William Godwin, she dies when her child Mary (later to marry the poet Shelley) is born.

1806 Gas lighting illuminates the boulevards and palaces of Europe.

1825 The Stockton–Darlington railway opens, the first public railway system in the world.

1770~1870

Blinded by the Light
The Brilliant Mr Turner

Turner always painted 'into the light'.

Joseph Mallord William TURNER (1775–1881) was the son of a London barber. Couldn't draw the human body to save his life, but put him in front of a landscape and ask him to paint the atmosphere and we go cosmic. Turner the prolific watercolourist. Oil painter of a hundred glowing sunsets in the Romantic tradition. Do you share Constable's put-down of Turner in the 1830s ('Airy visions painted with tinted steam'), or will it be superlatives all the way, comparisons with Monet, and others besides? Don't ask, 'Do you feel lucky today?' Ask 'Do you feel sublime?' This is your key word; use it to effect.

Turner is a great subject for table talk. Solitary by nature, a shrewd but penny-pinching businessman, a very young Academician (aged 27), and eventually the Academy's Deputy President, he died one of the richest-ever English painters, and left some 19,000 watercolours (your eyesight is fine) and 300 oils to his ungrateful country. The terms of T.'s will were mostly ignored for 100 years, and some features remain incomplete. It's a fair bet that Constable was irked by T.'s financial acumen just as much as by his technique. Turner's work is what people like who don't know much about art. Like Shakespeare, he gets to everybody.

Snowstorm: Steamship off a Harbour's Mouth making signals in shallow water and going by the lead.

J.M.W. Turner, 1842, Tate Gallery, London. The artist was in this storm on the night the Ariel left Harwich.

1833 Turner goes to Venice seeking inspiration, which he found.

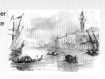

1838 Isambard Kingdom Brunel (1806–1859) builds the Great Western, a 1440-ton steamship which sails from Bristol, England to New York in 15 days.

Dutch painting influenced T.'s early moonlit images and stormy seas, but Claude's Italian landscapes were his greatest inspiration. Paintings such as *Dido Building Carthage* (1815, Tate, London) show Turner searching for that elusive Romantic attribute, the Sublime: hair-bristling natural phenomena to put butterflies into your stomach. Avalanches. Storms. Torrents.

THE FIRST MODERN?

Moderns are more interested in T.'s post-1830s canvases, for the atmosphere in some, and in others for what was then the very revolutionary subject of Machinery.

Stand stunned before *The Fighting Temeraire* (1838, N.G., London) or *Snowstorm: Steamship off a Harbour's Mouth* (c.1842, N.G., London), or *Rain, Steam and Speed* (c.1844, N.G., London), or Turner's last great painting, *Norham Castle at Sunrise* (1845, Tate, London), and wonder just how he did it. Talent oozed out of his every pore. Taxed by a lady who said she didn't like *Snowstorm*, T.'s riposte was that she wasn't expected to like it: he hadn't painted it for her to like it.

But Turner rarely told it like it was. In the spirit of the Romantic age, his pictures would allude to ideas, events, and let his audience get on with the job of interpreting the images. On the whole they did well, but posterity really capitalized.

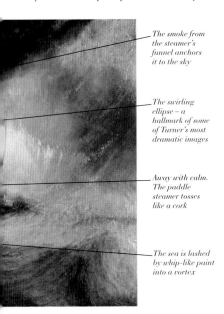

The smoke from the steamer's funnel anchors it to the sky

The swirling ellipse – a hallmark of some of Turner's most dramatic images

Away with calm. The paddle steamer tosses like a cork

The sea is lashed by whip-like paint into a vortex

Walk On

Turner's thousands of watercolours were the result of many journeys in Britain and Europe, when – in a pre-aerobic spirit – he preferred to walk great distances rather than take a coach and miss a detail. Some shoe bill. Several water-colours were often the basis for composite oil paintings.

1848 The Pre-Raphaelite Brotherhood is officially founded. Only Holman Hunt sticks to its principles.

1851 The Great Exhibition at Crystal Palace, London, instigated by the technophile Prince Albert, consort to Queen Victoria. The Palace is designed by Sir Joseph Paxton.

1875 Bedford Park, London, is built. It is the first Garden Suburb, designed by Richard Norman Shaw (1831–1912). Rus in urbe suburbia is born.

1840~1855

We know what we like
The Pre-Raphaelites

Although the Pre-Raphaelite Brotherhood, or PRB, were ignorant of much early Italian painting, they were positive that Raphael was overrated. They wanted their art to recreate a condition close to that of (so they imagined) Italian painting before his appearance. They also wanted to put closely observed Nature back on the artistic agenda. Who were these men who apparently lived only to paint drooping females and to illustrate medieval story-lines?

Other passengers oblivious to Woolner's parting wrench

Umbrella used to shield offspring from final, inhospitable view of motherland

The Last of England, Ford Madox Brown, 1855, Birmingham City Museum and Art Gallery. The emigrants leave home.

Holman Hunt, the staunchest of the PRB.

The PRB (as they secretively signed themselves) was formed in 1848 and lasted until 1853. Originally they were *William Holman HUNT* (1827–1910), (Sir) *John Everett MILLAIS* (1829–96), the brothers *William* and *Dante Gabriel ROSSETTI* (1828–82 and 1825–81), *James COLLINSON* (1825–81), *Frederic STEPHENS* (1828–1907), and *Thomas WOOLNER* (1825–92), the sculptor whose emigration to Australia was later immortalized by *Ford Madox BROWN*

(1821–93) in his painting *The Last of England* (1855, Birmingham City Museum and Art Gallery). All were in their late teens or early 20s, but in this case youth means nothing. The boys might seem strange now, with their belief in 'serious', often highly literary, subject-matter and elaborate symbolism, but they'd trash today's students in a few moments. In time (and history) the PRB become the Art-Rebels of Victorian England. It's hard to accept that Hunt's *The Hireling Shepherd* (1851, Manchester City Art Gallery), Rossetti's *The Girlhood*

1885 Karl Friedrich Benz (1844–1929) builds the first petrol-driven motor car. It is the dawn of Autogeddon.

1891 Oscar Wilde (1854–1900) publishes his only novel, The Picture of Dorian Gray.

1895 The Lumière bros (Auguste Marie and Louis Jean) unveil their invention and show the first ciné film.

Christ in the House of His Parents, Sir John Millais, 1850, Tate Gallery, London. Young Jesus seen in a realistic carpenter's workshop, complete with shavings; Charles Dickens loathed it.

of Mary Virgin (1848–9, Tate, London), and Collinson's critical *Answering the Emigrant's Letter* (1850) were once revolutionary pictures, but you'd better believe it. These boys influenced a whole generation of artists.

KEEP ON RUNNING

They never stood still. When Rossetti came clean about the meaning of PRB in 1850, the Art World went on the offensive. How dare they compare themselves with the Renaissance greats! They were attacked on every front, especially Millais by Charles Dickens, who made *Christ in the House of His Parents* (1850, Tate, London) a special target. It didn't matter: Kunstführer Ruskin was Millais's champion – until M. fell in love with Ruskin's wife, Effie. Indeed, of all the boys, Millais emerged as A Great Victorian Painter, and even made President of the Academy briefly, before his death in 1896: he had lapsed into lucrative society portraiture and sugary babes worthy only of chocolate box covers. Though the boys split, many successful artists followed their creed of observed Nature, coupled with a good religous or narrative scenario.

Holman Hunt alone stuck to the PRB line: *The Scapegoat* (1854, Lady Lever Art Gallery, Port Sunlight) was painted in the Holy Land with several other pictures. Dante Rossetti veered towards symbolic, romantic, sensual, and allegorical works.

THE FRAME — **NAMES IN**

The Solomon family of painters. The youngest, Simeon (1840–1905), is one of the most gifted draughtsman-illustrators of his age, and one of the last artists to be totally smitten by the Pre-Raphaelite bug. When popular painter Abraham (1823–62) hears of his election to the Academy, he suffers a fatal heart-attack; the middle child, Rebecca (1832–1886) is set for fame and fortune as a narrative artist, but neglects her career to help Simeon, a drink and drugs casualty. Simeon dies destitute, but after Rebecca, whose end is tragic, under the wheels of a cab in a London fog, while trying to find her useless brother.

1814 Napoleon exiled to Elba (he'll be back). Louis XVIII restored to the throne (not for long).

1820 Anglomania sweeps le tout France: les watercolours, le thé, les sandwiches de concombre et le stiff upper lèvre are le dernier cri in all modish salons.

1848 Louis Phillippe (1773–1850) dethroned. Republic re-established, again.

1800~1870

Realism, eh?
Courb-et. Mill-et. Man-et.
Telling it like it was

The Meeting, or Bonjour Monsieur Courbet, Gustave Courbet, Musée Montpellier. Self-portrait of the artist on his way to work, complete with backpack of artistic materials and aggressive beard.

Modern painting starts here. Or that's what they say. The 1850s and 60s saw the French artistic applecart overturned more than once by Gustave COURBET (1819–77), Jean-François MILLET (1814–75) and Edouard MANET (1832–83). Their crime? They dared to paint such unworthy subjects as real people doing everyday things. Why and how? Like much in Art, it was a young-blood reaction to an established but outmoded style. No more heavyweight classical allusions for these gents. Courbet put it as well as any: '…the art of painting can only consist of the representation of objects which are visible and tangible for the artist'. In other words, forget the Classics: let's get real.

Getting real' put the noses of newspaper critics out of joint. This was the era of gross art journalism (sometimes quite like our own), when journals printed detailed, florid descriptions of salon paintings with high-brow or moral content. Paintings whose subjects were (deep breath) Peasants… or Prostitutes… or Death were just asking for trouble. Gus slapped the pundits' faces when he showed his vast *Burial at Ornans* (c.1850, Louvre, Paris) with its real, boring people, its animals,

and drunken priests. The fleshy waists and bums of his *Bathers* (1853, Louvre, Paris) weren't exactly siren-like, and the low-life gathered in his own *The Painter's Studio* (1855, Louvre, Paris) left everyone speechless. Plus he often used a palette knife. It just wasn't done.

The problem didn't go away. Poor Millet was branded a red-hot momma for several oils showing peasants at work. Glance at *The Gleaners* (1857, Louvre, Paris), or *The Angelus* (1857, Musée

1849 Joseph Monnier invents reinforced concrete (concrete with steel rods in it). The birth of brutalisme .

1857 Charles Baudelaire (1821–67), poet, dandy and friend to artists, publishes Les Fleurs du Mal (The Flowers of Evil). Modern poetry starts here.

1889 M. Gustave Eiffel (1832–1923) astounds the world with his eponymous tower, designed as a temporary erection for the Paris Exhibition. Traditionalists loathe it and petition for it to be taken down.

d'Orsay, Paris), with its soiled toilers pausing to pray: they're hardly the stuff of revolt. Much more rumpus was caused by the energetic canvases of Edward Manet. For many they were just about the last straw.

Until the 1870s Manet's technique was based on the opposition of light and shade. Forget subtle *sfumato*; Manet used Black!! (*Quel horreur!!* So what if he'd studied Goya and Velázquez?) But in 1863 things got nasty. M. dared to defy social convention, by showing gratuitous nudity in *Le Déjeuner sur l'Herbe* and *Olympia* (both Louvre, Paris). Public decency… family values… morals… the sniping went on for years. Be warned: 'de-coding' Olympia is a hot PC issue. Be cool! Also, don't say the words Manet and Impressionism together. They co-existed, but that's as far as it went.

Olympia, Edouard Manet, 1863, Musée d'Orsay. Cool, classy, sophisticated homage to Titian's Venus of Urbino. They're sisters under the skin. Note the single shoe.

The Explosive Artist

One of the most political artists in nineteenth-century France, Courbet was an outspoken Socialist, Republican, and anti-cleric. A member of the Paris Commune of 1873, he was later jailed for six months, re-tried, released, and saddled with the cost of replacing the Place Vendôme Column, dynamited in 1871, an act with which he has long been tentatively associated. Faced with raising Fr 323,000, he fled to Switzerland, where his career never regained its former power, and where he eventually died.

Olympia's faithful slave stands by; part chaperone, part pandar

An extravagant bouquet; are there admirers at the door?

New use of space; Olympia boldly returns our gaze

Direct, unacademic painting of drapes and sheets

Shoe on, a courtesan's trick; not a classical nude

Inspiration from the Japanese trade.

1837–40 New colours introduced into the oil painter's palette: mauve, violet, bright green, intense yellow.

1843 Great Britain, the first iron-hulled steamer, crosses the Atlantic.

1846–8 The potato famine in Ireland drives huge numbers to emigrate to the United States.

1840~1920

American Patrol
Whistler & Co.

Whistler waves the US flag.

The Yanks are coming… Sure, James Abbott McNeill WHISTLER (1843–1903) was big in London, but American painters weren't strangers to European art. Benjamin WEST (1738–1820) had successfully set up shop in London in 1763, closely followed by the great portraitist John Singleton COPLEY (1737–1815). Nevertheless, by the 1850s, East Coast American landscape painting was developing nearly as quickly as access to the hinterland, and more than one American master had learnt his lessons home on the range. The wide open spaces of Frederic Edwin CHURCH (1826–1900) have often been compared with TURNER'S, but this is silly, mainly because Church looked at grandiose Nature and recorded all phenomena faithfully, much to his curious audience's delight, and Turner looked at grandiose Nature… and reconstructed it. (Brilliantly, of course.)

Twilight in the Wilderness, Frederick E. Church, Cleveland Museum of Art, Ohio. Church's vast coloured canvases fired East Coast American imaginations. Was this what the Wild West really looked like?

The intense colours of Church's paintings are exciting and romantic in ways similar to some of Turner's pictures

Rhapsody in red. The awesome power of God and Nature for the hot-blooded

Limitless vistas suggest a huge range of emotion and sentiment

The wild frontier awaits in the shadows

1858 Ralph Nadar (1820–1910), the photographer and friend of the Impressionists, goes up in a balloon to take the first aerial shot of Paris.

1877 Ruskin ridicules Whistler, calling his work 'a pot of paint flung in the face of the public', Whistler sues, he wins a halfpenny in damages.

1885 Whistler gives his famous Ten o' Clock lecture in London, setting out his manifesto ('art exists only for itself').

gents of change, two other major American masters, *Winslow HOMER* (1836–1910) and *Thomas EAKINS* (1844–1916), visit Europe between 1866 and 1882. These periods change their work radically, in Homer's case more than once. Early on, Homer goes through a Courbet phase, but it's temporary. The great change follows his stay in England in 1881: stark, Man-against-Nature/Society themes percolate the paintings executed when he returns to a solitary existence in Maine. As for Eakins, it's Spain and Velázquez for him, especially V.'s fidelity to observed fact, but even that pales into insignificance against the lure of the USA. Eakins's Philadelphia home calls, and teaching beckons, so his biggest waves (and they are big) are made there.

Nocturne in Black and Gold: The Falling Rocket, J.A.M. Whistler, 1875, Detroit Institute of Arts. Gorgeous.

Art on Trial

In 1877 Kunstführer Ruskin ridicules one of Whistler's paintings in a privately printed pamphlet, says it's not worth £200, and calls it '…a pot of paint flung in the face of the public'. Jim sues for libel. The following trial effectively puts modern painting into court. That hoary question But is it Art? is asked in public. In the event, Ruskin doesn't even give evidence (he's become manic depressive), and Jim wins the case… but only gets one halfpenny damages, and a big bill for costs. He announces his undying loathing for 'British Justice' (he's not the first).

West Point's too rough for the wannabe-Englishman Whistler, so it's off to France, for *une vie Parisienne*. Whistler paints away for three years, befriends Manet, falls out with him and heads for London in 1859. There, he is instrumental in bringing Japanese influence to England, particularly Japanese prints, which find a ready interest, and are echoed in many of his oils. His picture names are an unusual development: whether portraits or misty, beautiful Thames-side 'atmosphere', they reflect his interest in musical harmony: he calls them Nocturnes, or Symphonies, or Crepuscules.

1846 The first Christmas card is sent. It is hand-painted. A mega-industry is born.

1848-50 The Californian Gold Rush opens up the West Coast of America.

1856 Henry Bessemer (1813-98) invents a cheap process to convert pig iron into steel.

1830~1930

Sunrise: Monet, Monet, Monet
The First Series Painter

'...only an eye, but my God what an eye!' Thus Paul Cézanne on his old acquaintance Claude MONET (1840–1926): well, Cézanne wasn't what you'd call friendly with anyone. How to describe one of the great figures in Art's Hall of Fame? Exactly which Monet do you want to talk about? Haystacks Monet? Rouen Cathedral Monet? Waterlily Monet? Mr Poppyfield? He was like a pinball, hitting the bumpers hard and often, scoring most times, and changing his interests to suit. Monet called Le Havre home. There he decided to be a landscape painter, and there he painted the famous Impression: Sunrise (1872, Musée Marmottan, Paris). When it was first shown in 1874 at what later became known as the first Impressionist exhibition, French critics used this title as a convenient tag, to trash the reputation of everyone who painted similarly. Cézanne, Sisley, Renoir, Bazille, Courbet, Manet... the impoverished Monet first met these artistic pariahs in 1862 in Paris.

Direct, stabbing strokes of paint

Suggestions, not accurate depiction of what is there

Impression: Sunrise, Le Havre, Claude Monet, 1872, Musée Marmottan, Paris. Rumour has it that Monet dashed this off in a fierce hurry to catch his exhibition deadline.

Success came late. Monet escaped the Franco-Prussian War (1870–1) by running to London (where he met up with Camille Pissarro: they toured the National Gallery and studied the Constables and Turners – to nil effect, according to Monet, though it's hard to believe). Only on his return to Paris did he begin to gain a reputation. At the heart of his art are his total absorption with the fleeting effects of Nature, and – to his dying day – his determination to paint what he saw: not what he knew was there.

1870 The railway system in France and Belgium is completed. Cheap travel allows artists to go to faraway places, and paint them.

1886 The first Impressionist exhibition in the US. It is a fantastic success.

1903 Orville and Wilbur Wright make the first powered sustained flight at Kitty Hawk, North Carolina. Orville covered 36.6 m/120 ft and Wilbur managed 260 m/852 ft.

Inside Out, Outside In

Although Monet and the Impressionists liked to think of themselves as *plein air* (open air /outdoor) painters, the facts were different. Much of their work was completed in the studio, simply because light and weather changed so rapidly that they couldn't keep pace with it. In itself, this gave rise to Monet's fast methods of painting: variable brushstrokes, to suit all occasions.

Basic multi-coloured brushstrokes to give luminosity to the water

Certainly, Monet's famous repeated subjects verge on the obsessional. Begun in the 1880s, most occupied him over several years. Multiple paintings of his famous garden at Giverny, with its waterlily pond and Japanese bridge (the neighbours hated it), were begun c.1883, and by 1889 he was painting *Haystacks*. Lots of them (25). Then he monopolized poplar trees (24)(c.1891). After that came the great series of *Rouen Cathedral* (1892–5) at various times of day, encrusted with cement-like paint. But Monet was no home-boy, and occasionally revisited London to paint misty Thames scenes, always from the same balcony in the Savoy Hotel (1899–1904). Finally came the amazing *Waterlilies*, of which the very best date from 1916. Were they the first-ever abstract canvases? Or the logical outcome of a love-affair with Nature?

A Big Impression

10 April 1886 Durand Ruel, the Impressionists' dealer, opens their first exhibition in the USA at the American Art Association, New York. It is so successful that by the end of May it has transferred to the National Academy of Design, thus achieving the group's first official recognition anywhere. Monet had, typically, quarrelled with Ruel about selling to the USA.

1849 Amelia Bloomer invents the trouser for women. Many mock, but it allows women to combine mobility (on a bicycle) with modesty.

1857 Théophile Gautier (1811–72), poet, novelist and journalist, opines that 'Art is for Art's sake'.

1851–68 Baron Haussman (1809–91) redesigns Paris with a grid of wide boulevards, combining crowd control (streets wide enough for an army to march down and no cobbles for rioters to hurl) and aesthetics.

1860~1930
Just having fun, mostly
The Impressionists

Haystack, bucolic star of Monet's series paintings.

Everyone has their own notion of Impressionism. This wasn't an art movement, but an alliance of painters with broadly similar aims. Common to them all was the portrayal of modern life, in all its forms, in a realistic manner. In 1874, in an independent exhibition in Paris, Claude MONET showed Impression: Sunrise, *and Camille PISSARRO (1830–1903), Berthe MORISOT (1841–95), Edgar DEGAS (1834–1917), Paul CÉZANNE (1839–1906), Eugène BOUDIN (1824–98), Armand GUILLAUMIN (1841–1927), Alfred SISLEY (1839–99) and Pierre Auguste RENOIR (1841–1916) exhibited other paintings. The 'ism' was donated courtesy of art critic Louis Leroy and the French press, who mostly didn't appreciate this new development, and the name stuck forever.*

Race Horses at the Grandstand, Edgar Degas, 1879, Musée d'Orsay, Paris. Degas was fascinated by movement, and at the race track (as well as the ballet school) he found great inspiration, faithfully recording both the grace and the gaucheries of his subjects.

Even a forensic expert would find it hard to disentangle reality from myth in Impressionist history, because every artist had different priorities. Committed landscape painters – like the ridiculously underrated Sisley – followed the outdoor work of the Barbizon painters, based around Fontainebleau in the 1840s and 50s, or went to England to paint, and study Turner and Constable. Monet and Renoir liked people-watching, so, early on, they hung-out with the jet-set at La Grenouillière, an island in the Seine with a restaurant, boating... far out. Had some fun there. And then Renoir split to do the same thing in town. If, like Degas, you got your kicks from looking up ballet dancers' skirts, or at race horses, or working-class

1863 The Salon des Refusés is established as a display area for the artists the official Salon rejected. There are 4,000 pictures.

1867 Japanese prints exhibited at the Exposition Universelle. They make a great impact on the Impressionists, especially Degas and Cassatt.

1870-71 Franco-Prussian War. Degas serves in the army, Bazille is killed, Monet and Pissaro dodge the draft and Sisley is exempt (he is English).

Red Roofs or Village in Winter, Camille Pissarro, 1877, Musée d'Orsay, Paris. A characteristic Pissarro study: rural subject, solid forms, a scene recorded on the spot at human eye level (note the small expanse of sky).

Solid mixed warm tones

Fusion of the foreground with the houses in the middle background

girls (is there a connection?) …well, you went to the ballet, the track or the brothel. As for serious-minded family man Pissarro (there's always one), the only artist to exhibit at each of the eight Impressionist exhibitions, he would rarely ignore new ideas, even if they later proved a washout. The new railways took the artists from place to place, the new oil paints (in tubes) were much more portable, and as for the new subject-matter, it was really a matter of direct observation. Or was it? The press encouraged the public to ignore Impressionism in its heyday (roughly 1870–80). And this business of open-air painting… great idea, but it didn't last. The city and its studios beckoned, dry and weather-proof.

However, and whichever way you liked your Impressionism, it depended on a single, major factor. Colour. Bright. Usually put on in dabs. According to who you were, that is…

" ☆ "

American Connections

The American-born, English-domiciled Henry James (1843–1916) publishes Portrait of a Lady in 1881. The subject: young American culture meets the European artistic tradition for the first time. There was a lot of it going on. But James was a wise old man, and in his hands the arts usually survived, even when humans were humiliated.

1863 The first underground trains run in London. Travel for the masses made easier.

1865 Abraham Lincoln is assassinated while at the theatre by John Wilkes Booth.

1850~1930

Spot on or absolutely dotty?

Georges Seurat & Co. Neo-Impressionists

Those dots in close-up; think of all that work.

Don't mistake Neo-Impressionism for a blood relative of Impressionism: there's clear water between the two, and shy, retiring Georges SEURAT (1859–91) creates that distance. When his noisy Impressionist friends ask him to come and play fast and loose with their new expressive techniques, Seurat goes all quiet. He doesn't like their nasty games, and prefers to stay in his studio and work out a rigid order for his own work. He's mostly successful, but it takes rather a long time to break down every area of colour in a painting into a combination of its natural and contrasting colours, in thousands of coloured dots. We call his kind of painting pointillisme. He called it divisionism. Where you often see flickering light in Impressionist paintings, in Seurat's canvases – like La Baignade à Asnières (c.1884, N.G., London) – you have almost unnatural calm. Order prevails. Peace. At a price. He makes over 20 studies for La Baignade.

Why bother? Seurat's besotted with colour. He's spent two whole years drawing in black and white, just trying to understand it, and to master tone. Once he's got this act together, he studies what he calls 'Lines of Emotion': the idea that lines going in certain directions in an image can make you happy (up) or sad (down). His paintings carry this idea to the limit. Obsessive perhaps? Seurat does have his friends and followers: *Paul SIGNAC* (1863–1935) is the best-known, and for a time even *Camille PISSARRO* attempts

The Friendly Critic

Neo-Impressionism was the term coined for Seurat and his followers by Félix Fénéon, writer and art critic, in 1886, when La Grand Jatte was first shown in 1886 at the last Impressionist exhibition. Fénéon wrote many articles in support of Seurat, and he, Signac and others hailed Seurat as the 'Messiah of a new art'. Wrong again.

pointillisme (he called it *virgulisme*), but later, in a letter to his son Lucien, he refers to it as 'a blind alley'. It is far too precisely intellectual for the life-loving Pissaro.

1879 Norwegian poet and playwright Henrik Ibsen (1828–1906) invents modern drama in his play A Doll's House.

1885 James Mickle Fox of Philadelphia introduces the game of golf to the USA. He is thought to have learnt the game at St Andrews, Scotland. The consequences of his activities have (as they say) resulted in a whole new ball-game...

1889 First 'skyscraper' built in Chicago. It is a towering nine stories high.

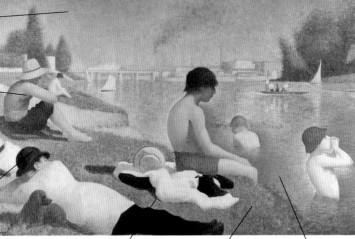

Heat haze represented by shimmering pinks and blues; the stillness of a long, hot summer is palpable

An early study of sunbathing; being bronzed by the sun would not be chic until Coco Chanel made it so in the 1920s; this is definitely a working-class luxury

Figure cropped off as in photography; note the anonymity of the figures – not one full face view

La Baignade à Asnières, Georges Seurat, 1884, N.G., London. Workers at rest: not a picture for the salon, but the size of 'Bathers' makes it so.

Stark black/white breaks up mixed pure colours of the grass

Orange, yellow and green meticulously blended to make up the grass colours

Handling of water varies from thick to thin brushstrokes

Sure, Seurat's work is impressive, but while you're reflecting on the qualities of heat, light, shade and sphinx-like imagery in the vast *La Grande Jatte* (1884–6, Art Institute, Chicago), you should know that it isn't necessarily the high-water-mark of his short career. Seurat's beautiful paintings of the Normandy coast, during 1885 and 1890 ('Bec du Hoc' et Grandchamp, 1885, Tate, London) in which this same technique makes light flare in a much less ponderous way, are unequalled by any Impressionist. And spare a thought too for his theatre and circus scenes of 1890–1, such as *The Circus* (1891, Musée d'Orsay, Paris.) They are often seen as a new (and in his case, final) factor, a change of tack from his landscapes. Reconsider. Ask yourself whether such intense, often uncomfortable stylization was a real development, or a determined escape attempt by Seurat from the self-imposed artistic treadmill of dot manufacture.

1866 Dynamite is invented by Alfred Nobel (1833–96). He later endows the Nobel Prize, to make up for his folly.

1867 Radio waves are discovered. Worldwide communication is only a whisker away.

1873 Arthur Rimbaud (1854–91) writes Une Saison en Enfer, after he has lived with the poet Paul Verlaine (1844–96) for two years.

1850~1900

Starry, Starry Nights
Van Gogh

Think of poor old Vincent and you think of … Kirk Douglas? Philistine! You could talk about Vince at breakfast, dinner and tea for months, so let's begin by scotching that old chestnut about his right ear. He didn't cut it off, OK? Only the lobe. Meet Vincent van GOGH (1853–90), the eldest of six children. He's stubborn and volatile, doesn't get on with his Dutch pastor father, or his mother, and leaves home as soon as possible. His brother Theo tries to find him a job.

A las. One hard-luck story leads to another. Awkward young Vincent is unemployable as a picture dealer, and as a teacher, and he hits the pits (sorry) as a lay preacher in the Belgian coalfields. Aged 27 he decides to become an artist, and (at Antwerp Academy) proves to be unteachable too. He learns what he can, when he can, by bumming around. To judge by some of his terrific drawings up to 1885, he learns a lot. Then, in 1886, he arrives on Theo's doorstep in Paris. Theo has a family, and is trying to run a gallery selling Impressionist paintings, but adds Vincent's money worries to his own. He

Vertical brushstrokes signify heaven's heights

Friendly yellow warmth of awning

Overhanging green branches contrast vibrantly with the blue and yellow; giant stars swirl in the sky, a van Gogh giveaway

Terrace of the Café at the Place du Forum in the Evening, Vincent van Gogh, 1888, Rijksmuseum Kröller-Müller. Vincent was teetering on the abyss of insanity at the time. The yellow awning protects the customers from the glare of the bright, threatening oversize stars which do not so much twinkle as pulsate.

introduces Vincent to *Edgar DEGAS* (1834–1917), *Camille PISSARRO* (1831–1903) (who encourages him) and others. Scales fall from Vincent's eyes. His painting style changes completely. Before

1876 Alexander Graham Bell (1847–1922) invents the telephone.

1879–80 The light bulb is perfected using a carbon filament. There is unseemly wrangling between its two inventors, the American Thomas Edison (1847–1931) and the English Joseph Swan (1828–1914).

1890 The first commercial sale of one of Vincent's paintings (The Red Vineyard) takes place for Fr 400, from a group show of Les XX in Brussels.

THE FRAME — NAMES IN

*Vincent would influence other artists. Gauguin aside, Norwegian **Edvard Munch** (1863–1944) and the German Expressionists, especially **Ernst Ludwig Kirchner** (1880-1938), were profoundly influenced by Vincent's searing, flame-like style.*

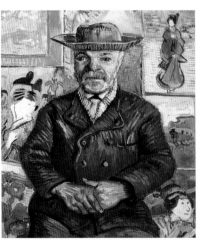

Père Tanguy, Vincent van Gogh, 1887/8, Private Collection. Vincent thought a lot of M. Tanguy (he painted him three times) who sits in his bleus de travail, wishing the sitting was all over. Behind him is the japonoiserie that changed Vincent's style in Paris.

Paris, it's a kind of atmospheric sludge. Once there, bright, vibrant colours are soon in evidence, in a style influenced by a new love, Japanese prints.

SOUTHERN DISCOMFORT

But Vincent's drinking and bad temper haven't lessened, and in 1888 Theo's relieved when Big Brother moves down South, to Arles. Soon after, *Paul GAUGUIN* (1848–1903) joins him for the ride. At first, all's well. Vincent paints brilliantly, with feeling: his pictures are vibrant. It doesn't last. Within two months he's mentally unstable, violent, and the 'ear incident' sends Gauguin running for Paris like a rat down a drainpipe. Who'd blame him? Vincent checks himself in to a mental asylum at St Rémy, begins to recover, draws fabulously, and creates a truly personal style from Impressionist techniques: heavy dashes of paint, and his own, densely coloured, 'swirling' brushstrokes.

Vincent's black fits recur every three months. At Pissarro's suggestion he moves to Auvers, northwest of Paris. But Theo has big money troubles, and these may worry Vincent too. On 27 July 1890 he shoots himself in the chest, and dies two days later, in his brother's arms.

Relative Correspondence

The van Gogh brothers corresponded regularly, especially Vincent, who used the mail like a diary. His letters have been published several times over, and are an extraordinarily rich source of information about every area of his life and art. But for Brownie points here, note that during Vincent's 'Paris period' (1886–8) there were no letters: he was living with Theo, and they didn't need to write. What passed between them has had scholars wracking their brains for years.

1851 Isaac Merit Singer (1811–75) invents the sewing machine.

1869 John Stuart Mill (1806–73), English utilitarian philosopher and early male feminist, writes The Subjection of Women.

1876 Queen Victoria becomes Empress of India. The British Raj rules, for now.

Paul Gauguin by himself.

1850~1910

Gauguin: The Savage Beast!
South Sea Bubble

Imagine the headlines: 'Stockbroker goes Ape'. 'Noble Savage Theory Claims Another Artist'...Paul GAUGUIN (1848–1903) That Was Your Life. P.G. wasn't the most likeable fellow around, but an early meeting with Camille PISSARRO (1831–1903) made him a supporter of the Impressionists. P.G. bought their works and, more important, joined their exhibitions from 1880 to 1886. In 1883, this delightful chap threw off his broker's clothes, charmingly left his family to fend for themselves, and went off to Brittany to paint. With few interruptions (including his disastrous 1888 visit to van Gogh in Arles), P.G. worked in Pont Aven or Le Pouldu from 1886 to 1890. From this period came the magnificent Vision After the Sermon (1888, N.G. of Scotland, Edinburgh), with its strong, Japanese echoes: whatever his sins, Vincent had introduced P.G. to the Japanese print. New influences were doing the rest.

Gauguin is best known for his travels to the South Seas: in fact he went twice, first in 1891, with the avowed intent of escaping civilization. Out of cash by 1893, he returned to Paris but headed south again in 1895. His health was bad, and it never improved. Cranky to the end, Gauguin died in the Marquesas in 1903, sick and poor. Romantic it wasn't. Primitive it was. In the end. Present wisdom suggests that P.G. knew very well what to expect in the South Seas: that his journey wasn't going to turn into the simple life that he wanted; that there would be no noble savages, least of all himself; that he couldn't reject civilization

The title of the picture included in the picture itself

A tropical deity confronts Gauguin's Christian culture

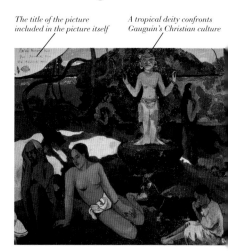

1883 Jazz and blues evolve from the worksongs of the black slaves in the southern US.

1900 Sigmund Freud (1865–1939) writes The Interpretation of Dreams. The birth of the shrinkwrapped generation.

A Final Statement

It's likely that Gauguin intended What Are We... to be his last statement. His terrible circumstances certainly inspired a failed suicide attempt immediately after the picture's completion, and so it may have been intended as a summary of his ideas. The title is not unique to Gauguin, but the painting's deep, beautiful colour scheme most certainly is.

in a corrupt and cynical French colony. It was a case of frying pans and fires, folks. P.G.'s calculated, bizarre decision is still under the microscope.

P.G. was one of the Greats. His colours were good before Tahiti, largely due to the influence of the painters *Paul SERUSIER* (1864–1927) and *Emile BERNARD* (1868–1941), who wound P.G. up to such a degree that he dumped Impressionism and all that belonged to it, and headed for non-naturalistic colour: the art of Emotion. He called it Synthetism. (see pages 82–83). In a painterly sense, the South Seas only improved P.G., and his

THE FRAME — NAMES IN

Apart from Vincent?

Georges Daniel de Monfried, *Gauguin's closest friend in the last 12 years of his life, who steadfastly ran his affairs.*

Paul Serusier *and* **Emile Bernard,** *young painters at the Academie Julian in Paris, who supported Gauguin's colour theories from an early stage, and who themselves influenced many others. Bernard, 20 years younger, is particularly important and is a vital intellectual influence during the maddening van Gogh period.*

ARTSPEAK

In 1888, Gauguin writes to his friend and supporter Emile Schuffenecker, from Pont Aven:

'Some advice: do not copy too much after nature. Art is an abstraction; derive this abstraction from nature while dreaming before it, and think more of the creation than of the result. Creating it like our Divine Master is the only way of rising toward God'.

work remains influential to this day. *Edvard MUNCH* and the German Expressionists were early supporters, and anyone who sees his meisterwerk *Where Do We Come from? What Are We? Where Are We Going?* (1897, Museum of Fine Arts, Boston) will understand why. No-one since the Renaissance had questioned the essence of humanity quite as eloquently.

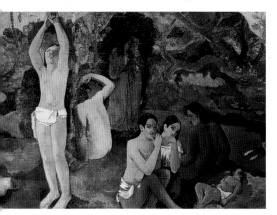

Where Do We Come From? What Are We? Where Are We Going? Paul Gauguin, 1897, Museum of Fine Arts, Boston. G.'s masterpiece?

1844–5 In a forest near Fontainebleau, France, the Barbizon school of alfresco landscapists is set up; this is where the Impressionists cut their teeth.

1851 Jean Foucault (1819–68), French physicist, demonstrates the rotation of the Earth, using a pendulum; he went on to invent the gyroscope.

1861 Cézanne works, reluctantly, in his father's bank. He scrawls a poem in one of the ledgers: 'Old banker Cézanne shudders and quakes Behind his counter a painter awakes'.

1830~1910

I want to be alone
Cézanne. Provençal Provincial

Cézanne saw formal shapes wherever he looked.

The child may be father to the man, said Picasso, but 'Cézanne was the father of us all'. Paul CÉZANNE (1839–1906) was a strange, reclusive curmudgeon, whose early pictures were occasionally (and unnervingly) based on erotic fantasies. His Provençal birth is sometimes given as the reason for his peculiar nature, but his father (rich, nasty and evilly repressive) is more likely to have made prickly Paul the inarticulate chap he often was. He blew an early, close friendship with his schoolfriend the writer Emile ZOLA (1840–1902) when Z. 'wrote' him into a novel (as Claude Lantier in L'Oeuvre). When Cézanne père died in 1886, Cézanne inherited, and settled in isolation near Aix-en-Provence with his mistress.

S o. What's all this 'Cézanne-the-father' business? Impressionist painting was often a matter of wham-bam-and-onto-the-canvas. Cézanne was more thoughtful, and his isolation helped. He proved by example that paint could be used to model. More difficult than you'd think. He enjoyed and respected the classical prototypes – he even said that he wanted to 'do Poussin again, from Nature', which shows his real and intense interest in the structure of a painting, and it's this that

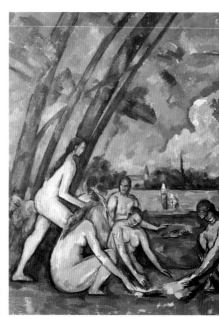

The Large Bathers, Paul Cézanne, c.1900–05, Philadelphia Museum of Art. Shape and form unified by colour.

1881 Electric trams cruise the streets of Berlin.

1895 'I should like to astound Paris with an apple'. Cézanne expresses his theory of form.

1898 Emile Zola (1840–1902) writes his famous piece 'J'accuse' in Le Figaro in defence of Alfred Dreyfus, the army officer accused of spying. He is imprisoned.

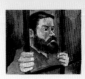

*On the other side of the Channel **Walter Sickert** (1860–1942) is wooing old man **Edgar Degas** (1834–1917), and Sickert's disciples, young **Harold Gilman** (1876–1919), **Spencer Gore** (1878–1914) and **Charles Ginner** (1878–1952) are looking very closely indeed at French painting. In 1911 they will form The Camden Town Group, the most important of the small independent exhibiting societies that are springing up. It will give birth to The London Group in 1913, still an important force in independent British painting and sculpture. **Lucien Pissarro** (1863–1944), eldest son of Camille, settled in England in 1890 and became a Camden Town Groupie.*

allows us to see Cézanne as the major forerunner of Señor Picasso y amigos. More than anything else, he was an original. But don't just swallow the waves of praise; ask yourself if you can understand it all, and then judge. You might not like it as much as you're told you will.

Cézanne's pictures after 1886 are mostly still-lifes, and landscapes of Mont Sainte Victoire. The still-lifes are usually of apples on tables. Magnificent stuff, except that most of them look like Mont Sainte Victoire. The Mont Sainte Victoires show the location nearby and far away. Either way they took time and infinite care. By 1890 Cézanne was exhibiting in Brussels, and in 1895 he had his first big show. But mountainous France gave way to mountainous nude bathers in his last years; it was almost a return to his roots. Nudes in landscapes. Heard that somewhere before? You'll hear it again.

> **You say Impressionism, I say Post-Impressionism**
>
> Post-Impressionism is the term Brits and Americans use to describe Van Gogh, Gauguin and Cézanne. It was invented in 1910 by Roger Fry, (1866–1934), British art critic and at one time Keeper of the Metropolitan Museum, New York. He had a point to make about Cézanne, and a new term was necessary. For decades the French saw no difference between this trio and the Impressionists, and have only very recently started to use the term to distinguish these artists from the main bunch. Although Cézanne exhibited with the main group for most of its life, Post-Impressionism is a convenient term to distinguish the three later, and really very different, artists from the crowd.

Trees follow lines of force like a triangle – or like Mont Ste Victoire

Ghostly mountainous shape in the background - can it be Mont Ste Victoire?

Carefully arranged integrated figures

Monumental bathing nymphs and goddesses recall Renaissance paintings

1865 Gregor Mendel (1822–84), an Austrian Augustinian monk and biologist, invents genetics. He uses peas as a demonstration model.

1884 Hiram Stevens Maxim (1840–1916), a British inventor born in the USA, invents the machine gun.

1890 Knut Hamsun (1859–1952), Norway's best-known novelist, writes Hunger, a story of deprivation.

1860~1945

Northern Lights

Edvard Munch. Asmundur Sveinsson. Frans Widerberg.

The Hellride, Asmundur Sveinsson, 1944, N.G., Reykjavik. A distorted masked almost humanoid rides a deformed headless steed.

Edvard MUNCH (Norwegian, 1863–1944), Asmundur SVEINSSON (Icelandic, 1893–1982) and Frans WIDERBERG (Norwegian, b.1934) show how intensely felt Northern painting and sculpture can be, and has been, over the past century. They say Munch was a neurotic: it's not surprising, when his mother and a sister died so young. The Scream (1893, N.G., Oslo) and a host of other paintings reveal a nineteenth-century avant-garde artist using twentieth-century themes, busting to shake off the shackles. Many of his paintings are nervy, streaky with turpentine. Confrontational. This feeling also seeps into many of his hundreds of wood engravings.

But towering against Munch's blackest moods stands much optimistic work, including his vast The Sun (1909–11), painted for Oslo University.

Among Iceland's greatest artists (yes, Iceland, and their artists are great) Sveinsson stands out, partly because he's a sculptor. Like his marvellous contemporaries, he was a man alive to the pagan and Celtic traditions of this volcanic mass, but as a response to World War II his *Hellride* (1944, N.G., Reykjavik) was among the best sculptures on the subject executed anywhere in the northern hemisphere during or after the event. An

1890s Scott Joplin (1868–1917), pianist and composer, brings ragtime to the millions. Maple Leaf Rag (1899) sold a million copies in sheet music.

1904 Anton Chekhov (1860–1904) writes his last play, The Cherry Orchard, a tale of loss and missed opportunity.

1913 Ernest Rutherford (1871–1937), New Zealand physicist, splits the atom and names the nucleus.

unknown figure in wood from Hades writhes and screams. You can hear it.

In recent years Frans Widerberg has emerged as one of Norway's finest. His heavenly odysseys have primitive horse/rider combinations in the sky (hear those twanging guitars), as guardians, as crossover-mythological/cabbalistic figures, as representatives of a watching presence; or infinitely moving water is featured. Where Munch mixed his colours to wail, Frans mostly sticks to primaries and hits the 'Turbo-Calm' button. Imagine the effect on large canvases.

Celestial Rider, Frans Widerberg, 1982–5. F. W. considers man's place in the cosmos by using ancient rider/figure motifs.

The Scream, Edvard Munch, 1893, N.G., Oslo. Probably the best known expression of modern angst in the world.

Deep blue sky suggests infinite space. The flying figure shows what we too might do

Long legs of rider and horse are typical stylistic features suggesting a long view into the distance

Striped foreground in primary colours, a scene above the earth

Love Hurts
In 1902, Munch's stormy relationship with Tulla Larsen ended with the artist shooting himself in the hand after a bitter quarrel. Tulla then left him, and married someone else, leaving Ed prey to his own jealousy and bitterness. Hardly a love song.

THE FRAME NAMES IN

From Norway **Harald Sohlberg**, *magical painter of Norwegian nightglow, and* **Harriet Backer**, *painter of lovely informal themes; from Denmark* **Vilhelm Hammershoj**, *peasant painter extraordinaire; from Finland* **Akseli Gallen-Kallela**, *whose Gauguinesque ideas were embodied in his Kallevala; from Sweden* **Ernest Josephson**, *great portraitist and profound paranoiac; and from Iceland* **Thorarinn Thorlaksson, Asgrimur Jonsson** *and, from a slightly later generation,* **Johannes Kjarval**, *all of whom made the lava sing.*

1888 John Boyd Dunlop (1840–1921) invents the pneumatic tyre; the idea came to him when he was trying to give his child a head start in a tricycle race.

1895 H.G. Wells (1866–1946) writes The Time Machine, popularizing science fiction.

1905 Albert Einstein (1879–1955) publishes his Special Theory of Relativity.

1880~1914
Enough's enough. We're off
Secession and Sezession

So you don't like what's on offer in the academies? Then break out. You have nothing to lose but your chains. Do something different. It didn't matter where you were from in the 1880s and 90s: if you thought your National Academy was past its sell-by date, you formed a new exhibiting society and let rip. You succeeded. It happened all over Europe – Berlin, Vienna, London, Munich, Dresden – and the results were never less than edifying. New groups sprang up where independent artists young and old could make visual statements that would have died in less tolerant surroundings.

The comforting scene of a pleasant lunch, à la Renoir

Atmosphere entirely created by the handling of light

Dappled sunlight, conscious or unconscious homage to Monet

Terrace at the Restaurant Jacob in Niestedten on the Elbe, Max Liebermann, c.1902, Kunsthalle, Hamburg. A Germanic take on the Impressionist style; however, the light is not so bright as in Provence.

In Britain, where the Royal Academy didn't understand the concept of 'dire', younger artists educated in the fleshpots of Paris or Brittany (or both) formed the New English Art Club in 1886, and thumbed their noses at the Academy's increasingly banal history painting. *James Abbott McNeill* WHISTLER (1834–1903) was admired by these young turks, and his ex-studio assistant *Walter* SICKERT (1860–1942) and his friend *Philip Wilson* STEER (1860–1942) with many others of sound quality. They would later inspire the Camden Town and London Groups, which would go, independent as anything, into the mouth of World War I.

1906 Roald Amundsen (1872–1928) navigates the North West Passage, to find the magnetic North Pole.

1908 Henry Ford (1863–1947) invents the assembly line for automobile manufacture; 15 million of his Model T are produced and sold.

1909 Louis Blériot (1872–1936), French aviator, builds his own monoplane and flies across the Channel in it.

NAMES IN THE FRAME

Max Beckmann *(1884–1950)*, *originally a German Impressionist, who would become a force to be reckoned with in the future.*

Käthe Kollwitz *(1867–1945)*, *recognized by all her contemporaries as one of Germany's major printmakers, but denied prizes for her work by the Kaiser, because its themes were far too Socialist, and we can't have that, can we...?*

The Caledonian Contribution

One of the most important Secessionist works was Charles Rennie Mackintosh's designed-and-built Glasgow School of Art (1896), plus its library wing (1907–9). Reported in detail in The Studio magazine, his ideas was lapped up abroad, and were an absolutely fundamental influence on the Vienna Sezession of 1897. Fame at home came later, as usual.

In Europe, Sezession encompassed those Austrian and German artists who resigned from the academies to promote newer ideas, often – but not always – the result of Impressionism. Munich, Vienna and Berlin had their secessions in 1892, 1897 and 1899 respectively, in the latter case headed by *Max LIEBERMANN* (1847–1935), promoter of the Barbizon School and fundamental in spreading Impressionist ideas in Berlin.

Today we tend to think of Secession as synonymous with other, major art movements of the period. For example, Art Nouveau inspired the Scot, *Charles Rennie MACKINTOSH* (1868–1928), which led to Jugendstijl (Youth-style) in Austro-Hungary. Paintings and posters by artists such as *Gustav KLIMT* (1862–1918) or the Franco-Slav *Alphonse MUCHA* (1860–1939) still typify the movement for many, not always accurately. As if this wasn't enough, the original Secessionists were found wanting by a second wave of artists, developing Expressionist idioms among exhibiting societies in Dresden (*Die Brücke: The Bridge*, 1905) and Munich (*Der Blaue Reiter: The Blue Rider*, 1911). There, many great names forged their careers. *Wassily KANDINSKY*-the-spiritual (1866–1944), libidinous *Ernst Ludwig KIRCHNER* (1880–1938), religiously nutty Nazi *Emil NOLDE* (1867–1958), *Franz MARC*-the-animal-lover (1880–1916) ...all carved their initials here – literally in the case of *Die Brücke*, since engraving and printmaking were major elements in that group's world's-eye-view of things. These independent eyes would prove to be the soothsayers of the world to come.

Two Skeletons Fighting Over a Dead Man, James Ensor, 1891, Koninglijk Museum voor Schone Kunsten, Antwerp. Ensor (1869–1949), a one-man secession, moved from Impressionism, via Expressionism, to Surrealism, producing some disturbing works along the way.

1870 John D. Rockefeller (1839–1937) founds the Standard Oil Company, better known as Esso. Fossil fuels replace horsepower.

1883 Brooklyn Bridge is opened for traffic.

1890 American surgeon William Stewart Halsted (1852–1922) introduced rubber gloves into the operating theatre, pioneering aseptic surgery.

1897~1917

AshCan: Knockout
Urban Realism on the Streets of New York

Whammo! The AshCan School was the American equivalent of Secession, if ever there was one. Respectively, the AshCanasi were William GLACKENS (1870–1938), Robert HENRI (1865–1929), Georg LUKS (1866–1933), Everett SHINN (1876–1953), John SLOAN (1871–1951) and late arrival George BELLOWS (1882–1925), and they trumpeted urban realism in the USA as never before, from 1897 to 1917. New York, New York was a wonderful town for the AshCan-ites, but at street level only. That towering feeling would have to wait a few years.

Anti-nature dramatic heavy duty framing device integral to image

Airy, insubstantial background blends with big city heat haze

Solid, stark foreground; figures in an urban wasteland

Blue Mornings, George Bellows, 1909, Private Collection. Vigorous, muscular, manly, All-American painting; Bellows originally trained to be a baseball player.

shCan was no more a 'School' than French Realism, and it was just as diverse. It's been accurately described as a case of 'Six Artists: Six Voices', and although their individual, vivid representations of the New York scene occasionally verge on the illustrative and brash, they are always exciting, even when they don't get it quite right: they were exceptional talents. Bellows – the Manet of them all – was a late arrival, but his

waterfront and the boxing ring scenes are intimate areas of excruciating clamour and – in the latter case – exquisite pain. With Sloan, who might have been an American prototype for the sleazy Berlin sidewalks later painted by *Ernst Ludwig KIRCHNER*, Bellows cornered the portrayal of middle-

1900 New York City is the second largest in the world with a population of 3.6 million.

1903 Richard Steiff invents the Teddy Bear, named after Theodore 'Teddy' Roosevelt (1815–1919), 20th President of the USA.

1905 Neon light signs invented. Bright lights, big city.

New York, New York

The City that Never Sleeps is a concept of New York developed by the AshCan artists, and one that Americans – unlike their French counterparts – were keen to support. AshCan shows were generally received with interest at the very least. A critique of Shinn's work might stand as a description of his colleagues' work too, as the embodiment of '...the real actualism of the street, of its scurry and bustle, of its rush and hustle...that tide of life that makes those who both know and love the city feel that it is a sentient thing'.

class life; they apparently share many of their street themes with the embryonic Italian Futurists. Sloan's drawings are superb, and should be compared (at this period) with those of the soon-to-be sculptor *Jacob EPSTEIN* (1880–1951). As for Henri, it was a case of 'few and memorable': his portraits of back-street 'types' would represent New York for years.

BIG APPLE

As everyone knows, New York at this time was a melting-pot for every race and nation under the sun, and the back-street life painted by Luks and Shinn brilliantly expressed this feature of the city, in every kind of weather. As for Glackens, his candidacy as the American representative of Whistler, Degas & Co seems assured; in London his opposite number is *Walter Richard SICKERT* (1860–1942) who shares his interest in low-life and the music halls. Verdict: the earliest, vital, vivid, vibrant period of US art. See next decade's equally exciting instalment.

New York Street under the Snow, Robert Henri, 1902, N.G., Washington DC. Henri (real name Robert Henry Cozad) went to Paris and was obviously much impressed.

1899 Aspirin invented by German pharmaceutical company Bayer AG.

1900 Count Ferdinand von Zeppelin (1838–1917) launches his first dirigible airship.

1900 Colette (Sidonie-Gabrielle) (1873–1954), writer, mime artist and stripteaser writes Claudine à l'Ecole/Claudine at School, the first of four novels based on her own life.

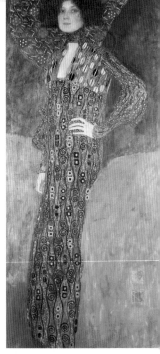

1860~1918
Gilt and Obsession
Klimt and Schiele

Gustav KLIMT (1862–1918) thought and painted big. From 1897 until 1904 he was a major member of the Vienna Secession, and, from then on, the undisguised eroticism of his art made waves across central Europe. Take The Kiss (1907–8, Vienna) for example. However you see it, it's a major twentieth-century artwork. Most of Klimt's Secessionist pictures carry this amount of gold leaf and decoration: they're throwbacks to his father's profession as a goldsmith, and his own early training in mosaics. K. adored the idea of combining the fine and the decorative arts, and concealed beneath those shimmering surfaces is great drawing: he was as good with the graphite as he was with the ladies.

Emilie Floege, Gustave Klimt, 1902, Historisches Museum der Stadt, Vienna. Klimt's mistress, bewitching in shimmering paint, as sparkling a seductress as ever was.

W hich was what he was all about. Klimt's painting exploits the sensual mysteries of sex and carnality, as modelled by his mistress, Emilie Floege. From the first *Judith* (1901, Osterreichische Galerie, Vienna), through several stylistic changes, Klimt confronts us with That Subject, just as he did his own Viennese contemporaries. Among these was *Sigmund FREUD* (1865–1939), six years his senior. Did Sigmund ever write about the way that Judith's breathy, parted lips and gilt-laden costume ill-become a murderess? Did he compare her with Klimt's next version, a highly-patterned, frenetic image of the same subject (1909) (sometimes both are called Salome)? Did he? Dream on.

Unfortunately, from about 1900 nearly everything Klimt did attracted flak. In 1904 he withdrew from a mural scheme for the University of Vienna after a bitter five-year wrangle with the morals of authority. In the years before the stroke which led to

1904 New York police arrest a woman for smoking in the street.

1904 Frank Wedekind (1864–1918), German dramatist, writes Pandora's Box, an update on the Greek myth about the meddlesome nymph who opened the box and unleashed all the troubles in the world. It is the basis for Alban Berg's opera Lulu (1929–1935).

1910 The craze for the tango, and Argentinian dance, sweeps the USA and Europe.

his early death, he became increasingly isolated, while remaining a real inspiration to friends and to younger artists.

FULL-FRONTAL SCHIELE

Among these was *Egon SCHIELE* (1890–1918), whom he met in 1907. Take care not to bracket them together. Schiele was an extraordinary, expressive draughtsman, but his work is perhaps best described as gross neurotic pornography: flagrant, full-frontal nudity that we view despite ourselves. As 'Unhinged Art About Sex', it's too often irrational, occupying a lunatic fringe never entered by Munch or Klimt, or any of the later Expressionists, even in their darkest, most cynical moments.

The Vienna Secession

The first exhibition of the Vienna Secession was held in 1898, with Klimt as its first President. Arranged by the architects Hoffmann and Olbrich, the show is the first of its kind in Vienna, with pictures at eye-level only, an international section including Rodin, and a strong selection of graphics, architectural designs, sculpture and applied art. Klimt attracts censure for his poster of a full-frontal Theseus, which he is forced to hide behind a tree-trunk for modesty's sake. In its lifetime, the Secession will be an annual event of major artistic importance throughout Europe, resulting in considerable commercial and artistic success.

Excellent figure drawing combining accuracy, fragility and directness

Texture of skin and hair typical of Schiele's work

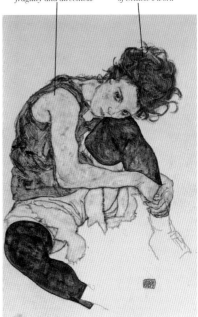

Seated Woman with Bent Knee, Egon Schiele, 1917, Narodni Galerie, Prague. Casually provocative pose, curiously modern clothes, one of Schiele's many erotically charged young women.

1886 Robert Louis Stevenson (1850–94) writes Dr Jekyll and Mr Hyde.

1894 Baron Coubertin founds the committee to organize the modern version of the Olympic Games; the first games are held in 1896.

1895 King Camp Gillette (1855–1932) invents the safety razor.

1870~1914
Some Crystal Balls
Les Nabis: the Prophets

The Dining Room in the Country, Pierre Bonnard, 1913, Minneapolis Society of Fine Arts. A beautiful Fauve warm interior with an airy scene outside.

Les Nabis. As a group they last from c.1889–1899, and include Odilon REDON (1840–1916), Pierre BONNARD (1867–1947), Edouard VUILLARD (1868–1940) and Maurice DENIS (1870–1943). Later the sculptor Aristide MAILLOL (1861–1944) is an ally. But the initial, fundamental pairing is that of Paul SERUSIER (1864–1927) and Emile BERNARD (1868–1941), who forge the group's philosophy direct from the famous one-off tutorial that Paul Gauguin gives Serusier at Pont-Aven in 1888… 'OK', says Gauguin. 'How do you see those trees? They are yellow? Well, paint them yellow. The shadow is bluish? Make it pure ultramarine. …Red leaves? Use vermilion'. Serusier's cigar box top, The Landscape at the Bois d'Amour aka The Talisman (1888) follows, and even Gauguin is impressed. They launch a new style, Synthetism (or Cloisonisme or Symbolism), which rejects Impressionism for a more spiritual art, where colours are dominant within heavy black borders.

Maurice Denis (a better writer than he ever was a painter) sums up the idea memorably: 'Remember that a picture, before being a horse, a nude or some kind of anecdote, is essentially a flat surface covered with colours assembled in a certain order'. Prophetic? The Art-Telegraph runs red-hot in Secession-ridden Europe. One look at 'King' Klimt's painting shows how fast he gets the message. But like every group, including the very Impressionists whose work they so dislike, the Nabis are individuals. They use the process of Synthetism to improve their own work.

1901 Guglielmo Marconi (1874–1937) sends radio signals across the Atlantic from Cornwall to Newfoundland.

1909 Bakelite invented by Belgian-born American chemist Leo Hendrik Baekeland (1863–1944); the dawn of the Plastic Age.

1907 The first daily comic strip (Mutt and Jeff) appears in the San Francisco Chronicle.

THE FRAME NAMES IN

Gustave Moreau *(1826–1944), arch Symbolist painter, whose statement 'I believe only in what I do not see, and wholly in what I feel' says just about everything...*

The Femme Fatale as she appears in every art-form of the period, from Ibsen to Munch to Wagner to Klimt...

The young painters **Wassily Kandinsky** *(1866–1944),* **Kasimir Malevich** *(1878–1935) and* **Piet Mondrian** *(1872–1944), who could not have functioned without Symbolism, and who later changed the world as a result.*

" ☆ "
International Symbolism

Symbolism was absolutely vital to late nineteenth-century artists in every country, and to the development of twentieth-century art. Its ideas, which were essentially those of the poets Paul Verlaine (1844–96) and Stéphane Mallarmé, and of the writer J. K. Huysmans (1848–1907), enabled them to make images of the 'real' world without having to refer to 'perceived phenomena' – what we would call 'Nature' – which they saw as unreal because of its process through the retina. If we follow this idea all the way, we see the gradual emergence of abstract art.

Redon is very influenced by Gauguin, but – unlike the anti-naturalistic work of the younger Nabis – his art reveals an imagined world, influenced by literature (especially Poe and Baudelaire), natural sciences and philosophy. With a backward nod to Romanticism, Redon's interests propel the Nabis much further intellectually, and so usefully prolong the group's life as an art 'movement'.

Bonnard, Vuillard and Redon are now the best known of the Nabis. B. and V.'s own style, Intimisme, has lasted well:

small, quiet pictures of the small, quiet moments in a day, in deep, often lamp-lit, fragmented colours. Bonnard moves on, to larger, masterly canvases of nudes bathing, which occupy him for years, and which must be compared with Matisse's work.

Typical intimate setting; a room which someone has just left for a moment

Details of ordinary domestic life given a special significance

Glowing light source in patchy paint strokes typical of Vuillard

Softer background colours correspond and give depth

Interior with Madame Vuillard, Edouard Vuillard, 1895, Christie's, London. One of V.s many intimate scenes of quiet domestic bliss featuring his mother or his sister.

1883 Buffalo Bill (William Frederick Cody, 1846–1917) took his Cowboy and Indian extravaganza, The Wild West Show, on the road.

1884 George Eastman (1854–1932) invented photographic film; the holiday snap is born.

1898 Marie (1867–1934) et Pierre (1859–1906) Curie, the radiant couple, discover polonium and radium.

1870~1914
The Wild Ones
Fauvism

You can't trust anyone with a tube of red paint nowadays, least of all Maurice VLAMINCK (1876–1958). Leave that man alone in a studio for five minutes and he'll squirt vermilion straight onto the canvas; no subtlety at all. And his friends are as bad. Henri MATISSE (1869–1954) is easily the worst of the lot. As for André DERAIN (1887–1954), Albert MARQUET (1875–1947), Georges BRAQUE (1882–1963), Raoul DUFY (1877–1953), and Georges ROUAULT (1871–1958), they're a mixed bag but just as loud. Animals, every one.

Spring Sunlight beside the Seine, Maurice de Vlaminck, 1906, Galerie Daniel Malingue, Paris. April is the cruellest month. Harsh, expressive treatment in broad brushstrokes.

L es Fauves gained their nickname and their reputation at the 1905 Salon d'Automne exhibition in Paris, from the art critic Louis Vauxcelles, later – reputedly – the originator of the term Cubism. Fauve means 'wild beast' and has as much to do with the group's vivid, flattened colour-schemes and their disfigured images as with the fact that Vauxcelles found their work sharing a room with some pseudo-Renaissance sculptures. Although Matisse became their willing leader, the group came together gradually, and were never really coherent, even in their 1905–1908 heyday. Gauguin was an early god. Some had toyed with pure colours in their painting since the late 1890s. Some were

more openly against the Academy system than others. Some – including Matisse himself – experimented with pointillisme. And the big 1901 Van Gogh retrospective in Paris was the ultimate European colourfest, for Fauves and future German Expressionists alike. Vlaminck swore he was the original Fauve and did his worst to prove it. Dufy joined late and was happiest (and best) in the Seine Valley, at or near Le Havre, where the splendid, nowadays neglected, Marquet worked with him from time to time. And Braque: he was breaking out the rope and crampons ready for that long, mountainous climb he was about to make with Picasso. Make no mistake about it: no Fauves = no Cubists.

1901 Fingerprint system introduced to England. It was first used in India.

1905 The exhibiting society Die Brücke (The Bridge) is founded in Dresden by Ernst Ludwig Kirchner, Karl Schmidt-Ruloff and Erich Heckel. It takes its cue from the Fauves but is Northern Expressionist in character.

1906 The San Francisco earthquake; 700 are killed.

But if you need to name the two artists whose work truly represents Fauvism at its best, then Derain and Matisse are your men. In Summer 1905 Matisse and Derain head for Collioure on the Mediterranean. Here they execute the truest Fauve canvases. It is hardly surprising that, later, Derain heads for London, where he brilliantly out-Monets late Monet in thrilling sun-drenched, colour-sodden paintings, the apex of his career. Matisse? That's another story.

Wild beasts in harmony

The relationship between Derain and Vlaminck was at least as important for Fauvism as that of Picasso and Braque was for Cubism. D. and V. met at Chatou, on the River Seine. It was like gospel music: call and response. One would 'call' to the other in his work, and the other would be forced to respond. Vlaminck was determined that Fauvism was his to command. Le fauvisme, c'est lui. 'What Fauvism is? It's me. It's the manner I had in those days, the way I revolted and set myself free all at once, the way I broke away from the School, from bondage: my blues, my reds, my yellows, my pure unmixed colours. As for Derain, he must have caught the infection from me.'

THE FRAME — NAMES IN THE FRAME

Let's hear it for all those Fauves who always seem to go without a mention but are perfectly good enough to make an appearance: from Holland the Paris-based **Kees van Dongen** *(1877–1968), who favoured nudes, especially female ones, and from France landscapist* **Othon Friesz** *(1879–1949),* **Henri Marguin** *(1875–1947),* **Louis Valtat** *(1869–1955) and the undecided pointillist* **Henri Edmond Cross** *(real name Delacroix) (1856–1910).*

Houses of Parliament, André Derain, 1905, Private Collection. Le Big Ben, wonderful in a 'red sails in the sunset' setting, a masterpiece of Fauve painting and among the best of D.'s London pictures.

Colour theories courtesy of Seurat – but contrast and complementaries are easier to spot: they shine

Note the difference between overlaid, contrasting colours on tower and streaky brushstrokes on bridge, letting in light on the right of the picture

Stubby streaks of paint typical of the open treatment used by most Fauves

1871 Phileas Taylor Barnum (1810–91) opens The Greatest Show on Earth in Brooklyn, New York; there's one born every minute. The show travels the country in 100 railway carriages.

1873 Lawn Tennis invented by the British Major W.C. Wingfield; he called it Sphairistike (a Greek coining meaning Battle of the Balls).

1888 The first ever beauty contest is held in Spa, Belgium.

1890~1950
Matisse
He fought the law

Henri Matisse, the king of colour.

On paper Henri MATISSE (1869–1954) had done the business around 1905 when he led the Fauves to fame and notoriety. Those ladies in red. The lurid greens and yellows. The stark, strong, startling brushstrokes. But this was an important passing phase. In fact, the title of one of his more uncharacteristic paintings – an early-ish pointilliste composition entitled Luxe, Calme et Volupté (Luxurious, Calm and Delightful), (1904, Museé d'Orsay) – is just about as all-embracing a description of Matisse's painting as one could have. And that phrase – 'all-embracing' – is the key to Matisse's art and life. He wanted his paintings to be 'complete' in every respect. To achieve a total unity, in which the rules were made by the artist and no-one else. In later years he also said that he thought good painting should be like an easy chair, and the means to that comfort was expression, which could come only from the use of colour to portray life. His career supports this idea, and if a look at his colours leads you to believe that you've another madman on your hands…wrong; M. may not have it all worked out, but he's close.

As a reluctant law student with artistic longings recovering from appendicitis in 1888, Matisse convinced his father that school was O.U.T., unless it was Art School. M. père gave in, and sent Henri to the studio of the fashionable-but-fusty academic painter *Adolphe BOUGUEREAU* (1825–1905). Not a success. In 1892 Matisse became an unofficial pupil of *Gustave MOREAU* (1826–98), who told him to copy Old Masters, to draw in the Paris

Russian Roulette

Matisse was fortunate in his patrons. The Stein family – especially Gertrude – encouraged him, bought pictures from him, and recommended him. His greatest successes came with his commissions from Russia: Counts Schukin and Morisov became his best patrons, but the best type also: tolerant and considerate – which is why so many great Matisse paintings are in St Petersburg.

1903 The first Tour de France bicycle race. It is won by Maurice Gerin, who gets to wear the first maillot jaune.

1908-10 New Orleans becomes the world centre of jazz.

1911 Sergei Diaghilev (1872–1929) commissions Petruschka from Igor Stravinsky (1882–1971) for the Ballets Russes.

The Dance, Henri Matisse, 1909–10, Hermitage, St Petersburg. A hymn to rhythm but not a million miles from Cubism. Contrasting colours pared down to a minimum to focus on the dance itself. Figures seen from all directions to offer 3D possibilities to the viewer.

streets from life and, from that, learn to go his own way. The education of this Wild Beast was complemented by a thorough understanding of prickly, don't-call-me-an-impressionist CÉZANNE (1839–1906), and a visit to Algeria in 1906 which convinced him that colour was king.

THE FRAME — NAMES IN

André Derain (1880–1954), who was Matisse's companion in Collioure in 1905 and who was as much responsible for Fauvism as a result – forget big-mouth **Vlaminck** (1876–1968): he was telling whoppers…**Renoir** (1841–1919), who loved the sun and painted there…and everyone else attracted to the Provençal town of Vence in later years: **Picasso** (1881–1973), **Chagall** (1887–1985) and all the rest.

TOTAL ART

Matisse's work in all media – painting, paper cut-outs or sculpture – is a series of fanfares to harmony. Pattern, colour; every stroke is laid on the working surface with feeling, with a purpose. Even the most severely abstract images are sound. It isn't tight: it's controlled, and it's a real antidote to the noisy caperings of Matisse's posturing contemporary PICASSO. No fidgeting here. Calm, delightful, luxurious indeed.

Dance Away

In 1909 Count Schukin commissioned three large decorative panels for his Moscow palace, one of them the famous Dance. It was intended for the first floor, and Matisse drew his subject from folk dances in Collioure. The image is more than the essence of dance: it is of life itself, and the pure colours used support that sensation.

1875 Captain Matthew Webb swims the English Channel in August. It takes 21 hours 45 minutes from Dover to Cap Gris Nez.

1884 Lewis Edson Waterman (1837–1901) patents the fountain pen, which contains its own ink reservoir. Dip pens become obsolete.

1901-10 Manhatten Bridge, New York, built. In 1907, an unsurpassed number of migrants (1¼ million) entered the USA, to stream, metaphorically, across the bridge to a new world.

1880~1940

From a Kiss to a Scream: Crisis in Sculpture
Brancusi to Giacometti

Auguste RODIN (1840–1917) was nineteenth-century Europe's best sculptor: no mistake, a megatalent, a magician able to breathe life into bronze or stone, but his major projects were misunderstood and mistreated by the French authorities, and the critics hammered (ouch) the work along the way. Such treatment linked Rodin with the Impressionists, but beware; although Rodin wasn't what you'd call an establishment figure, it's not a sensible connection to make. His range is illustrated by his beautiful Kiss (1901–4, Tate Gallery, London, others elsewhere), and by his powerful character-study of the outspoken writer Balzac (1891–1917, Musée Rodin, Paris). R.'s habit of leaving large and small figures purposely unfinished was a clay modeller's mannerism, not a carver's, and these suggestive fragments were important for many later sculptors, including the charismatic Romanian Constantin BRANCUSI (1876–1957).

As a newcomer in Paris c.1904, Brancusi soon found his own level, though a statement of his from 1927, that '…art must give suddenly, all at once, the shock of life, the sensation of breathing…', shows how highly he still rated Rodin. Brancusi himself carved at least four sculptures, a world away from Rodin's, but also called *The Kiss* (1907/8–1930s), which became simpler as they evolved, until their final form (1937/8) at Tirgu Jiu, a Romanian war memorial site near Brancusi's

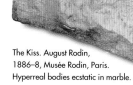

The Kiss. August Rodin, 1886–8, Musée Rodin, Paris. Hyperreal bodies ecstatic in marble.

1910 The combine harvester dominates the US wheatlands.

1912 The unsinkable Titanic sinks off Newfoundland on its maiden voyage; 1,513 people are lost.

1913 The zip fastener (patented by Whitcomb Judson in 1891 as a fastener for shoes) becomes popular on other apparel.

birthplace, where they assume a calm expression of elemental love. Also there, his *Endless Column* was erected in 1938: a candy-stick in bronze 87 ft/29 m high, and his greatest achievement. Don't overlook 'truth to material', a concept vital to the Brancusi mystique, but not unique to it, in which polished bronze, selected stones or wood suggest particular animal and body shapes of all sizes. As for recent notions of Brancusi-as-Shaman, these may be hard to swallow at first, but bang that drum and see where it leads you... Perhaps to *Germaine RICHIER* (1904–59) whose sinister, crossover human–animal ideas are nowadays drowned out by the crackly static surrounding *Alberto GIACOMETTI* (1901–66), sometime-Surrealist loner whose spindly figures seduce and fascinate, but which are the stuff of obsession. It isn't healthy.

Remember Lithuanian *Jacques LIPCHITZ* (1891–1973), a Cubist sculptor tough enough to tell Picasso where to get off, and *Ossip ZADKINE* (1890–1967), whose monument *Destroyed City* (1953–4) still screams along Rotterdam's waterfront.

Stylish linear elements can make Cubist sculpture more accessible than some paintings

The appearance of a reversed image; compare with Braque

The Reader, Jacques Lipchitz, Private Collection. Cubism made real in real 3D.

Filthy Sculptures?

Brancusi's purified folk-art forms were the subject of a celebrated court case in the USA during 1926–8, when US Customs not only refused to accept them as art, but also suggested that they were obscene. Amazing how a curvey, polished bronze can turn an Excise Man's brains...

A Perfect Form

In 1877, when Rodin's Age of Bronze is first exhibited, French critics start the rumour that it has been cast from a human form. It hasn't, it's just Rodin being a great anatomist. The sculpture doesn't gain any proper notice until exhibited in 1884.

THE FRAME — NAMES IN THE FRAME

Between the 1880s and the 1960s the human figure also got the full treatment from the likes of **Pierre-Auguste Renoir** *(1841–1919),* **Edgar Degas** *(1834–1917),* **Aristide Maillol** *(1861–1944),* **Henri Matisse** *(1869–1954),* **Alexander Archipenko** *(1887–1964) and* **Henri Laurens** *(1885–1954).*

1903 Russian Prince Peter Kropotkin (1842–1921), anarchist and geologist, publishes Modern Science and Anarchism. Society falls apart.

1906 Allergies discovered by French physiologist Charles Robert Richet (1850–1935). Human beings no longer compatible with the world they have made.

1905–8 The Blues, expressions of despair at the miserable state of the human condition, gains popularity.

1905 ~ 1914
Things Fall Apart
Cubism

By 1910, Cubism was The Next Big Thing. Younger French painters were buzzing like flies round the Cubist jam-jar, but to little effect; only Fernand LÉGER (1881–1955), Juan GRIS (1887–1927) and Roger DELAUNAY (1885–1941) had anything worth saying. Orphic Cubism is Delaunay's claim to fame, and it is not without its rather imaginative aspects. This left Picasso, Braque, Léger and Gris, the 'Big Four' of Cubism. All went through the famous three periods in which Cubism

Smokers, Fernand Léger, 1911–12, Guggenheim Museum, New York. Still recognizably puffing, but not for long.

developed: Scientific (1907–1909/10), Analytical (1910–1911) and Synthetic (1911–1913/4... but everyone will give you different dates). That said, Gris and Léger didn't share the mountaineering habits of their new colleagues, and certainly couldn't match the Founders' exclusivity when it came to exhibiting. Gris's early death deprived Cubism of a major talent. Léger would make the machine age his own, brilliantly.

And that term Cubism? It was first popularized by the painters *Albert GLEIZES* (1881–1953) and *Jean METZINGER* (1883–1956) in their book *Du Cubisme* (1912; translated into English 1913). G. & M. weren't bad painters, but having nailed their colours to the Cubist masthead they just couldn't hack it with Picasso; they didn't fully understand him. Derain (who didn't stay long) was also named in *Du Cubisme*, along with the lady Fauve, Marie Laurencin, plus the whacky deviants *Francis PICABIA* (1879–1953) and *Marcel DUCHAMP* (1887–1968), and Duchamp's sculptor brother, *Raymond Duchamp VILLON* (1876–1918; another war casualty).

So many artists were trying to describe visual reality without using the special effects department that sooner or later someone was bound to come up with the idea of pasting things onto canvas: *papier collé* or collage. Picasso stuck chair-caning

1911 Ernest Rutherford (1871–1937) evolves his nuclear theory. The atom no longer the smallest fragment in the world. Scientific certainty falls apart.

1912 The theory of continental drift is put forward by German geologist Alfred Lothar Wegener (1880–1930). The Earth falls apart.

to a canvas in 1912. Braque followed with wallpaper. All manner of meanings were intended. Newsprint came next. Then numbers written onto the picture surface. Shapes and images are over-drawn. Everything becomes complex. On the basis of such foment, it's hardly surprising that the Italian Futurists sneaked out with enough visual ideas to launch their movement from *Le Figaro* in 1909.

THE FRAME NAMES IN

In the first wave **le Fauconnier,** *minor Cubist rated by* **Gleizes** *and* **Metzinger**... **de la Fresnaye,** *ditto, interesting, evocative but ultimately decorative...* **Lhote,** *more of the same...* **de Segonzac**...*and again. And later we include such luminaries as* **Amédée Ozenfant** *(1886–1966) and the architect* **Le Corbusier** *(aka Charles Jeanneret, 1887–1965), both of whom used Cubist ideas in decorative ways.*

G.B. is about to dump landscape in favour of all those still-lifes. Have a good look. He won't paint Paris's famous hilltop, or anywhere else, until 1928–9.

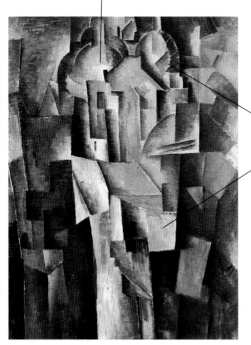

Le Sacre-Coeur de Montmartre, Georges Braque, 1910. The well-known Paris landmark deconstructed in the Cubist mode, but still eerily recognizable.

The famous Sacre-Coeur, seen this way and that in a tentative Cubist composition

G.B.'s stylish attempt to convey the depth of Parisian streets and the tall apartment blocks

1912: A Definitive Year

Gleizes and Metzinger are writing history (their own, with themselves writ large) and Apollinaire is doing likewise, except that he calls his The Cubist Painters. That same year Roger Fry (inventor of the term Post-Impressionism) holds his Second Post-Impressionist Exhibition at London's Grafton Gallery, in which Picasso is seen for the first time in England. The English are not turned on.

War Work

The work executed by Léger on his furloughs from the Western Front (c.1915–17) would be dubbed 'Tube-ism' by unkind critics. As an artilleryman helping to destroy what was left of the First Machine Age, Léger was fascinated by the smooth, cylindrical new shapes around him, and quite probably painted the first really abstract canvas.

1901–4 Picasso works through his Blue period; paintings and etchings focus on the struggles of the poor and the predominant colour is blue.

1913 Igor Stravinsky (1882–1971) composes the controversial ballet The Rite of Spring

1913–27 Marcel Proust (1871–1922) writes A la Recherche du Temps Perdu /Remembrance of Things Past, a series of novels chronicling his own life and emotions in minute detail.

1880~1970

Picasso
Love him or hate him

Flattened hand, flattened background, but space still uncertain —

Without Pablo Ruiz y PICASSO (1881–1973), modern art simply wouldn't be the same. You liked it as it was? You're not alone. Alas, we can't turn back the clock, but let's give this legendary, lecherous old goat a break…

Picasso's take on a traditional African mask.

At his best, Picasso made tidal waves. Even if you (rightly) question his strange grip on European art from 1910–1950, please accept that Picasso's greatest and longest moment in art history was the period 1905–1914. A worried man, isolated in his fears for the development of European painting, he dared address the single, most direct question then plaguing the art of his own epoch. Broadly speaking, this was 'A fine mess we've got ourselves into. And where the hell do we go from here?' He then went off alone in search of the answer.

Picasso challenged accepted scientific beliefs about art, and about painting in particular – Renaissance bastions which Manet, Impressionism or the Fauves had battered but not overturned. For Matisse, colour harmony and decoration were enough to tell a story or suggest a mood. Picasso dismissed this and instead enlarged on Cézanne's investigations of form and

space. Using the conventional, flat, two-dimensional surface of a stretched canvas, he tried to indicate all volumes of an object in space, and its inter-relationship with other objects, without being decorative. If you think of Impressionism as a hall of mirrors, then watch the glass shatter after Picasso's attentions. Initially, he limited his colours to earth tones: hence the

The only reference to conventional representation is the basket of fruit ⁄

Cubism? What Cubism?

It's important to understand that neither Picasso nor Braque ever exhibited their so-called Cubist work publicly: it was sold, and privately, by their dealer Daniel Kahnweiler. Nor did either man refer in writing to 'Cubism' for some years after the event. It was probably the first great example of 'talking up' a style of painting. All the best people are buying Cubism this year, Sir…

1913 The sell-out Armory Show introduces Post-Impressionism and Cubism to the art aficionados of New York. It is a great success.

1924 Clarence Birdseye (1886–1956) invents frozen foods as a result of his experiences as a fur trader in Labrador.

1937 Picasso paints Guernica, probably his most famous painting; it is an expression of his anger and disgust at the cruelty of war.

This face, like the one above it, probably reflects Picasso's interest in African masks

Les Demoiselles d'Avignon, Pablo Picasso, 1907, Museum of Modern Art, New York. Probably the most revolutionary painting in twentieth-century art.

murky, forbidding paintings we know today. He also used his new interest in African masks to depart from older ideals of beauty. It was heady stuff, and still is. We call it Cubism, although P. didn't.

Picasso's most famous painting was the starting point for Cubism: the radical, brothel-based *Les Demoiselles d'Avignon* (1907, MOMA, NY), painted over two years and unseen until Picasso showed it to Georges Braque (1882–1963), his ideological conspirator. Braque's most famous comment about his relationship with Picasso at this time was that they were like 'two mountaineers, roped together'. They goaded each other on, the one daring the other to jump newer, more dangerous artistic precipices. Although their association had to end, please handle with care. An interesting, but absolutely valid, standpoint is to suggest Picasso as the Ideas Man, and Braque as the Better Painter. Watch them go critical when you say it, but stand your ground.

1886 Friedrich Wilhelm Nietzsche (1844–1900), inventor of the übermensch (superman), annnounces the death of God in Beyond Good and Evil.

1890 Kaiser Wilhelm II dismisses his chancellor Otto von Bismarck (1815–98); all B.'s careful alliances lapse, paving the way for world war.

1895 Wilhelm Röntgen (1845–1923) discovers x-rays. Medical diagnosis revolutionized.

" ☆ "

True Blue

Kandinsky reputedly said that Der Blaue Reiter was so-called because he liked the colour blue, and Franz Marc liked horses. Do you believe in fairies too?

1880~1940s

Apocalypse Then
German Expressionism

Blame it on Vincent and Munch. In Germany and Scandinavia Munch was as big as Cézanne in France. He paved the way for a new Northern art built on the psyche. Expressionism paralleled Fauvism in its overall colour scheme and outlook: the Dresden group Die Brücke (The Bridge) was even formed in 1905, the year the Fauves painted Paris red. Die Brücke comprised Ernst Ludwig KIRCHNER (1880–1938), Erich HECKEL (1883–1970), and Karl SCHMIDT-ROTLUFF (1884–1976), heart-and-soul Bohemians to a man. Even Emil NOLDE (1867–1956) joined, but when these kinder weren't mystical enough for him, he left. The art of the Vienna Secession went out with the bathwasser, and the Expressionists turned back to Grünewald for inspiration.

Coincidence? Not. Even if Kirchner, leader of this happy band, did pre-date some of his work to make it look as if it and Fauvism appeared simultaneously, Expressionism and Fauvism are absolutely different. Where the French combined expression and harmony, the Germans denied that relationship; for them, emotion was always going to be a big deal, and with colour they would control the art world. In paint or wood-engraving, every Brücke member carried that idea forward. When – after intensive contact with Matisse –

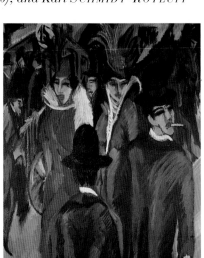

Berlin Street Scene, Ernst Ludwig Kirchner, 1913, Brücke Museum. Harsh lighting and slashing strokes of uncomfortable colour result in an anti-social picture.

1896 Rudolf Diesel (1858–1913) invents the engine named after him.

1905 The Cullinan diamond discovered – the largest diamond (over 3,000 carats) found to that date.

1912 The first human parachute jump; in 1785 balloonist Jean-Pierre Blanchard had experimented with parachutes for dogs.

Woman by the Sea, Erich Heckel, Lehmbruck Museum. Heckel was terminally affected by the restless, febrile lines and colours of van Gogh and Munch. And is that a broken Mont Ste Victoire in the background?

Crudely painted features suggest influence of other expressionist painters, but also African masks

Wassily KANDINSKY (1866–1944) helped to found *Der Blaue Reiter* group in Munich in 1911, he emphasized the part of colour in providing musical harmony and mystical fusion. A committed spiritualist, these were his interests, and he used them to blot out the neurotic posturings of *Die Brücke*.

Daring to be full frontal: harsh treatment common among all Expressionist work of the time

Swift, loaded, crude brushstrokes, as unfeminine as they come

KINDRED SPIRITUALISTS

Kandinsky found a totally kindred spirit in *Franz* MARC (1880–1916), a sensitive painter who summed up the world in visions of animals. When Marc was killed at Verdun, Kandinsky was inconsolable: neither his German Fauviste 'companion' *Gabriele* MUNTER (1877–1962), nor his German-Swiss colleague *Paul* KLEE (1879–1940) could replace the lost Marc. Nevertheless, Klee and Kandinsky were a very major item in European art until Klee's own demise. Before 1914 *Ludwig* MEIDNER (1884–1966) played chief German antidote to Kandinsky: he projected his own fearful imaginings of German civil strife onto an apocalyptic setting. In local terms Meidner was wrong. Internationally he was spot on.

THE FRAME — NAMES IN

NAMES IN

Gabriele Munter *(1877–1962), soulmate to Kandinsky for a few years, and* **Paula Modersohn Becker** *(1876–1907) might not have been quintessential Expressionists, but they could take on the boys any time. They enjoy cult status today, and with reason.* **Alexei von Jawlensky** *(1864–1971) was a major and reliable courier on the Fauve–Expressionist axis, and a good painter too: another cult artist...and the woodcuts of* **Auguste Macke** *(1887–1914), early victim of World War I, are now enjoying a deserved renaissance.*

THE FRAME — NAMES IN

NAMES IN — THE FRAME

1897 John Philip Sousa (1854–1932), the March King, writes The Stars and Stripes Forever for the Marines.

1902 Enrico Caruso (1873–1921) makes his first recording.

1905 Achille-Claude Debussy (1862–1918) writes his orchestral piece, La Mer.

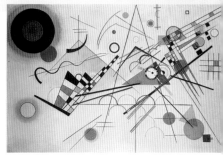

1900~1933

Sweet Soul Music
Kandinsky and Klee

You wouldn't think that the Russian ex-attorney Wassily KANDINSKY *(1866–1944) and the Swiss painter-etcher Paul* KLEE *(1879–1940) had much in common. It's true that their paintings don't; but they do. Kandinsky's artistic transition from fiery Fauve to ordered intellectual bears little relation to Klee's bad case of Jugendstijl blues, followed by a prismatic hangover. But this odd couple are one of modern art's great pairings. Like beautiful planets they orbit the same solar system, regularly meeting and parting, first briefly in Munich around 1898, and then regularly after 1912, when Klee shows work with Der Blaue Reiter, the group Kandinsky co-founded. Friendship follows. Kandinsky's famous book* Concerning the Spiritual in Art *(1911), full of evangelistic spiritualism and far-reaching theories about the psychological effect of colour on the senses, is of great interest to Klee. Kandinsky equates colour and music, says that one should be able to 'hear' pictures and to 'see' sound. Interchangeable sensations. Synaesthesia. As Klee is a violinist of concert standard, he's impressed by this concept. Many of his works have a deep, inner musical resonance, and search for harmony.*

Composition VIII, Wassily Kandinsky, 1923, Guggenheim Museum, New York. Cosmic circles and triangular shapes attempt to bring harmony to this canvas.

Before 1914 Kandinsky's version of Expressionism seems to head for Abstract territory, with titles like *Composition*. Klee toys with Cubism, but Delaunay's colour systems really grab him, especially after a visit to Tunisia in 1914 with the German *August* MACKE (1887–1914). The light and colour are

revelatory. Klee writes, 'I and colour are one. I am a painter!' Separated by the Great War, the K.s re-unite in the 1920s at the Bauhaus design school in Weimar, and are close colleagues there for a decade. They study, work and teach together, and share enormous mutual admiration, but there's only a rickety bridge between their

1921 Sergei Prokofiev (1891–1953) writes his opera, For the Love of Three Oranges.

1924 Edwin Powell Hubble (1889–1953) discovers spiral galaxies.

1928 Kurt Weill (1900–50) and Bertolt Brecht (1898–1956) write The Threepenny Opera, a politicized update of John Gay's The Beggar's Opera (1728).

ideas. Klee – who likes amusement, but also likes 'taking a line for a walk' because he needs to know why it's there – never completely dumps Nature, however much it looks that way, whereas Kandinsky develops a very elaborate, formal language of abstract signs and signifiers, loaded with psychic significance. Spooky.

Everything changes in 1933. The Nazis declare the K.s' work 'degenerate', and they separate, Klee heading home to Berne, where he dies depressed and ill in 1940, while Kandinsky goes to France to die in Paris four years later.

Senecio, Paul Klee, 1922, Basel Kunstmuseum. Old red eyes is back, mean and peevish. A Klee speciality.

"☆" Our House, Bauhaus

In 1922 Kandinsky returns from Russia to teach at the Bauhaus. This famous design school, headed by the architect Walter Gropius (1883–1969), is first at Weimar and then at Dessau. Some of the most important design theories of the mid-twentieth century are forged there, and many 'design classics' also, such as the aluminium framed chair (1922) by Marcel Breuer (1902–1981), who names the piece The Wassily Chair in honour of you-know-who. Kandinsky and Klee are next-door-neighbours at Dessau, and the intellectual climate is strictly for hot-house plants.

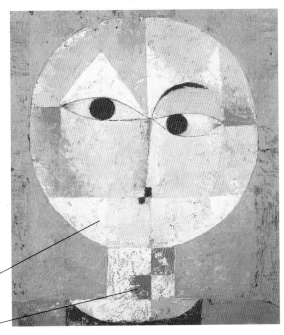

Scraped-on white paint, a dry application

Use of colour experiments à la Picasso to suggest variable space, tone and form

1903 USA is traversed coast to coast by car; it takes 65 days to complete the journey.

1903 Konstantin E. Tsiokovsky (1887–1935) invents rocket fuel.

1907 Paul Cornu (1881–1944), a French engineer, successfully flies a two-rotor helicopter. However, it was unstable; Igor Sikorsky (1889–1972) builds the first single rotor helicopter in 1939 and flies it a year later.

1909~1914

High on Volume, Low on Fuel
Futurism

Fired-up by the bombastic, high-decibel, attractive-but-often-empty rhetoric of Filippo Tomasso MARINETTI (1876–1944), Futurism's principal, egocentric spokesman, this rowdy crew – Carlo CARRA (1881–1966), Umberto BOCCIONI (1882–1916), Luigi RUSSOLO (1885–1947), Gino SEVERINI (1883–1966) and Giacomo BALLA (1871–1958) – were a mixed bunch of creative individuals. Futurismo (sounds great in Italian) was about things happening simultaneously. About the Means being more important than the End, especially in painting. But above all it was about the artistic expression of Dynamism: the new art of the Second Machine Age. Speed especially. Motor cars. Aeroplanes. Electricity. Motive Power. And about Anarchy too. Riots. War. Destruction. Tear it all down and start again.

Unique Forms of Continuity in Space, Umberto Boccioni, 1913, Mattioli Collection, Milan. A powerful striding figure displaces the atmosphere. The Futurists wished they could.

Marinetti launched *Le Futurisme* on 20 February 1909, from the front page of *Le Figaro*. Consider: '…the world's splendour has been enriched by a new beauty: the beauty of speed. A racing car, its frame adorned with great pipes, like snakes with explosive breath… a roaring motor car which seems to run on shrapnel, is more beautiful than the Victory of Samothrace…' Great cred. Kick out the Antique, trash two thousand years of art, and burn down the Museums. Many similar statements followed.

Of the Futurist painters, only Balla successfully turned Futurist dreams into Dynamism, using what he calls 'lines of force' to suggest the ragged channels of air in the wake of speeding cars (25 mph!) or, after World War I, idealized images of flight. The other painters turn to pointillisme to put their ideas across, because it's nearest to the flickering electric light they want to suggest. Or they borrow ideas from Gleizes & Co: the decorative fragments of Cubism come in handy. In sum, Futurismo is frustrated in paint …but sculpture and architectural design are another matter altogether.

1908 Five years after Kitty Hawk, Wilbur Wright (where was Orville?) flies 30 miles in 40 minutes.

1909 First commercial 2-stroke motor bike off the production line. It is built by Scott of Bradford, Yorkshire, England. Motorbikes later do sterling work as ridden by despatch messengers in World War I.

1910 Barney Oldfield, driving a Benz car, reaches 133 mph at Daytona Beach, Florida.

Fast Women

In spite of the inherent misogyny of the movement, there were many female Futuristas: Valentine de Saint-Point (1875–1953), who wrote The Manifesto of the Futurist Woman (1912) and Futurist Manifesto of Lust (1913); Adriana Bisi Fabbri (1887–1918), cousin to the sculptor Boccioni, and the sculptor Regina (Prassade Cassolo 1894–1974), the most successful of the group.

HIGH AND MIGHTY

Boccioni is the Futurist sculptor. His pig-snout armoured figure *Unique Forms of Continuity in Space* (1913, Tate Gallery, London and elsewhere) strides through time, displacing air, as a swimmer pushes away water. And *Antonio* SANT'ELIA (1888–1916) is the architect. Futurismo's last recruit (1914), his designs for La Città Nuova (The New City) will influence Fritz Lang's film *Metropolis* (1924) and, more recently, Ridley Scott's setting of *Bladerunner* (1982). Their cities are Futurist cities.

De-humanized. Fascist. Think again about all those towers in downtown LA, New York, London, Paris, Hong Kong. Futurism is Now. Unfortunately, some might say.

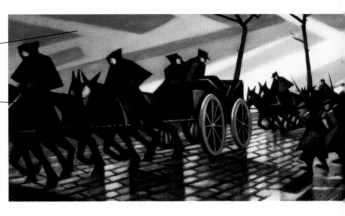

Limited colours plus Futurist 'lines of force' convey ominous gloom

Dark caped drivers like modern inquisitors; dark horses too

On the Road to Ypres, C.R.W. Nevinson, 1915–16, the Fine Art Society, London. A diabolical artillery train heads for the Western Front.

1900 Max Planck (1858–1947) posits his quantum theory; energy is made up of small disparate packets, or quanta. This heralds the beginning of modern physics.

1902 Beatrix Potter (1866–1943) publishes Peter Rabbit, her first book.

1907 Robert Stephenson Smyth, 1st Baron Baden Powell (1857–1941) establishes the Boy Scout movement; the first camp is held at Brownsea Island in the English Channel off Portsmouth.

1913~1915

Hot Damn!!! That Long, Hot, Last Summer

Vorticism

It is July 1914. In London, Art Capital of Europe (just for once), Percy Wyndham Lewis (1882–1957), fiery self-styled Vorticist, launches his large, puce-covered magazine BLAST on an unsuspecting British public, and announces the English Vortex. With excessive typography and literary ill-feeling, he 'blasts' the British for their insularity ('Curse abysmal inexcusable middle class'), tells them to get off their butts, dump their precious feelings for the Empire, and join the modern movement. The illustrations are hard-edge abstract wood engravings, excellent in themselves but poor indicators of the abilities of Lewis's coterie.

The Crowd, P. Wyndham Lewis, 1915, Tate Gallery, London. An eye-boggling composition from the founder of Vorticism and supremo of BLAST.

*B*LAST contains a manifesto signed by Lewis and ten others, among them the soon-to-die *Henri Gaudier-Brzeska* (1891–1915) and the 'Imagist' poet *Ezra Pound* (c.1885–1972). Like every posturing movement of its time, Vorticism is rooted in city life. Derived from Cubism, it is contemporary with, and antagonistic to, Futurism, for whose English flag-waver *C.R.W. Nevinson* (1889–1946) it reserves its greatest spite.

But Lewis has a problem. The artist signatories of his manifesto are revolutionary enough, but – *William Roberts* (1895–1980) and *Edward*

Wadsworth (1889–1949) aside – they aren't the best. He would like the American-Jewish sculptor *Jacob Epstein* (1880–1959) and the Anglo-Jewish painter *David Bomberg* (1890–1957) on board, but they won't bite. They will ally, but insist on their independence. No groups please; no signatures on any dubious bits of paper. Born in tough lower East Side New York, Epstein has already tasted the hypocrisy of British 'outrage' when his full-frontal sculptures for the new British Medical Association building in the Strand (1908) result in accusations of obscenity in the press, but friends defend him.

1911 English Captain Robert Falcon Scott (1868–1912) and Norwegian Roald Amundsen (1872–1928) race to the South Pole. Amundsen wins. Scott's team perish heroically.

1914 Oscar Barnack designs the prototype Leica camera for Leitz.

1914/15 Franz Kafka (1883–1924) publishes The Trial, a story of infinite bureaucracy.

THE FRAME NAMES IN
NAMES IN THE FRAME
THE FRAME NAMES IN
NAMES IN THE FRAME

Spencer Gore *(1878–1914), under whose Presidency the first London Group is formed in 1913: it's a society of independent artists, and the name is coined by Epstein.* **Roger Fry** *(1866–1934), whose Omega Workshops, and their one-off design objects, are the excuse for an irreconcilable rift between himself and Lewis in 1913...* **Stanley Spencer** *(1891–1951), supreme religious freak and oddball but great young prizewinning draughtsman.*

Bomberg is Birmingham-born, East European in heritage, and a great draughtsman. Life will be very harsh to him, but right now he is the most potent painter in the country: articulate and clear. His 1912–14 paintings *The Mud Bath, Ju-Jitsu* and *In the Hold* are full of the energy Lewis wants to harness, which is a pity, because he and Bomberg don't get on.

BLAST OUT

Vorticism continues into 1915. Another edition of *BLAST* appears, but this abstract movement falters in the face of war, and never fully recovers. Lewis will become ever more right-wing; Epstein will attract 20 years of vitriolic criticism and suddenly experience a renaissance in the 1950s; and poor Bomberg will inspire a new generation of great painters but will himself die a pauper.

In the Hold, David Bomberg, 1913–14, Tate Gallery, London. The authentic Vorticist swirl from the movement's best draughtsman.

Op Art avant la lettre D.B. uses a squared-up canvas, superimposed semi-abstract figures and selected colours to make an old scene modern and machine-like

The scene: probably the London docks near Bomberg's East End studio

Futurist Rivals

In June 1914 Nevinson and Marinetti pre-empt BLAST with a Futurist manifesto called Vital English Art, in which they manage to name most of the Vorticist artists. Lewis isn't pleased (he's never pleased), because Nevinson is named in his mag. All change, and more acrimony follows...

1917 The Russian Revolution, led by V.I. Lenin (1870–1924) and Leon Trotsky (1879–1940) sweeps the Russian tsars under the carpet of history.

1921 Communist party in Russia suppresses Suprematism, the movement which Malevich founded.

1922 T. S. Eliot (1888–1965) writes The Waste Land.

1912~1935

Inner Space
Malevich and Mondrian

Malevich's Black Square, an icon of modernism.

How radical can you get? Kasimir Severinovich MALEVICH (1878–1935) soon found out. In Moscow in 1913 (or 1915 according to your source) he gave Nature a rain-check… forever. To show he meant it, Malevich painted a black square on a white ground, and hung it above a doorway, where the family icon usually went. So, 'no' to God too. Then he painted a white square on white ground. He'd been to Paris in 1912, saw Cubism, bought the Futurist T-shirt, absorbed those styles and, when he arrived home, used them to excellent effect (as big collections at Amsterdam's Stedelijk Museum show). It still didn't feel quite right. Malevich thought that the logical direction for art was to go away from visual languages which depended on things seen. So, away from Cubism, to the projection of a mental state onto a painted surface, to soar above the mundane.

Malevich called his art Suprematism. 'Feeling is the determining factor', he wrote, '…this is how art arrives at non-objective representation'. It was all in keeping with the boundaries being broken by the Russian Revolution, but the Communist state wanted real pictures… tractors, smiling peasants, trains… something you can understand. By 1922 Malevich was virtually ignored in Russia but doing well everywhere else.

The Dutch artist *Piet MONDRIAN* (1872–1944) had his own theory of art: Neo-Plasticism, using those famous black scaffolding right-angles, with their primary colours, greys and off-white grounds. They try to offer something contemplative: an inner stability, what we might now call karma, totally unrelated to outside, material things. Mondrian – like many artists of his day – was deeply attracted to Theosophy, the 'New Age' philosophy of

Out of the Frame

Mondrian and Malevich dispensed with picture frames: they wanted to integrate their pictures with the spaces in which they were hung, without any artificial borders. Both men favoured the purity of white wall, and so the colours in their paintings are usually on white ground. However, Mondrian wasn't entirely humourless, and did allow himself an amusing title every so often, such as Broadway Boogie Woogie, painted in New York, where he lived from 1939 until his death.

1927 The Big Bang theory to explain the birth of the universe is put forward by Belgian astrophysicist Georges-Henri Lemaître (1894–1966).

1928 John Logie Baird (1888–1946) demonstrates colour TV.

1928-31 Le Corbusier (1887–1965), Swiss architect and one of the founders of Modernism, builds the Villa Savoie using his trademark pilotis (stilts) roof garden, glass wraparound windows and concrete construction.

Composition with Yellow, Red, Black, Blue and Gray, Piet Mondrian, 1920, Stedelijk Museum, Amsterdam. An early statement in primary colours to stir the spirits.

Black lines = predefined grid on which to base this contemplative exercise

Primary colours used to balance and simplify optical/spiritual experience and meaning

Underlying white, a clean basis for new theories

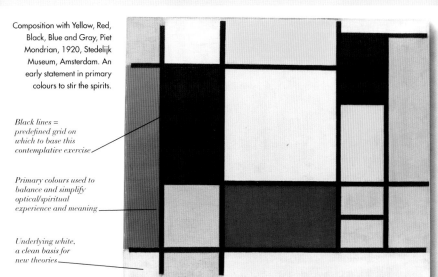

THE FRAME — NAMES IN

*American **Morgan Russell** (1886–1953), Synchromist artist, exponent of the dynamism of coloured forms... **Vladimir Tatlin** (1885–1953), Russian painter and designer influenced by Picasso, but gradually turning towards Russian Socialist Realism... **Naum Gabo** (1890–1977), with his brother **Antoine Pevsner** (1886–1962), among the first to use transparent materials in sculpture to suggest weightlessness. They publish The Realistic Manifesto (1920) announcing Constructivism, a move away from Malevich...**El Lissitsky** (1890–1947), Constructivist artist who joins De Stijl briefly, before moving on...*

the early 1900s. His paintings try to plot his feelings, and – like Malevich – he was an eager (but not a best-selling) theorizer. However, it's easier to understand Mondrian's development, his growing rejection of Nature and of the world in which he lived, if you remember that his process began in earnest during the period 1914–18, when most of mankind was bent on self-destruction, and that he had supporters. With *Theo van* DOESBURG (1883–1931), Mondrian founded *De Stijl* (1917–28), an important design group whose very influential magazine *(De Stijl)* spread the gospel of Total Harmony Through Clear Sober Logical Total Abstraction across Europe, to the very studios of the Bauhaus itself.

1916 Prohibition starts in the USA. Alcohol banned in 24 states. Crime rates soar and villains make fortunes bootlegging.

1919 British aviators John William Alcock (1892–1919) and Arthur Whitten Brown (1886–1948) fly the Atlantic nonstop from Newfoundland to Ireland.

1920 Herman Rorschach (1884–1922), Swiss psychiatrist, devises his famous inkblot test offering ten symmetrical inkblots for interpretation.

1914~1924

If I say it's Art, it isn't
Duchamp, with Dada

Is there really Anti-Art? Does Santa Claus exist? The answer is A Lemon. The full-scale emergence of Marcel DUCHAMP (1887–1968) and the anarchic, intuitive antics of Dada's heyday (c.1915–c.1924) were roughly simultaneous. Duchamp recognized some kindred spirits within Dada, but take care: the two aren't inseparable.

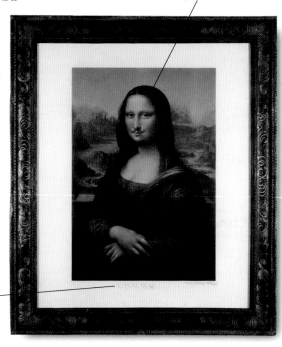

That moustache; one of the most subversive anti-images ever made

LHOOQ. Schoolboy innuendo taken to illogical extremes

LHOOQ, Marcel Duchamp, 1930, Private Collection. A reproduction of the Mona Lisa to which naughty M. Duchamp has added a moustache and beard, and the letters LHOOQ. If read in French, these go: Elle a chaud au cul (translated at its most polite as 'She's got hot pants', but actually much worse). Saucy eh?

Duchamp was always ahead of the game. In New York during 1913, he became notorious for trying to infiltrate public exhibitions with what he called 'Ready Mades'. These were everyday objects, whose presentation as sculptures, or art objects, gave them a new meaning, changed the way we think about them. *Bicycle Wheel* (1913) was the front forks of a bicycle, plus wheel, upended and screwed to the seat of a stool, like a sculpture on a plinth. *Fountain* (1917) was an upturned urinal. A snow shovel was called *In Advance of the Broken Arm*. Duchamp's friend *Man Ray* (1890–1977)

1920 Visitors to the Dada Exhibition in Cologne are invited to trash the artwork. They do.

1927 Werner Karl Heisenberg (1901–76) establishes his Uncertainty Principle: the closer you look at the subatomic structure of the universe, the more impossible it becomes to accurately measure the dimensions or movement of more than one particle at a time; therefore precise scientific certainty is unattainable.

1937 American chemist Wallace Carothers (1896–1937) invents nylons. He commits suicide after his success.

Is it Art?

In 1920 the Chief Constable of Cologne attempts to prosecute the Dadaists for fraud, because they charge an entrance fee for an exhibition which is clearly nothing of the sort. Max Ernst replies: 'We said quite plainly that it is a Dada exhibition. Dada has never claimed to have anything to do with Art. If the public confuses the two, that is no fault of ours.'

attached a line of nails to the bed of a flat iron and called it *Gift*. These antics were intellectualized anarchy, and they typify Duchamp at his best/worst. But they are vital items for dyed-in-the-wool Modernists, because they ask us to accept objects as art which have no association whatsoever with the accepted art of the past. It's been 80-plus years and some of us still find that hard.

It helps to see Duchamp against Dada. Forget about how it got its childish name. Dada was founded in Switzerland, apparently by the actor *Hugo BALL* (1886–1927), with Franco-German draft-dodger *Jean (Hans) ARP* (1887–1966), Romanian poet *Tristan TZARA* (1886–1930), and others. It was a gut-reaction to World War I. These artists had no 'agenda', but instead asked the pithy $64,000 question: How could a so-called civilized, high-minded society collectively descend to acts of such barbarism? In its cabarets, Dada confronted the bourgeois public with absurd art forms. Irony, cynicism, anarchy, satire were its weapons. Poetry, automatic writing, chance were all used creatively, often negatively, and pre-dated the 'Happenings' of the 1960s by some

50 years. 'Dada', said the Surrealist poet *André BRETON* (1896–1966) 'is a state of mind'. It was international too: its members contaminated the art of nearly every European country. In Germany *Neue Sachlichkeit* (New Objectivity) was an important result. By 1924, Dada's original acid strength had been eroded by a changed member-ship, whose interests were now strongly inclined towards the artistic expression of the subconscious. Surrealism beckoned…

THE FRAME — NAMES IN

Kurt Schwitters *(1887–1948), major Dada sculptor and poet, famous for his 'Merz' collages and junk constructions. One such completely filled his Hanover house, but was destroyed during an air raid in the World War II…* **John Heartfield** *(1891–1968), subversive communist collagiste…* **George Grosz** *(1893–1959), this century's leading German satirical draughtsman and a member of Berlin Dada…* **Hannah Hoch** *stage designer and Berlin Dadaist from 1918… and* **André Breton** *(1896–1966), Surrealist supremo, who engineers the final destruction of Dada.*

1914 Dr Alexis Carrel successfully performs heart surgery on a dog.

1919 Oliver Smith, a Californian, invents the electric rabbit to tempt greyhounds out of their traps and along the dogtrack.

1925 A solar eclipse, the first in 300 years, blacks out New York.

1920–1939

In Your Dreams
Surrealism

The main difference between Dada and Surrealism? Where Dada was loopy and anarchic, rebellious, anti-bourgeois, and international in scale, Surrealism was all of these, but organized, especially in its pursuit of the unconscious, a point emphasized by founder André BRETON (1896–1966) in his First Surrealist Manifesto (1924). Breton was a poet and writer; Surrealism was primarily a literary movement. When Breton's manifesto talks about his Surrealists expressing their 'pure psychic automatism'

The Elephant of the Celebes, Max Ernst, 1921, Tate Gallery, London. The biggest vacuum cleaner in the universe.

(control-free thought) or about 'the omnipotence of the dream', he's talking about …talking. Or writing. Painting only gets a footnote. It's hard to recall more dream-like, threatening images than the paintings of Giorgio de CHIRICO (1888–1978).

Surrealist artists followed two main directions, and didn't often overlap. With *Max ERNST* (1891–1976), *Joan MIRÓ* (1893–1983) and *André MASSON* (1896–1987) practised Automatism (free association) in their work. Miró was a Catalan (so was Dali), and his early work is autobiographical, crisply drawn, with unearthly colour gradations. In later paintings – those we think of as characteristic – Miró floats shapes linked by spidery lines across undefined coloured atmospheres. But these aren't just the meanderings of an undirected brain: the arrangement of colours and shapes provides emotional content, gained by using whatever material was available – even (so it's said) jam on one occasion.

1929 Wall Street crash; the US stock market collapses on October 28, Black Friday. The air is filled with the sound of breaking glass as plutocrats defenestrate themselves. Economic crisis envelops the world.

1938 International Exhibition of Surrealism in Paris. Duchamp decorates the space with 1,200 coalsacks hanging from the ceiling.

1938 Ferdinand Porsche (1875–1951) builds the Volkswagen ('the people's car') to the specifications of Adolf Hitler.

Against this, the world of dreams, of incongruous associations, was explored by *Salvador Dali* (1904–89) and *René Magritte* (1898–1967), if 'explored' is the right word for Dali. More obsessively fearful of sex than Munch, the opening scene of Dali's famous Surrealist film *Un Chien Andalou* (1929) shows a woman's eye sliced by a razor blade. The film is riddled with Freudian metaphors referring – among other things – to parental control and childhood repression, and contains many images found in Dali's paintings (including ants – but not the famous floppy clocks). As for Magritte, his work wants to argue with us: make us question the reality of all our values and senses. Is it a Pipe? A Train emerging from the fireplace? Or nothing more than sexual innuendo? Ask the Men In The Bowler Hats.

Don't try this at home: frottage

In 1925 Surrealism's co-founder Max Ernst (1891–1976) 'discovered' frottage. At first he placed canvas or paper randomly over grainy wood floorboards, rubbed it hard all over with black lead, and used the resulting imprint of this unconscious activity as part of a picture or painting. When Ernst became bored with paper he used canvas and oil paint. Wax crayon is good. But don't attempt this in your kitchen, or on the new hall carpet. Try the garage floor first. And always wash up before coming back inside.

The night sky of your mind; is this the dreaming self? Or a parallel universe?

Positive/negative image; an invisible presence sheds light on a darkened landscape

The mind's vision is not impeded by any obstacles

Obsessive attention to dream-clear detail

L'Heureux Donateur, René Magritte, Private Collection (date unknown). Meticulous detail and dream-like clarity but what does it all mean – if anything? Inside out or Outside in?

1923 Margaret Higgins Sanger (1883–1966) opens the first legal birth control clinic in New York. In 1917 she had been jailed for trying to open a clinic in Brooklyn.

1927 Isadora Duncan (b.1878), pioneer of expressive dance and loose attire, dies when the long scarf she is wearing is caught in the wheels of a car.

1931 Franz and Toni Schmidt, Swiss mountaineers, climb the north face of the Matterhorn.

1920~1960

Carving Holes for Posterity
Moore and Hepworth

Those see-through sculptures by Henry MOORE (1898–1986) and Barbara HEPWORTH (1902–1975) just asked for ridicule from the moment they were first exhibited. Both artists were Yorkshire born-and-bred, studied at the Royal College of Art in London, were immensely competitive and, in 1930s Paris, claimed influence from the ancient past. You must also know that both were carvers: an intense 'Which is right: Carving or Modelling?' debate ran throughout the 1920s and 30s, and Hepworth cast none of her work in bronze until c.1957/8. Moore succumbed earlier.

'Pierced' area with new concept of volume and space

Round curving or an organic form: is it a natural or woman-made form?

The void, the emptiness that paradoxically draws the eye

Smooth finish invites the spectator to touch

Involute I, Barbara Hepworth, 1946, Private Collection. A 'pierced' sculpture in white stone, typical of her best middle-period work, and derived from natural forms.

H. and M.'s short time in 1923 with underrated British maverick sculptor *Leon UNDERWOOD* (1890–1975) at his tiny Brook Green School of Art in London gave them a much-needed sense of direction. Moore's apparent reluctance to discuss Underwood in later years probably means that he benefited considerably.

Those holes? They weren't novel, but they – literally – opened up new ideas about space in British sculpture. The space was always there, but we never saw it or thought about it as we do now until H. and M. penetrated their respective figures with holes, or cut them into two separate-but-related parts. If you feel like a fight, suggest that the first hole appeared c.1931 in a Hepworth piece that is now lost. Moore's supporters will then disagree, and you can then punch holes in them.

Seen together, holed or two-piece, Moore's mature work is often hefty where

1936 Edward VIII (1894–1972) abdicates after 11 months on the throne to marry Mrs Wallis Warfield Simpson (1896–1986), an American divorcée.

1939 Barbara Hepworth and Ben Nicolson (1894–1982) move to St Ives, Cornwall.

1942 The National Loaf, devised by nutritionists, sustains the British nation through the dark teatimes of war.

Outdoor Influences

The great outdoors is a vital factor in the execution of H. and M.'s best work. Moore's crammed sketchbooks show him always thinking on these lines (even – in 1937/38 – to the extent of Christo-like wrapped sculptures), but his themes are universal: they don't often echo the places that inspired them. Hepworth's sculptures can work either way, though her more intimate, smaller pieces can succeed outside or in. They are always 'about' nature.

Hepworth's is more lyrical, romantic, influenced by her years in Yorkshire and Cornish landscape settings. Moore's trademark reclining figures were an obsession worked out during World War II, first in a (rightly) famous series of drawings (1940–41) of underground bomb shelters in London, and then in sculptures ranging from the small to the (frankly) titanic, as anyone walking through an open space in any city, anywhere, today knows.

Hepworth's career was not so excessive: her greatness was duly recognized without the fanfares, but later. Married for some

Ben Nicholson *(1894–1982), an important figure in British and European modernism of the 1930s, and a major figure in British art until his death...*
Herbert Read *art critic and commentator, major spokesman for the Modern Movement in Art in Britain during the inter-war period, and the man who coined the phrase 'a gentle nest of artists' for everyone working in Hampstead, London, before World War II, including* **Walter Gropius** *(1883–1969) and* **Piet Mondrian** *(1872–1944) just passing through...*

years to the painter *Ben NICHOLSON* (1894–1982), she had three children by him, and this, plus Nicholson's own refusal to be second to anyone else, checked her career. Since 1990 her work has become much better known, whereas Moore's reputation, which once carried all before it, has suffered since his death. Who said Moore is Less? Or was it vice versa?...

ARTSPEAK
'Scale is a mixture of physical size and mental scale... independent of actual physical size'.
Henry Moore, 1964

Hill Arches, Henry Moore, 1973, Yorkshire Sculpture Park. A bronze two-piece sculpture, alluringly smooth yet menacing, like Darth Vader's helmet.

1916 The Battle of the Somme, which lasts from July to September. There are 60,000 casualties in the first offensive alone.

1916 The Easter Rising, to gain Home Rule in Ireland; civil war in Ireland is threatened but the rebellion fails, overtaken by global crisis.

1916 The tank makes its first appearance on the battlefields of the Western Front. It is not used to its full advantage. The first tank battle takes place in 1917 at Cambrai.

1914~1918

Expressing the Inexpressible
World War I

The greatest leveller of all time, war has been depicted in nearly every format known to the artist, more or less since art began. From The Arch of Titus (after 70 AD) and Trajan's Column (c. 120 AD) in Imperial Rome, through C. S. JAGGER'S Royal Artillery Memorial (1925) at Hyde Park Corner, London, to Maya LIN'S Vietnam Memorial (1982) in Washington DC, stone has been used in attempts to sustain memories, or to prompt questions.

The Merry-go-Round, Mark Gertler, Tate Gallery, London. Oh, what a lovely war! Uniformed figures, their faces in a rictus of fear, are trapped on a hectic, hellish roundabout.

Until the 1850s, warfare was seldom drawn in the heat of battle and always painted after the event. Whatever their allegiance – American, as Trumbull, Singleton Copley or West, British, as Lady Butler or Maclise, French, as Gros, Delacroix or Meissonier – the object of the exercise was the portrayal of heroism, courage, daring; the frisson of battle, pity for the wounded, dying or dead. As pictorial journals developed from 1850, they took battle painting from the academies and treated warfare as news. It was lower grade, but the new breed of journalist-illustrators kept the essential components of battle painting in their work. They drew the battles more or less as they happened and sent their drawings by ship and – later – wire across the globe.

Modern warfare and increased security changed this. By 1900 artists could no longer roam and interpret a

Eye Witness

On 16 November 1917 the British war artist Paul Nash writes to his wife '...I am no longer an artist interested and curious, I am a messenger who will bring back word from the men to those who want the war to go on for ever. Feeble, inarticulate will be my message, but it will have a bitter truth, and may it burn their lousy souls.'

1917 Mata Hari (Gertrud Margarete Zelle, b. 1876) the Dutch femme fatale and alleged double agent, is executed for espionage in Paris.

1917 The USA joins in the war; US troops in France led by General Pershing (1860–1948).

1918 World War I ends; the armistice is signed at the eleventh minute of the eleventh hour of the eleventh month.

battle. And warfare itself had changed. By 1916, battles could and did last for months. New ideas in art meant that, along with the heroism, the horror of modern warfare cried out for expression. The armed forces of every combatant country of World War I had artists, musicians, writers, in their ranks. Of the many who died, most were slaughtered on Europe's Western Front. But as many fought and lived, on land, sea and in the air. Their art attempts to convey the unthinkable. Gross existence in a landscape of death. Mindless patriotism. Numbing boredom. Squalor and stench. Gratuitous killing. Re-birth in the moment of dying. Commemoration.

These artists were young men. *Otto DIX* (1891–1969) and *George GROSZ* (1893–1959) in Germany; *Paul NASH* (1889–1946) and *Stanley SPENCER* (1891–1959) in Britain; *GROMAIRE* (WHEN), *Fernand LÉGER* (1881–1955), *Félix VALOTTON* (1865–1925) in France. They incited contemporaries and those who followed to consider their own situations, and they were by no means alone. No improved technology can put the Holocaust or Vietnam, or the Gulf, or any other conflict beyond the reach of the artist. Artists' voices are still voices to be reckoned with.

War Artist Scheme

World War I saw the creation of an Official War Artist Scheme in Britain, as a result of the failure of photography as a propaganda weapon. Begun in 1916, the schemes were intended to provide propaganda material for the duration of the war, and to act as the basis of a national monument when the war was over. By the time the Peace Treaty was finally signed at Versailles, the British had amassed some 3,000 works of art by just under 300 artists. By no means all the pictures were the result of official commissions, but the scheme is notable as the first major act of public arts patronage in the history of the UK.

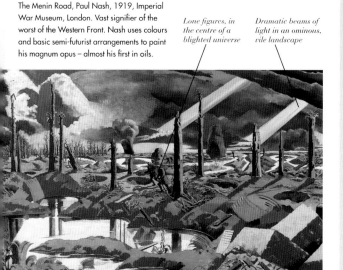

The Menin Road, Paul Nash, 1919, Imperial War Museum, London. Vast signifier of the worst of the Western Front. Nash uses colours and basic semi-futurist arrangements to paint his magnum opus – almost his first in oils.

Lone figures, in the centre of a blighted universe

Dramatic beams of light in an ominous, vile landscape

1928 Brazil makes an awful lot of coffee – so much that the country's economy fails.

1929 St Valentine's Day massacre in Chicago; seven unarmed members of the 'Bugs' Malone gang are gunned down by Al Capone's hit squad disguised as policemen. The gang warfare is the result of Prohibition and the profits to be made from illegal alcohol.

1932 Ernest Hemingway (1898–1961) writes Death in the Afternoon, a memoir.

1900~1960

Europe? Who needs it?
Hopper and O'Keeffe

Certainly not Edward HOPPER (1882–1967) or Georgia O'KEEFFE (1887–1986). O'Keeffe's outside artistic influence was gained second hand, and in time New York, Lake George and New Mexico became important sites for her work. Hopper visited Paris three times before 1910 and, like all its lovers, enjoyed its charms and appearance. But its art? Nope. No Fauvism and no Cubism for Edward. Instead, Hopper took what he needed from Goya, Rembrandt, Degas and especially from the etchings of AshCan artist John SLOAN (1871–1951). Don't overlook Hopper's etchings: they are seriously good, and up to a point his needle-work was better than his brushstrokes. In 1920 recognition came at last. A sell-out watercolour show in New York allowed Hopper to leave commercial art; the real world beckoned.

Neon signs convey a strong sense of an urban setting

Space, height and depth suggested by verticals; a typical Hopperism

Foreground figure with back to the viewer, shutting us out of the scene turning us into eavesdropping voyeurs

Chop Suey, Edward Hopper, 1929, Whitney Museum of American Art, New York. In Hopper's world, ideas of intimacy and isolation come into conflict.

O'Keeffe's early career wasn't unlike Hopper's (she was also a commercial artist), and their mature interests are different but often parallel. No early visit to Europe for her, though: that came in the 1950s, when she was well known. Her first outside stimuli came via Alfred Stieglitz's 291 Gallery, where she saw work by Rodin and Matisse. In 1912 at the University of Virginia, O'Keeffe really got into simplified forms and Kandinsky's writings, which led her to make her own nature-based abstractions in 1915–16. Stieglitz liked them so much that he gave her a show in 1917, and O'Keeffe liked him so much that she married him in 1924.

The wide open spaces in and out of town meant a lot to O'Keeffe and Hopper,

1935
Alcoholics
Anonymous
founded in
New York.

1938 Howard Hughes
(1905–76), tycoon, film
director, aircraft designer and
aviator, and recluse flies
around the world in 3 days,
19 hours and 17 minutes, not
once getting his hands dirty.

1940 Raymond Chandler
(1889–1959) immortalizes
mean streets and the private
eye Philip Marlowe in
Farewell My Lovely.

but in very different ways. According to
Hopper, any of his works – even the
voyeuristic views of apartment blocks,
seedy rooms and bars – were '…the most
exact transcription of my most intimate
impressions of nature'. A doorway to the
man's brain? No. Many of his paintings
seem to present intimacy and alienation
combined, of things and people together
but apart. They involve distance, but don't
have the space found in O'Keeffe's wide-
open, romantic New York paintings
(1925–29), or
those made in the
solitude of New
Mexico (1929–30
and 1949–c.1970).
But O'Keeffe is
best known for
her monumental,
subtle paintings
of flora, abstract
and represen-
tational. Many
saw sexual
imagery in them,
and to prevent
any further 'mis-
readings' O'Keeffe
quit abstraction
in 1924.

The American Way
Alfred Stieglitz (1864–
1946), photographer and
art dealer, did more than
any other American to
challenge American
opinions on art. In 1905
he opened 291 Gallery
on Fifth Avenue, New
York as a venue for
modern art; they had
contemporary, already.
He used artists (and
patrons) with a European,
avant-garde bias, and his
efforts were vindicated by
the interest (if not the
sales) generated by the
1913 Armory Show.
Perhaps his greatest
achievement was his
successful promotion of
Modernism in the USA
by adding the word
'American' to
everything he did.

Cow's Skull with Roses,
Georgia O'Keeffe, Art
Institute of Chicago. A
reflection on nature in
general, and on life, love, and
death in particular, with images
chosen from the artist's own
immediate sources.

Marsden Hartley (1877–1943), often
misunderstood exponent of Modernism in
America, with a strong leaning towards
German art, emblems and people…
Charles Demuth (1883–1935) and
Charles Sheeler (1883–1965), great
exponents of the New Deal: precise,
depopulated landscapes of fascinating
machinery… **Ben Shahn** (1898–1969),
America's greatest Social Realist artist,
and the national counterpart to the
German George Grosz. **Andrew Wyeth**
(b.1917), meticulous realist and painter
of the American heartland in haunting,
often strange, watercolour or egg
tempera images.

1947 First sighting of UFOs in the USA; they are nicknamed 'flying saucers'.

1951 Colour TV perfected, but not in commercial use yet.

1952 The USA test the destructive power of the first hydrogen bomb on Eniwetok Atoll in the Pacific Ocean.

1947~1960

Splashing Out
Abstract Expressionism

It's been said before: it's easier to say what Abstract Expressionism wasn't than to define it, and the 15 artists assembled in a famous Life photograph of 15 January 1951 prove the point. How can you think of Jackson POLLOCK (1912–56), Mark ROTHKO (1903–70), Franz KLINE (1910–62), Willem DE KOONING (1904–97) and Clyfford STILL (1904–80) and think of only one thing? And that's only five different agendas. In this they merely echoed groups of the past. But – like a good support group – they acted in unison when their broadest ideals came under fire. Which was very frequently.

Black on Maroon, Mark Rothko, Tate Gallery, London, 1958. Romantic Rothko, the leader in the colour field. Shimmering spaces to delight (or repel) the senses.

In a canvas executed at the height of Abstract Expressionism you won't find a trace of Surrealism, of 1930s geometric abstraction, of Cubism's tight composition. From about 1947 those ideas go out of the window, and suddenly the painter's canvas is growing much larger; it's being treated in a totally new way. Some critics think that this is to do with the concept of the USA as limitless in size and in make-up of population: nice idea. Like an open space without a fence. Either way, shape and size of image aren't defined. No preliminaries. Retinal overkill. None of that exhausting Cubist visual leapfrogging all over the picture surface without knowing where you're going. De Kooning said it was all Pollock's fault: he '...busted our idea of a picture to hell. Then there could be new paintings again.' Abstract Expressionism busts things in several different ways, as you can see.

1953 English physicist Francis Crick (b.1916) and American biochemist James Dewey Watson (b.1928), using data provided by English biophysicist Rosalind Franklin (1920–58) discover the structure of DNA, the basic pattern of human life. It is a double helix.

1957 Sputnik 1, the first communications satellite is launched by the USSR. It orbits for 92 days, bleeping constantly, before burning up in the atmosphere.

1958 The Beat scene emerges. Jack Kerouac (1923–69) is king; poetry, jazz, coffee and black sweaters all round

Gesture in Abstract Expressionism at first centres on young 1940s' Pollock. His long canvases carry broad, dry streaks of paint, recalling tribal or totemic figures. De Kooning and Kline follow faithfully. But when Pollock starts drip painting in 1949–50, all hell breaks loose. Call that Art? A bizarre 1950s' film charts the dance-like rhythm of this process: the artist's fatal 1957 car wreck elevates this bad boy to legendary status. Pollock, Still, Rothko and *Barnett NEWMAN* (1905–70) – whose writing is required reading – develop colour field painting: essentially the coverage of a canvas with a single colour, or limited colours. Newman's zip paintings, with their thin strips of colour, still incite elderly gallery-goers to apoplexy, and Rothko – with his colour-band, and colour-on-colour paintings of the 1960s – is deeply implicated in this hideous crime. The meaning? To tell is to reveal all.

DON'T TRY THIS AT HOME

Drip Painting the Pollock Way

Buy a very large sheet of canvas. Spread it out if possible, but if you can't, don't worry: you can roll one end while you work on the other. Buy some paint. Oil paint. Aluminium paint. Bitumen. Think of an abstract way to express a deeply felt emotion. Take a stick or a knife or a rolled-up Rolling Stone, dip it in the paint and drip it onto the canvas. No brushing allowed. Walk or crawl or leap or boogaloo around the canvas with the paint, keeping up a steady trickle as you go. Now try flicking paint across the canvas – Now try a different colour. When you've run out of paint or energy, call the framers and the auctioneers, in that order.

It wasn't new, but it was new to Pollock's work. He called drip painting 'Energy and Motion made visible – memories arrested in space', and the continuous, densely over-dripped lines seem to bear this out

'When I'm in my painting, I'm not aware of what I'm doing'. Thanks J.P. – we never would have guessed

Yellow Islands, Jackson Pollock, Tate Gallery, London. The very first drip painting, a technique pioneered by Pollock, and not as easy as it looks.

1956 Rock 'n' roll electrifies the Western world; Elvis Presley records Heartbreak Hotel, Hound Dog and Love me Tender.

1960 The Laser (Light Amplification by Stimulated Emission of Radiation) invented by Theodore Harold Maiman (b.1927). A beam of laser light can reach temperatures higher than that of the surface of the Sun.

1961 Staff at MOMA, New York, hang Matisse's Bateau the right way up; it's been upside down for 46 years.

1956~1970
All you need is love
Pop!

Remember Pop Art? You know – the Swinging Sixties? All that stuff? Wrong and not wrong. By the mid-1960s Pop was already into its second generation. And to complicate matters, Pop has two heads, one British and one American. For once the Brits got there first. The name Pop was coined during the Independent Group's 1956 London exhibition This is Tomorrow, *based on a fusion of their main, twin concerns: modern technology and consumer, mass-media culture. Say that again in pictures? Look no further than Richard HAMILTON (b.1922) and his famous collage, made for the exhibition catalogue cover – just what is it that makes today's homes so different, so appealing?*

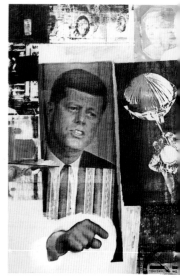

Retroactive II,
Robert Rauschenberg, 1964. An excellent example of the artist's use of collage and paint to achieve a contemporary but disembodied effect.

Although Hamilton milked the mass-media, Pop was a 'Fine Art' movement on both sides of the Atlantic. In the UK it went through three stages, and its many followers included *Peter BLAKE* (b.1932), later designer of the artwork for the Beatles' *Sgt Pepper's Lonely Hearts Club Band* album, a memorable Pop statement; *David HOCKNEY* (b.1937) and American *R.B. KITAJ* (b.1932).

Hamilton's definition covers much American Pop, but the 1960s' Stateside version has a longer, more complicated pedigree. The American orginators – *Robert RAUSCHENBERG* (b.1925) and *Jasper JOHNS* (b.1930) – were much more 'painterly' in their collages and flags than their irreverent successors, *Andy WARHOL* (1928–87), *Roy LICHTENSTEIN* (1923–97) and *Claes OLDENBURG* (b.1929), who go back to Duchamp in their enlarged images of real objects. And New York Pop badly needed to throw over Abstract Expressionism, even though some artists

1967 It was 30 years ago today...Sergeant Pepper's Lonely Hearts Club Band forms and produces a record. Peter Blake does the cover; the Beatles do the music.

1968 Les Evénements shake Paris; students and workers ally in a storm of political unrest that sweeps across Europe's campuses.

1969 First Moon landing; US astronaut Neil Alden Armstrong (b.1930) takes a small step for man.

learnt much from it. Lichtenstein's giant canvases of brushstrokes and cosmic comic cuts show how much, and Oldenburg's wondrous saggy, soft sculptures are more than just sophisticated fun. But just a minute... with acid *Ed KEINHOLZ* (b.1927) at the helm, Pop grew faster in LA than in NY. And, depending on your belief, its West Coast statements were occasionally more heavyweight. You might also say that they lasted longer. But the work's all so large. Was Pop only intended to be seen in museums? Was it just to remind us of our strange post-war cultural habits?

ARTSPEAK

'All hail, Pop Art, the first lively thing that's happened in painting since Jackson Pollock tripped over his bucket of despair in East Hampton. (You can stop trying to like Kline, Rothko and de Kooning and breathe easy; it's over at last. The Museum of Modern Art will soon be fun enough to hang around in for more than a movie, a fast cruise and tea with your friends on the staff.)'

Alfred Chester, observer of American Art, 1964

NAMES IN THE FRAME

So many of them. **Joe Tilson** *(UK, b.1928), king of the slot machine, alphabet box and wood relief...* **James Rosenquist** *(US, b.1933), whose billboard-sized paintings are as complex as a Chekhov play...* **Eduardo Paolozzi** *(UK, b.1924), sculptor and scrap collector...* **Edward Ruscha** *(US, b.1937), Hollywood-inspired word-painter.*

The Eleven Commandments

In 1957 Hamilton wrote Pop's Eleven Commandments.
Let Pop be:
- *Popular* (designed for a mass audience)
- *Transient* (short-term solution)
- *Expendable* (easily forgotten)
- *Low cost*
- *Mass produced*
- *Young* (aimed at youth)
- *Witty*
- *Sexy*
- *Gimmicky*
- *Glamorous*
- *Big Business*

American comic books 30 second romances – featherweight for the feather-brained

Sex, sex, sex and more sex

New ideas of human beauty – Charles Atlas – remember him?

Just what is it that makes today's homes so different, so appealing? Richard Hamilton, 1956, Kunsthalle, Tübingen. You can see, can't you? Consumerism, of course.

1955 The image of the Stars and Stripes comes to Jasper Johns in a dream. He goes on to paint it.

1963 The Civil Rights Movement, organized by Martin Luther King (1929–68) among others, stages a massive (200,000 people) but peaceful march on Washington to demand an end to racial inequality.

1967 In the USA, 12 billion cans of beer are consumed.

1955~1987

Baton Passers
Johns and Warhol

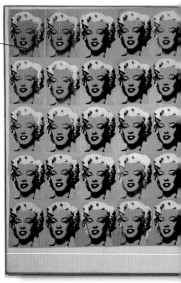

Marilyn Monroe's iconic features screenprinted (Number 1)

Marilyn Diptych, Andy Warhol, 1962, Private Collection. The first of many 'wallpaper' silk screened prints, and probably the next most famous, after the soupcans.

To contrast influential Jasper JOHNS (b. 1930) with influential Andy WARHOL (b. Andrew Warhola, 1928–87) is to create twin peaks above Pop and acknowledge the murky contemporary American artistic landscape below. To some, Johns is The Greatest Living American Painter. He's certainly what many call 'an artist's artist': a guy mud-wrestling with personal ideas, in order to take them and his art further forward, and therefore deserving a following. Johns's first (and best-known) Flag Paintings are from 1955, when Abstract Expressionism ruled the earth, but his techniques were so radically different from A.E. that they caused an immediate sensation on first showing in New York (1958).

Johns – in his many guises – is all about not standing still. Wanting to make moves on the basis of discoveries. The 1958 mixture of A.E. brush-strokes, wax encaustic and collage gave extra texture to simple images – what Johns called 'things the mind already knows'.

Not so Andy Warhol, a talented draughtsman. No clear meanings for him. After his Series painting *100 Soup Cans* (1962), he made the notorious remark, 'The reason I'm painting this way is because I want to be a machine', and, with a team of assistants in his New York studio (The Factory), Clown Prince Andy went on to claim the crown of Pop Art, producing work at an industrially prodigious rate: plywood Brillo boxes with silk-screened labels, multiple Elvises, car crashes and Marilyns; interminable 'underground' 1960s films called *Eat*, or *Kiss*, using stationary cameras; links with rock bands such as The Velvet

1967 English 'supermodel' Twiggy (Leslie Hornby) takes the US by storm.

1968 Chester Carlson (b. 1906), inventor of the photocopier, (1938) dies.

1976 Concorde supersonic passenger service begins; two planes take off simultaneously, one from London, one from Paris, to fly to Washington.

Three Flags, Jasper Johns, 1958, Private Collection. Johns used encaustic (hot wax) pigments to give extra texture to simple 'known' images, ensuring that they stuck in the mind's eye.

Marilyn Monroe's iconic features screenprinted (Number 2)

Marilyn Monroe's iconic features screenprinted (3) You get the picture?

Underground; experiments in 'High' and 'Low' culture; his peroxide hair(pieces).

In 1968, Valerie Solanas, radical feminist and founder of SCUM (the Society for Cutting up Men), was acting in one of his films and took against Warhol. She shot him. Andy recovered. His work changed. In the mid-70s, out went the assistants and in came 'collaborators' such as *Francesco CLEMENTE* and *Jean Michel BASQUIAT* (1960–88), who worked with A.W. on portraits until an argument broke up the arrangement. Already a cult-figure, Andy became an Art Superstar. In the films

of the books of twentieth-century art Warhol is often cast as King Arthur, the deliverer of modern art from a fate worse than …itself, possibly.

Warhol's early death has set hordes of whitewashers running around the royal tomb, who tell us that this state didn't last right to the end, when allusions to Raphael's Sistine *Madonna* and Leonardo's *Last Supper* crept into Warhol's AIDS-related work; when his sustained adherence to Catholicism and his charitable acts became known. What do you want to believe now?

DON'T TRY THIS AT HOME

Moviemaking the Warhol Way

This game tests the limits of human endurance. First buy an old, working 16mm home movie camera. Spend hours (days even) trying to find someone who'll sell you enough film to last 24 hours. Load film. Set the camera up in your kitchen/bedroom/ bathroom. Tripod? No. Someone will knock the camera over and it will look 'artistic'. Camera angle? Where you think someone will walk past it, but don't worry too much. Switch on. Now just do whatever you have to. Go shopping. Go to the movies. Cook. Wash. Eat. Sleep. Play cards. Go to bed, but don't do anything you shouldn't. When all the film has run, develop and show to your friends.

1962 The US launch Telstar I, the worlds first communications satellite; it could pick up radio waves, amplify them and send them on.

1972 Hammer-wielding fanatic attacks Michelangelo's Pietà in the Cathedral at Florence.

1976 The disastrous effects of CFC (chlorofluorocarbon) aerosol propellant gases on the ozone layer are discovered.

1950~1990

Heavy Metal, Steelyard Blues
Smith, Caro, Serra

When Pop broke in Britain, the boundaries between art-forms began to blur; after 25 years of Moore, Hepworth and others, its hardly surprising. The chance to change sculpture was quickly seized by younger artists. One of these was Anthony CARO (b.1924), a qualified engineer and an ex-studio assistant of Moore's. But a promising Academy-style career wasn't enough for him. One day in 1959 his genie appeared, in the shape of influential American critic Clement Greenberg, who uttered the magic words, 'If you want to change your art, change your habits'. On a scholarship to the USA in 1959–60, Caro met David SMITH (1906–1965), who gave him the final push.

Cubi XIX, David Smith, Tate Gallery, London, 1964. One of a series of Cubini.

An art school drop-out, the ebullient Mr Smith built a career just like one of his sculptures: a combination of mis-shapen fragments. In the 1920s he was a welder and riveter for Studebaker in Indiana. From 1929–31 he studied painting part-time in New York, and there met de Kooning, Gorky and Gottlieb; in the 1930s, he also first saw welded sculpture by Picasso's chum, *Julio GONZALEZ* (1876–1942). Get out the blow lamp and rivets, hammer noisily, and hey presto: you have the makings of an artist. Even so, until the 1940s Smith supported his art by working as a commercial welder. Then, as his career picked up during the early 1950s, he began to incorporate machine parts from his workshop (The Terminal Iron Works) into his sculpture.

Whatever Caro heard through Smith's cigar smoke, it took effect. Home in the UK, Caro began to bolt and weld together steel units – scrap, sheet metal, girders – to

" ☆ "

The New Generation

In 1965 Caro's influence as an innovator–teacher at St Martin's School of Art, London, is visible in The New Generation, an important exhibition at the Whitechapel Art Gallery, where St Martin's students and staff – given the same name as the exhibition – exhibit constructed, coloured sculpture. The effects continue until the late 60s.

1980 The wreck of the Titanic found, 12,000 ft/4,000m below the north Atlantic, surrounded by empty champagne bottles.

1983 The first artificial chromosome is produced; it is grafted on to yeast. Genetic engineering begins.

1984 The Thames Barrier, the largest such structure in the world, is completed; it is designed to save London from flooding.

form abstract sculpture. He painted it bright colours. It worked. Now he doesn't. Smith didn't paint but polished. It worked. Then he painted. It also worked. But this stuff is genteel in contrast with Post-Minimalist *Richard SERRA* (b.1939). Serra's cradle was the steelyard, though his first sculpture was in neon tubing. He graduated to metal in his *Splash* series (1967), where molten lead was thrown into the corners of rooms. Process art, for the confused. In the 1970s Serra began to create anti-environments using Cor-Ten steel plates as a favoured medium, and focusing on sculpture's raw materials: its weight and its gravity. His sculpture became vast, coming out of the studio and into public spaces. There's probably one going up somewhere near you, as you read this...

Early One Morning, Anthony Caro, 1981, Tate Gallery, London. A characteristic Caro, primary colour, simple shapes, pleasing proportion, a machine designed to perform an unknown function.

Arc Building
Serra's largest commissions, his Arcs, have all hit the hot-spot of public reaction. In 1981 two Manhattan pieces, TWU and St John's Rotary Arc offended the burghers of New York. Tilted Arc, a vast wall of Cor-Ten steel, was erected in Federal Plaza, NY, in 1981 and destroyed in 1989 after long and bitter legal wrangles throughout 1986. In London, an imposing, (but small by comparison) piece was erected at Broadgate, on the City's boundary, in 1989, and this too attracted flak, but at least it's still there.

An energy source? A square sun? Do we hear Malevich thinking?

Big and red. A piece designed for a white interior. Eat your heart out, Mondrian

Counterweights to the cut and thrust of verticals and horizontals

1967 Pulsars (pulsating stars) discovered: they do not twinkle, they throb. They were detected by scientists using a huge array of receivers designed by the English astronomer Anthony Hewish (b.1924).

1969 International modernists and Bauhaus colleagues Walter Gropius (b. 1883) and Ludwig Mies van der Rohe (b.1886) die.

1971 Stanley Kubrick (b.1928) directs A Clockwork Orange, a film based on the dystopian novel by Anthony Burgess (1917–93).

1960~1980

The Search for Small
Minimalism

You're bound to hear that Minimalism was all poor old misguided Malevich's fault; that all this started back in 1913–15 with his Black and White Squares. In a way it's true. He wanted an art as far away from representation as possible.

Soft Blue Drainpipe, Claes Oldenburg, 1967, Tate Gallery, London. A characteristic Claes, whose work is all puns on size, scale and material.

And what about Mondrian? Just as bad, constantly bleating about the need for complete visualization before even touching the canvas. In 1960s' America there were several who agreed with these ideas and put them whole-heartedly into practice. First, though, you have to understand that a Minimalist art-work may not coincide with your preconceived ideas. Think of neon tubes. Of perfect geometric shapes: The Cube is important, and the Minimalists introduced it as a symbol of clarity, of clear-thinking, of simplicity.

And who were these bright sparks? *Don JUDD* (b.1928), *Dan FLAVIN* (1933–96), *Carl ANDRÉ* (b.1935), *Robert MORRIS* (b.1931), and *Frank STELLA* (b.1936). Their work has caused many thousands of gallery-goers to enter states of mind ranging from the apoplectic to the hysterical. What's important about the Minimalists is that many of them began as painters, and not only reacted against Abstract Expressionism as a form of painting but also against its failure to produce any sculpture. What did they do in its place? They used industrial materials, such as firebricks, fluorescent tubes, copper plates, styrofoam. They made symmetrical things. Flavin is the fluorescent king. Here a tube, there a tube. Upright, vertical, diagonal, singly or in hundreds, unlike that old softy of Pop, *Claes OLDENBURG* (b.1929), still turning out sculpture, Pop

ARTSPEAK

'I had to do something about relational painting...the balancing of the various parts of the painting with and against each other'.

Frank Stella on his Black series.

1977 Blackout in New York City. No power for 25 hours. Much burning, looting and pillaging (3,700 arrested); the birthrate soars in '78.

1978 The first test-tube baby, Louise Brown, is born; in 1997 she will have a baby of her own in the natural way.

1981 The Chinese successfully clone a golden carp.

or no Pop, hard or squelchy, and making it big, imposing and full of face value. None of that intellectual stuff like Frank Stella's, still famous for a series of so-called 'Black' paintings, stripes of black enamel, straight from the tin, onto canvas.

Morris was prepared to suggest that you didn't need to make art at all: the thought was good enough. Blame that one on Duchamp, but call it Conceptual.

In 1966 New York's Jewish Museum presented the exhibition *Primary Structures*, giving the impression that Minimalism is an established movement, but Judd and André have other ideas…

DON'T TRY THIS AT HOME

Sculpture the Minimalist Way

First, prepare yourself and remember that your motives are pure. Think of absolutely nothing. In this state of grace try and remember where you last put your tape measure. Once found, measure one of your window-frames. Taking your pick-up, visit your local lighting emporium, buy one fluorescent tube for each side of your window frames (or as many as you need to run around the entire area), plus all necessary wiring and socketry. At home, attach light fittings around windows, connect all wiring, plug in, switch on and drop out. If you don't cut off the entire neighbourhood, you will have a very large electricity bill and a fabulous Minimalist artwork. Now think of absolutely nothing.

Equivalent VIII, Carl André, 1976, Tate Gallery, London. The infamous fire bricks that outraged art lovers who knew what they liked.

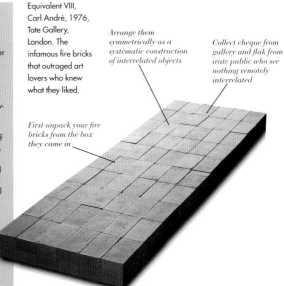

First unpack your fire bricks from the box they came in

Arrange them symmetrically as a systematic construction of interrelated objects

Collect cheque from gallery and flak from irate public who see nothing remotely interrelated

1954 Composer John Cage (1912–92) writes his 'silent piece' for piano entitled Four Minutes and 33 seconds, in which the pianist sits at the instrument and reads the score for the appropriate period, but does not play.

1968 Marcel Duchamp (1887–1968), arch Dada art gangster and the patron of Conceptualism, dies. Or does he?

1977 Punk music (no musical training necessary) erupts from the London scene.

1950~1980

Conceptualism. Get it?
Morris and Beuys

Piano with felt rolls? Or felt with piano rolls?

Farewell then, Art Object! Welcome… The Idea!! Conceptual Art was universal by the 1970s, and DUCHAMP was canonized, in Art at least. Following Marcel's first claims for ready-made objects ('if I say it's art, it's art'), things had moved on, past RAUSCHENBERG's telegram of 1953, which read + This is a portrait of Iris Clert if I say so + and even beyond the four minutes of silence composed by the American avant-garde composer John CAGE (1912–92).

Josef Beuys's Constructing an Exhibition in Düsseldorf. Arch-conceptualist Joseph Beuys in one of his own environments, a major art figure of the 1970s and 80s.

Why, Conceptual Art is such a varied idea. And such a change from that awful Minimalism that left your brain with no bolt-hole. Because – whatever your opinion – the two essential elements of Conceptual Art are your brain and language. You have to be able to think, to use the brain as a tool for logic, for the imagination, for fantasy. And you can only communicate using very specific language, or your 'receiver' (the person who sees your artwork) won't be able to gain anything

ARTSPEAK

Sol LeWitt (b.1928), one of Conceptualism's more artistic users, noted in 1967:
'Conceptual art is only good when the idea is good'.

from it, however hard they try. As one of its practitioners explained in 1974, Conceptual Art in its most ideal state needs to be capable of being '…described and experienced in its description, and …be infinitely repeatable. It must have absolutely no "aura", no uniqueness to it whatsoever.' Which is completely intelligible, but very hard to achieve.

Two artists who used the same material – felt – for not-so-different conceptual ends were *Robert MORRIS* (b.1931) and

1982 Scientists at the University of Groningen (Netherlands) theorize on the existence of a black hole at the centre of our galaxy.

1983 A metre is officially redefined as the distance that light travels in $^1/_{299,792,458}$ of a second.

1989 Crop circles appear overnight and mysteriously in UK wheatfields; there is much speculation, a name (cereology) and a magazine for researchers.

Joseph BEUYS (1921–86). Morris used felt, piled, draped or hung, at first in random arrangments, and then in deliberately controlled settings with sexual connotations. You had to think about it.

Beuys was very different. A major pioneer of the 'Happening', his strange appearance and idiosyncratic behaviour could disguise some very sane ideas. This was the man who, on one hand, accepted full responsibility for any snowfall in Düsseldorf during February, and who, on the other, spent a week in New York in 1974 talking to a live coyote. For Beuys, felt was a fibrous life preserver, a memory of the Russian Front, and one embodiment of life itself. Forget Virginia Woolf – who's afraid of Conceptual Art?

The consensus of opinion is that Conceptual Art reached its apex as a major movement during the mid-1970s, and that, although several of its original practitioners still operate today as they did then, subtle changes have crept into the formerly severe works of some of their colleagues.

Bagism, John Lennon and Yoko Ono. A happening performed in April 1969 by Japanese conceptual artist Ono and Lennon, ex-art student and rock megastar.

Self-Destruct Mode

On 17 March 1960 Jean Tinguely (b.1925) exhibits a characteristic junk motive sculpture in garden of MOMA, New York, uncharacteristically painted white. It incorporates an old upright piano, an old addressograph machine, a klaxon, fire- and smoke-making chemicals and a fire extinguisher. It's called Hommage to New York. This evening it shakes and burns itself to bits, having briefly been a work of art in one of the world's best-known museums. Auto-Destructive Art is here, for a while at least.

Lennon and Ono became soul partners in more than marriage. Ono had already attracted some notice as a Conceptualist leaning towards performance. And who better to bed, bag and blag with than Dr Winston O'Boogie himself, a willing bagee?

1965 Bob Dylan (b.1941) releases his seminal electric album, Highway 61 Revisited. Highway 61 links Minneapolis – St Paul with St Louis.

1971 Mariner 9 space probe sends back pictures of the surface of Mars. There are no canals, but lots of craters.

1973 Worldwide fuel shortage.

1964~1997

Wrapped Objects and Land Art

Christo and Jeanne-Claude, Long, Goldsworthy, Turrell

Walk a line somewhere in the world with Richard LONG (b.1945). Check out Andy GOLDSWORTHY (b.1956) for something beautiful but temporary. Get your kicks on Route 66 with James TURRELL (b.1943) and his extinct volcano near Flagstaff, Arizona…

Ice, Andy Goldsworthy. A beautiful, but temporary, mark on nature, recorded in photographic form.

In 1958 *Christo JAVACHEFF* (b. 1935) met Jeanne-Claude de Guillebon (b.1935) in Paris. In 1964 they moved to New York, where they are now known as Christo and Jeanne-Claude. They packaged their first public building in 1968, in Spoleto, Italy; wrapped a part of the Australian coast in 1969; and produced *Valley Curtain* at Rifle, Colorado in 1972, the forerunner of *Running Fence* (1976). A freak wind blew the whole exciting affair to pieces, but it has happened… later developments will be *The Pont Neuf* (1985), *Umbrellas* (1991) and *The Reichstag* (1993). You don't think *Running Fence* is Art? Some people say it's a lot more beautiful than the Great Wall of China, and Christo and Jeanne-Claude took the Fence away; the Wall's still there.

The ecological impact wasn't a problem when Land Art, or – as it's sometimes called – Earth Art really went public in the late 1960s and 1970s as form of Conceptualism. And though Land Art's various ideas are recent, the basic concept's much older. Take the time-machine back to the 1700s. Meet the first Land Artist, a real earth mover, Lancelot ('call me Capability') Brown (1715–83), ground improver to the monied classes and landscape gardener *par excellence*.

DON'T TRY THIS AT HOME OR ANYWHERE ELSE FOR THAT MATTER

Think big. Think of a nice big shape; a circle, a snakey sort of wiggly shape, a trench. Hire a mechanical excavator. Find out how it works. Then head for the nearest piece of unpopulated land. Start digging. If it works out, call the newspapers. If it goes wrong, start again. If you get bored, return the excavator and go for a hundred-mile walk on a straight line in the Hindu Kush, leaving a small stone every ten feet. That should keep you busy for a few months…

1978 Italian Reinhold Messner and Austrian Peter Habeler climb Everest without extra oxygen supply.

1979–82 British Ranulph Twistelton-Wickham-Fiennes (b.1944) travels round the world by the polar route, crossing both poles.

1987 The Channel Tunnel, linking England and France, is started. It will be officially opened in 1994.

DID THE EARTH MOVE FOR YOU?

Can artists such as Long or Christo and Jeanne-Claude do for the wide-open unclaimed spaces of uninhabited lands what Brown did in a smaller way with trees and lakes for the parks of the English aristocracy? Some say, absolutely not. But in both cases the artists have thought of themselves as inhabiting the landscape, leaving marks that won't destroy or cause major ecological upheaval, and which may be something of beauty, however temporary they are.

Running Fence, 18 ft (5.5 m) high and 24½ miles (39.4 km) long, extending East–West near Freeway 101, north of San Francisco, on the private property of 59 ranchers, following the rolling hills and dropping down to the Pacific Ocean at Bodega Bay, was completed on 10 September, 1976.

Stargazing

In 1977 ex-flier and aerial map-maker James Turrell bought an extinct volcano called Roden Crater, in the Painted Desert, near Flagstaff, Arizona. Here, he has been trying to make a series of spaces that will 'engage celestial events' – like dawn, sunset ('nightrise'), the moon and the stars. If it's ever finished visitors will be able to lie at the bottom of the crater, look up and experience 'celestial vaulting' – the eye's tendency to see the sky as a curved dome, instead of the shapeless expanse we usually think of.

Christo and Jeanne-Claude on Running Fence

All parts of Running Fence's structure were designed for complete removal and no visible evidence of Running Fence remains on the hills of Sonoma and Marin Counties. As it had been agreed with the ranchers and with the County, State and Federal Agencies, the removal of Running Fence started 14 days after its completion and all materials were given to the ranchers.

Running Fence crossed 14 roads and the town of Valley Ford, leaving passage for cars, cattle and wildlife, and was designed to be viewed by following 65 kilometres (40 miles) of public roads in Sonoma and Marin Counties.

Running Fence was made of 240,000 sq.yds (200,000 sq.m) of heavy woven white nylon fabric

The poles were embedded 3ft/1m into the ground using no concrete and braced laterally with guy wires and 14,000 earth anchors

The fabric hung from a steel cable strung between 2,050 steel poles (each 21ft/6.4m long, 3½ ins/8.9 cm in diameter)

The top and bottom edges of the 2,050 fabric panels were secured to the upper and lower cables by 350,000 hooks

1969 Oh Calcutta! (nude review show) hits the stage in New York; devised by English drama's radical enfant terrible, Kenneth Peacock Tynan (1927–80), its title is allegedly from the French phrase 'O, quel cul tu as' (trs: 'great buns').

1972 J. Edgar Hoover (b.1895), paranoid transvestite Director of the FBI, dies.

1978 Disco fever sweeps the world.

1950~1997

The Return of the Big Figures

Bacon, Freud and Rego

Detail from Three Studies for Figures at the Base of a Cross by Francis Bacon, c.1944, Tate Gallery, London.

Adulation has made Francis BACON (1909–92) and Lucian FREUD (b.1922) into powerful cult figures. Some say that a 'mantle' passed to Freud on Bacon's death. Some don't. And some say, 'What mantle?'

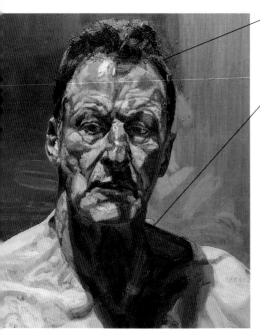

Fascinating investigative brushstroke on face, hair, eyes – you name it, it's alive

Torso fairly briskly handled, but the head's the thing

Reflection (Self-Portrait), Lucian Freud, 1985, Private Collection. As systematic an examination as any MD will give.

After all that splattered paint, the acres of polythene, the not-so-daring repeat prints, it's still there…the Human Figure. Such a many-splendoured thing that we almost forgot it. Painting about real people. But what figures these are, used to convey all manner of messages; and how notorious their creators. A 1930s' designer, Bacon developed his painting skills to the point of notoriety in his best-known series *Screaming Popes* (1960s) which challenged 'the human condition', and from which he never looked back. And did he have a grand scheme? Yes. '…to make images of my nervous system as accurately as I can [which would affect the viewer]… more violently and poignantly'.

1978 Muhammad Ali beats Leon Spinks, becoming the first boxer to win the World Heavyweight title three times

1978 Disney's Mickey Mouse is 50 years old.

1980 Mae West (b.1892), actress and writer, dies. All her work got her into trouble with the censor, and she was imprisoned for 10 days in 1926 for obscenity, after her play *Sex* was closed down on Broadway.

ARTSPEAK

'I've always tried to put things over as directly and rawly as I possibly can, and perhaps if a thing comes across directly, people feel that it is horrific... because people tend to be offended by facts, or what used to be called the truth'.

Francis Bacon

Much of this applies just as well to Freud, and to the dark side of *Paula Rego* (b.1935). Despite the visual differences in their source-material, and in their respective images of humanity, their figures give off raw, intense feelings often absent from the work of other contemporaries. Bacon's pungent, provocative imagery of despair comes from many sources, especially the homoerotic, whereas Freud's big, bold impasto paintings of the 1990s are an analytical celebration of human flesh-in-paint: a far cry from the parchment-like skin in his small, taut 1950s' portraits.

Rego's 'truth' is expressed in similarly human terms, but gravitates towards Feminism. She often includes herself and her family in large, figure-filled canvases in which there's a very thin line between

THE FRAME NAMES IN

Feminist High-Priestess **Germaine Greer** *(b.1939) supports Rego from the start, and David Sylvester does likewise for Bacon and Freud, whose Soho years collide with those of the painters* **Frank Auerbach** *(b.1931),* **John Minton** *(1917–57) and* **Michael Andrews** *(b.1928), the writers* **Colin MacInnes** *(1914–1976) (author of Absolute Beginners and others) and* **Jeffrey Bernard**, *grand seigneur of the Soho scene...*

imagination and reality. Rego's sources have been given as her Catholicism, and/or her early experiences of Portugal under a dictatorship. Her paintings from the 1960s to the present suggest sinister combinations of power, pleasure, religion and eroticism, using images that contain clear, but distorted, echoes of children's role play. They are usually at least disquieting, and frequently disturbing.

Mine's a large one

How did Bacon and Freud survive the 1950s? On non-painting days they were – with several others – excessively happy warriors in London's Soho and, according to one source, 24 hours in their company would have induced a hangover of seismic proportions among any but the experienced. The Colony Club in Dean Street was the group's preferred watering hole, presided over by the eagle-eyed, sharp-tongued proprietress Muriel Belcher.

Scavengers, Paula Rego, 1994, Marlborough Fine Art, London.

1969 Woodstock, the first free rock festival. Over 400,000 people crammed onto an upcountry farm where they dance and love for three days.

1971 Disneyworld in Florida opens; Disneyland, Anaheim, California has been open since 1955.

1984 Synchronized swimming becomes an Olympic sport at the LA games.

1960~1997
A Bigger
Hockney and Kitaj

What a pair of self-mythologizers. Emerging peroxided from the black lagoon of Royal College Pop, with his owlish spectacles and his photo taken by Lord Snowdon, Yorkshire-born David HOCKNEY (b.1937) went on to become a permanent guest at Hotel California. His candy-toned series of Los Angeles pools quickly followed. R.B. KITAJ (b.1932), visually anonymous, and a romancer of the human figure, was a US ex-pat power in the UK until recently and a 'name' in British painting. Hockney's first London solo show in 1971 was un succes d'estime. What a way to 'come out'; everyone wanted to go and see the blond, gay wunderkind's work. It was a blast, with light-heavyweight American leanings, and it showed the way D.H. wanted to go. He was good then, but The Vital Question still remains unanswered: can he hack it? How many more Picassoid derivatives can we take? The jury's still out, and the verdict's uncertain.

If Not, Not. R.B. Kitaj, 1975–6, Scottish National Gallery of Modern Art. A major dialogue on the apparent contrasts between evil and the poetic in our times, this painting is being specific and imaginary in its references.

Now Kitaj... During a recent (1994) intercontinental ballistic retrospective tour, one critic called this ex-Pop peripheral person the greatest draughtsman since Degas. What nonsense. There's just no comparison, although his drawing is truly vital to his work. Kitaj has always kept his painting literary, narrative even, and his tastes – which embrace the

The Golden Boy's Golden Show
In 1971, Hockney's first major exhibition, Paintings, Prints and Drawings 1960–1970, is held at London's Whitechapel Art Gallery, and proves that since graduation in 1962 not a year has gone by when D.H. hasn't won some sort of praise or award. The Whitechapel's Director, Mark Glazebrook, emphasizes D.H.'s wit and humour (praise be to Pop), but at the same time points to his studious attitude to art (buy, buy). They do.

1987 Van Gogh's Irises sell for $49 million in New York; his Sunflowers snapped up in London for a bargain $37 million. Poor old Vincent.

1990 A controversial photography exhibition of work by Robert Mapplethorpe (1946–89) is shown at the Contemporary Art Center, Cincinnati, Ohio; 175 overt pictures celebrate homoeroticism, body piercing, sadomasochism. The museum's director is charged with obscenity but found innocent.

1997 Huge retrospective exhibition in London for Hockney, the first for some 20 years. Millions flock.

Typical marks to suggest rudimentary ground

High bright colours show D.H.'s acknowledgement of past art, e.g. Gauguin, the Fauves. It's all very happy – but is it good painting?

Nichols Canyon, David Hockney, 1979–80.
A Californian image showing a new brilliance of colour and other beginnings of a new style.

idea of the artist as autobiographer and commentator (James Joyce, T. S. Eliot) – almost certainly influenced the young Hockney. In the 1980s Kitaj rediscovered a long-buried Jewish identity and set about expressing his innermost, complex responses to his religion, the Holocaust, and to later Jewish philosophy (Walter Benjamin) in what is arguably his best ever series of images: fluid, thoughtful, provocative paintings. He even wrote a supporting tract: *The First Diasporist Manifesto* (1981).

A Yank at Oxford

Spared the war in Korea, Kitaj found himself in the UK as a result of the GI Bill, which enabled him to study Art in a British art school. R.B.K. went to the Ruskin School of Drawing at Oxford University, where he was taught by Professor Percy Horton (1897–1970), a Cézanne-ist worth more than these few words. Horton pushed R.B.K. to take the exam for the Royal College of Art and the rest is history.

This introspective seam in Kitaj's art is one he appears to want to mine still further. One recent series of small canvases suggests that, with increasing age, he may want to identify with his elders and betters. Watch this space.

1978 Norman Rockwell (b.1878) dies. He designed and painted the covers for the magazine Saturday Evening Post.

1984 Ray Kroc, founder of the McDonalds hamburger empire, dies.

1989 Satellite TV blights the world. After a long struggle, the dish wins the fight with the square aerial.

1975~1997

Sell! Buy! Post-Modernism
Basquiat, Schnabel, Koons

What a trio. If ever there was a bunch of band-wagon-jumpers, it was this lot, and the late-and-not-great Jean-Michel B ASQUIAT *(1960–1988) takes the cake. Reduce Post-Modernism to its lowest common denominator, and (if you listen to the pathetic mumblings of French deconstructor Jean Baudrillard) you'll hear that nowadays none of us have a shred of artistic originality because we're all pre-conditioned to such an extent that we're incapable of such things. Thanks a bundle. You'll end up like Basquiat. Not even the Brothers Grimm could have invented him. He called his work 'Eye-Rap'. Indeed. A one-note samba by an abstract tagger, a vision of life and art distorted by drugs and fake adulation. Is this cruel? Yes. Basquiat was a casualty of late twentieth-century art, and it doesn't mean that the ancient past is better: just that balance is needed before we start believing in the Emperor's New Clothes.*

As for *Julian* SCHNABEL (b.1951), the man who made a film (1997) of Basquiat's brief life, the same is true. His own career hasn't exactly been a bed of roses. Decide for yourself whether Schnabel's monumental canvases of the 1970s (the ones that have broken crockery clinging to them for dear life) echo the art of the past, or are Post-Modern. What are they trying to say? They certainly aren't small, but then neither is his output. New York's Mary Boone and Castelli Galleries

Vive la différence! Cock and Cunt play, Judy Chicago, 1970, performed at Womanhouse by Faith Wilding and Jan Lester.

1981 Charles, Prince of Wales (b.1948), marries Lady Diana Spencer (b.1961). They divorce acrimoniously in 1996.

1995 Jeff Koons and his wife Ilona, 'La Cicciolina', porn star and politician, split up.

1997 Julian Schnabel's film Basquiat starring David Bowie as Andy Warhol and Jeffrey Wright as Basquiat , is released to mixed acclaim.

Mixed media used throughout; acrylic, oil stick, collage – to create a hurried effect both repellant and crude

Man from Naples, Jean-Michel Basquiat,1982, Galerie Bruno Bischofberger, Zurich.

mounted simultaneous shows of Schnabel's work in 1979. So? While it's true that he hasn't stood still, and that his subjects have embraced current concerns, such as AIDS, or have paid homage to past masters such as Beuys, the quality of Schnabel's work is still in question, plus there's little of what you'd call continuity. There seems to be a very explicit (but whispered) question-mark hanging over the possibility that it all might be too brash, too artificial ...and every so often too meaningless to guarantee S. a place in the history books.

But compared with *Jeff KOONS* (b.1955), Schnabel is Titian and Basquiat is Caravaggio. This ex-commodity broker is a poseur. His encased, floating basket-balls, purpose-built, craftsmen-made kitsch animals, his photos of explicit sexual intercourse send your eyebrows into orbit. He's said that he's interested in 'the morality of what it means to be an artist'. Ha. Koons's aesthetic morals are as mobile as shifting sands. Observe at a distance only, with several sacks of salt to hand.

Dinner Party Art

In 1973, Judy Chicago, aka Judy Cohen Gerowitz (b.1939), arranges first state of the Dinner Party, a kind of Feminist Last Supper. Designed as a homage to 39 women whom the artist considered to be major figures in Western art, the Dinner Party is a huge art-work, based on a triangular table accommodating 39 specially designed place-settings with individual goblets and runners, with special china painting and specifically feminist imagery which – for Chicago – focused on the 'fundamental' differences between male and female. It cost $250,000 to complete, and it looks fabulous.

THE FRAME

Andy Warhol *(1928–87), erstwhile collaborator with Basquiat (while it lasted)...* **Lucy Lippard,** *great feminist critic and incisive writer on the modern movement...* **Keith Haring** *(1958–1990), AIDS casualty and subway graffitti artist, whose stick figures reached a huge audience while they were a feature of the New York subways during 1980...* **Cindy Sherman** *(b. 1954), photographer and identity-swapper...* **Bill Viola** *(b.1951), high-tech installateur whose subjects include quantum physics and mysticism.*

NAMES IN THE FRAME

> **ARTSPEAK**
> Hirst has listed several influences (but by no means the only ones) on his work. Here are some. 'Like Bacon, like Soutine. Gericault. Denis Potter. Anybody who dealt with the gruesome.'
> *(Modern Painters, Vol. 9, No. 2, 1996)*

1985~1997

Plaster and Formaldehyde
Whiteread, Hirst et al

Not a substitute for milk and alcohol, but as potent when it comes to art-speak, these two substances and their occasional users – Rachel WHITEREAD (b.1963) and Damien HIRST (b.1965) – are a major feature of a rising tide of British art in the 1990s. The problem – as ever – is whether or not it's Art. Some items have a better claim than others. Consider: casts of mattresses; casts of whole rooms; casts of the space underneath stools and chairs. Plaster casts that don't move. Wibbly wobbly rubber ones with lovely opaque colours. That's Whiteread, and every bit of it's serious: her House (1995, which took interior plaster casts of every room in a house about to be demolished) and, most recently, her project for a Vienna Holocaust Memorial (1996–7) speak real volumes about past lives. Yes, you could say it's been pretentious, but critics love to knock. Nevertheless, if you consider the art detritus of Warhol and Duchamp, there's now a strong argument for putting a fast-maturing Whiteread forward as a really serious alternative to some of the dross created by these people.

But where Whiteread has climbed out of the formative bog and is heading (at the time of writing) for the 1997 Venice Biennale, Damien Hirst can – and often does – look pretentious and absurd. If paintings of large coloured dots in household paint, or canvases spun at varying speeds while paint's poured over

House, Rachel Whiteread, 1993–4. The entirety of an East London terraced house interior, cast before demolition to form a ghostly presence. The cast itself no longer exists.

1985 Terrible famine in Ethiopia prompts worldwide response from ordinary people. Live Aid, free show featuring most of the rock stars of the day, raises around £60 million

1990 East and West Germany formally reunited, after the Wall that has divided East and West Berlin since 1961 is pulled down in 1989.

1987 Black Monday on the London stock exchange. Britain forced to withdraw from the European Monetary Union.

THE FRAME — NAMES IN

Jake *(b. 1966)* and **Dinos Chapman** *(b.1962), unnerving brothers who produce very controversial and disturbing installations using maimed or deformed mannequins; the Palestinian exile* **Mona Hatoum** *(b.1952), auteur of physically and conceptually engaging multimedia pieces; her Corps Etranger (1994) was an audio-visual portrait of the artist's inner self using a laporoscope hooked up to a video camera;* **Marc Quinn** *(b.1964), currently best known for Blood Head, a glass cast filled with the artist's own blood (taken at judicious intervals);* **Helen Chadwick** *(1953–96), who crossed sculpture with land art; best known for her Piss Flowers, casts of flower shapes made by urinating onto virgin snow.*

Memorial
On 9 November 1996 Whiteread's Holocaust Memorial is unveiled at Vienna's Judenplatz, 58 years after Kristallnacht – the Night of Broken Glass – and on the site of a synagogue destroyed in a pogrom of 1421. The idea of the 'unspoken residue' of the site is very important to her.

Lines of cages: metaphors for cells of every kind. Seeming freedom but actual captivity. And more

Light is imprisoned yet still shines freely

Light Sentence, Mona Hatoum, 1992. This is an installation piece which has been shown in many venues, here seen in Cardiff. It is a work dealing with barriers: alienation, captivity, belonging, expulsion, enclosure.

them, or rotting sharks floating in formaldehyde are your bag, then search no further. D.H. is your man. What about a piglet bisected, similarly preserved: *This Lttle Piggy Went to Market* (1996)? Or butterflies embedded in paint (*In and Out of Love*, 1991)? David Bowie loves it. But… is it or isn't it? Art. Hirst's work is often experimental and isn't always fully developed. It seems his need to 'find out' is paramount (what did he do at school?), and many of his past comments suggest a (real) desire to understand various states of existence – or lack of it – including dead animals in formaldehyde. OK. But why not keep it in the lab with the Monster Mash, eh? It's an interesting problem: consider *The Ambassadors* by Hans Holbein (c.1479–1543) (1533, N.G., London), with its skull. Does Hirst seriously convey similar intimations of mortality?

Hirst's new game: Megapointillisme.

1984 The Internet (global computer network) established for everyone's use (previously only military and academic personnel had access). By 1994 there are an estimated 23 million users.

1987 Ivan Boesky declares that greed is good. Wall Street goes into hyperdrive.

1988 Thomas Zimmerman invents the wired glove; sensors in the glove allow the wearer to 'pick up' objects that exist only in virtual reality.

1997~2000

This is Tomorrow...
To the Millennium...and Beyond

What next? Will we stay or will we go after 2000? Will we experience 'retread art', with tired ideas and no technique? Or be pulled along breathless by the adrenalin rush of new, creative developments? Probably some of both, with the emphasis on neither. Will it be any good, though? And how can we tell? Only by sniffing the product. The same way as we've accepted or denied the art of the last half-century.

Across the board, art is now more international than at any time in its history. The world's Museums will still dictate the trends, because only they are potentially capable of exhibiting and storing some of the more ... interesting creations, the ones that have little to do with painting. Remember Painting? Canvas? Paper? Wet colours and brushes? It'll still be there, but – like it or not – only as one of a series of categories including the art object, the large-scale installation, performance art, photography and video. And straight in at Number One is the Internet, the World Wide Web, which will almost certainly transform 'creativity' as we now understand it.

The danger of w.w.w. is that too many humanoids will risk forgetting that most art is derived from real life, as it always has been, and instead unthinkingly accept the Web's huge potential for the blanket distribution of second-hand images. The Internet already forces its users to make choices. You can stay in and make (or re-make) art, or accept it second-hand on your monitor, with the limitations which will always be imposed by new technology; even Virtual Reality has its drawbacks. Or, with your senses, wits and emotions intact, you can get out of the house and see and respond to art first hand – as it is, wherever it is. And recognize it for what it is.

1997 Comet Hale Bopp blazes in the northern skies; many cults take it as a signal of impending doom, bliss or liberation.

1998 Winter Olympics held in Japan. The big show in 2000 is in Sydney, Australia. Pac Rim rules.

2000 the Millennium: apocalypse now or the biggest party in the world?

The status of Irish and Scottish artists looks interesting: the 1990s Irish cultural buzz in Britain has by no means run its course, and the USA probably won't go untouched for much longer; this may take up some slack and create new areas of interest. You're reading the books; now see the art.

In the market-place, though, things are going slow. So, for some really sensible inactivity, why not get away from it all; head for a Turrell crater, lie on your back and forget the inanities and jealousies, the sturm und drang, the cut and thrust of this funny old aesthetic world. You'll enjoy it better.

Glass Series, Michelle Charles, 1996. Now you see it, now you don't. Charles's glasses and bottles suggest nourishment but rarely show it; only the deposit remains, while the glass – like the Cheshire Cat – is revealed or hidden. A metaphor for our times. Think about it.

Depends who you are. Of the British old guard, **David Hockney** *(b.1939) makes a return in 1997 with his first major show in 10 years, but it would be good to see due recognition for his almost unknown contemporary, landscapist* **David Blackburn** *(b.1939)…* **Alan Davie** *(b.1920), major Scottish expressionist and jazzer of the 1950s and 60s, is still on the road, while Op artist* **Bridget Riley** *(b.1931) has comprehensively slammed the non-painting, shark-baiting lobby of young British Turks, who continue to offend. If you're placing bets on the so-called BritArt pack,* **Rachel Whiteread** *to win, but evens only on* **Damien Hirst**, *and watch* **Tracey Emin** *(b.1963),* **Mark Wallinger** *(b.1959), Turner Prizewinner* **Douglas Gordon** *(b.1966) and a large supporting cast of sycophants eventually fade into the wallpaper.*

Crib Sheet

This as an emergency modern art course; if you want to know about an 'ism' in a hurry, consult this list, compiled in roughly chronological order, which will safely cover you from Boudin to Basquiat

IMPRESSIONISM
1874–1886

French painters of modern life attempt to trap its fleeting nature, in the cities and countryside of France and – sometimes – Britain.

NEO-IMPRESSIONISM
1880s–1900s

Scientific development of Impressionism, using pointillisme: dot painting in pure colours, in a search for purity.

POST-IMPRESSIONISM 1890s–1900s

Term invented by Roger Fry, English art critic. Used by the Brits to denote van Gogh, Gauguin and especially Cezanne, but not in French usage until recently.

EXPRESSIONISM
1890s–1920

Effectively begun by Norwegian painter Edvard Munch, but centred on Germany, especially pre-1914. Painting from the depths of one's primitive soul.

FAUVISM 1905–10s

The Fauves (The Wild Beasts) were so called after an exhibition review. Led by Matisse and Derain, their hotly coloured canvases did much to provide a brief alternative to Cubism, and gave Matisse himself a deserved reputation as one of the greatest colourists ever.

CUBISM 1907–20

The twentieth century's most important artistic revolution. Painting's process is overturned. The way we see things utterly changes. The Spaniard Picasso and the Frenchman Braque lead the way up this treacherous mountain.

FUTURISMO 1909–14

Italian painting and sculpture, launched in Paris, with speed, the machine age, anarchy and war high on their list of 'great cleansing agents'. To some extent dependent on Cubism, but arguably more important in Russia and Britain than in good old Italia.

VORTICISM 1913-14

Britain's fifteen minutes of fame, with a small but important avant garde led by Wyndham Lewis, until World War I stamps it out.

DADA 1916-25

Anti-art movement begun in Zurich in response to trauma and slaughter of World War I. Schoolboy humour of Marcel Duchamp, with deeper meanings of Max Ernst, creates logic-less work which is great but can't last.

SURREALISM 1924-69

Dada's offspring and logical relative, at first a mainly literary movement, dependent on the psychological

subconscious, dreams and other, similar phenomena. A riot of disbelief then and still packing 'em in.

NEO-PLASTICISM 1917-44

Piet Mondrian's own movement, and the vehicle for his famous grid paintings, based on Theosophical ideology. Also strongly linked with the Dutch design movement De Stijl.

SUPREMATISM 1915-37

Kasimir Malevich's own movement, and the vehicle for his famous paintings of geometrical objects floating in space, alone, supreme, infinite and above the rest of mortality. Abstract Abstract.

EXPRESSIONISM 1940s-60s

Or the New York School, in honour of the main location of this artistic phenomenon, led by Jackson Pollock, which controlled American painting until the advent of Pop and in the process made a massive impact on European art too.

POP ART 1957-70

Throwaway art begun in the UK and then independently in the USA, with dissimilar ideals. In the UK a response to the new post-war consumerism, and in the US to Abstract Expressionism. Both types could be brash or subtle, depending on author, and the meaninglessness of some of Pop created a nutrient-rich environment for:

MINIMAL AND CONCEPTUAL ART 1950s ON

These movements took several forms, one of the most extreme (and absurd) being that art required no making process: a solid idea was good enough. This has resulted in all kinds of work: some interesting – such as Land Art – and some utter garbage.

Where to Look

Many of the artists in ART A CRASH COURSE *are particularly well-represented in certain galleries and museums or in certain art cities of the world (Florence, Rome, Vienna, Paris, London). If you've got a free day in Birmingham, take in the Pre-Raphs. Driving past Padua? Drop in for the Giottos. This list tells you what's where. Big-time artists not name-checked are represented in too many galleries to mention.*

ARTIST	GALLERY
André, Carl	MOMA, New York; Tate, London
Arp, Jean	Tate, London; MOMA, NY; Grenoble; Strasbourg; Leeds
Baldung Grien	H.M. The Queen, London; Cleveland, Ohio
Balla	Tate, NG, London; NG, Rome; MOMA, NY
Bellini (all of them)	Venice
Blake	Tate, London
Bomberg	Tate, London; Israel Museum, Jerusalem
Botticelli	Uffizi, Florence
Boucher	Wallace Collection, London
Boudin	Le Havre
Brancusi	Centre Pompidou, Paris
Bronzino	NG, London
Bruegel (both)	NG, London
Caro	Tate, London
Cellini	Florence; Madrid; Oxford
Cimabue	Siena
Constable	V & A, Tate, NG, London
Cotman	Castle Museum, Norwich
Courbet	Louvre, Musée d'Orsay, Paris
Crome	Castle Museum, Norwich
Dali	Tate, London
David	Louvre, Paris
Derain	Musée d'Orsay, Paris
van Dyck	London; Antwerp; Brussels; Edinburgh
Delaunay	Stedelijk, Amsterdam; Tate, London; Guggenheim, NY; Art Moderne, Paris; Musée de Tissus, Grenoble
Duchamp	Philadelphia
Dix	Stuttgart; Art Moderne, Paris; MOMA, NY
Duccio	Siena
Eakins	Philadelphia
van Eyck	NG, London
Fragonard	Wallace Collection, London
de la Francesca	Florence
Friedrich	Stadtsgalerie, Dresden
Gainsborough	NG, London; Huntingdon, Pasadena CA
Géricault	Louvre, Paris
Ghirlandaio	Florence
Giotto	Assisi; Arena Chapel, Padua
van der Goes	Florence for Portinari Altarpiece
van Gogh	Van Gogh Museum, Amsterdam
Grünewald	Colmar
Gros	Louvre, Paris
Grosz	Berlin; Cologne; Stuttgart
Hepworth	Tate, London; St Ives, Cornwall
Hogarth	Sir John Soane Museum, London
Holbein	H. M. The Queen, Windsor
Hopper	Whitney Museum, NY
Ingres	Musée Ingres, Montaubon, France

ARTIST	GALLERY	ARTIST	GALLERY
Kandinsky	Guggenheim, NY	**Renoir**	Musée d'Orsay, Paris
Klee	Berne, Switzerland	**Rivera**	Detroit; Mexico City
Klimt	Osterreichische Galerie, Vienna; Musée d'Orsay, Paris	**Rothko**	Menil Collection, Houston, Texas
de Kooning	Tate, London; MOMA, NY; Buffalo	**Rubens**	Wallace Collection, Banqueting Hall, Whitehall, Dulwich College, Courtauld Institute, London; Prado, Madrid; Accademia, Naples
Leger	Musée Leger, Biot, France		
Leonardo	Louvre, Paris; NG, London; Cracow		
Limbourg Bros	Chantilly, Musee Conde; Bibliotheque Nationale, Paris	**Sargent**	UK and US only; no European representation
Lipchitz	Barnes Collection, Merrion, PA; Tate, London	**Schiele**	Osterreichische Galerie, Vienna
		Schwitters	Newcastle UK; LA; Tate, London; MOMA, NY
Malevich	Stedelijk Museum, Amsterdam		
Manet	Musée d'Orsay, Paris; Courtauld, London	**Seurat**	Chicago; London
		Shahn	Murals; Bronx, Radio City NY; Washington, DC
Mantegna,	Hampton Court, London; Louvre, Paris		
Millet	Boston	**Sickert**	Liverpool; Rouen
Michelangelo	Vatican, Rome; Accademia, Florence	**Signac**	Musée d'Orsay, Paris
		Sveinsson	NG Iceland, Reykjavik
Miro	Miro Foundation, Barcelona; Palma Majorca	**Spencer**	Tate, Imperial War Museum, London
Mondrian	Gemeente Museum, the Hague	**Titian**	Met, Frick, NY; all over Europe
Monet	Musée Marmottan, Paris; Giverny	**de La Tour**	Metropolitan Museum, NY
		Turner	Tate, London
Moore	Leeds; Tate, London; Ontario	**Uccello**	Uffizi, Santa Maria Novella, Florence; NG, London; Ashmolean, Oxford; Fitzwilliam, Cambridge
Morisot	Met, NY; Boston; Washington, DC; NG, Tate, London		
Munch	Munch Museum, Oslo		
Murillo	Seville; Madrid	**Velazquez**	Prado, Madrid
Nash	Imperial War Museum, London	**Veronese**	Venice
Nevinson	Imperial War Museum, London	**Verrocchio**	Toledo, Ohio; NG, Washington, DC
Nolde	Nolde Foundation, Seebüll, Germany		
		Vischer	Vienna; Innsbruck
		Watteau	Wallace Collection, London
O'Keeffe	MOMA, Met, NY; Chicago	**Whistler**	Freer Collection, Washington, DC; Glasgow City Art Gallery
Pissaro	for drawings, Ashmolean Museum, Oxford		
		Witz	Basel
Picasso	Les Demoiselles d'Avignon, MOMA, NY; Guernica, Prado, Madrid	**Wolgemut**	Germany; Brighton UK
Pre-Raphs	City of Birmingham Museum and Art Galleries	**Abbreviations:** MOMA: Museum of Modern Art (New York); NG: National Gallery	
Raphael	Uffizi, Pitti, Florence		

Index